ILLUSTRATING
CHILDREN'S BOOKS

ILLUSTRATING CHILDREN'S BOOKS

Creating pictures for publication

MARTIN SALISBURY

BARRON'S

First edition for the United States, its territories and
dependencies, and Canada published in 2004 by Barron's
Educational Series, Inc.

All inquiries should be addressed to:
Barron's Educational Series, Inc.
250 Wireless Boulevard
Hauppauge, New York 11788
http://www.barronseduc.com

International Standard Book No. 0-7641-2717-9

Library of Congress No. 2003107035

A QUARTO BOOK
Conceived, designed, and produced by
Quarto Publishing plc
The Old Brewery
6 Blundell Street
London N7 9BH

QUAR.ICB

Project editor Nadia Naqib
Senior art editor Penny Cobb
Designer Louise Clements
Text editors Sarah Hoggett, Diana Steedman
Editorial assistant Jocelyn Guttery
Additional picture research Claudia Tate
Photographer Paul Forrester

Art director Moira Clinch
Publisher Piers Spence

Manufactured by PICA Digital, Singapore
Printed by SNP Leefung Printers Limited, China

9 8 7 6 5 4 3 2 1

CONTENTS

Introduction

The art of illustrating children's books has received an increasing amount of attention and respect in recent years. "It's about time," you might say—for this is surely an area of profound and innovative creative endeavor. For children, pictures in books are often their first means of making sense of a world that they have not yet begun fully to experience. The creator of those pictures, then, carries a considerable burden of responsibility.

ATTITUDES TO CHILDREN'S BOOK ILLUSTRATION It has to be said that illustrating children's books is a profession that attracts more than its fair share of comments along the lines of "I could do that." Well, you probably could "do that"—but to do it well you might need to look a little further into the subject than you first anticipated. What can appear effortless and spontaneous may turn out to be the tip of the iceberg in terms of the amount of work involved in drawing, designing, and conceptualizing. But there are, to my mind, few more satisfying and rewarding ways of spending one's time. At its best, children's book illustration is a subtle and complex art form that can communicate on many levels and leave a deep imprint on a child's consciousness. For a long time in art schools, children's book illustration was regarded as something of a soft and uncool option. The U.S. illustration scene began changing in 1964 with Maurice Sendak's *In the Night Kitchen*. Suddenly, perceptions about what children can appreciate and understand were being challenged. The consequent quality and range of illustrative work raises again some of those hoary old questions about distinctions between "fine" or "pure" art and "commercial" art. Illustration is usually referred to as a "hybrid" art form and tends to be viewed in terms of its success, or otherwise, in translating words into pictures. But increasingly, at least where picture

CONTEMPORARY APPROACH *Children's books are becoming increasingly sophisticated in terms of illustration and design. Sara Fanelli is a much-admired example of the new generation of artists working in the field.*

EDWARD ARDIZZONE *The artist Edward Ardizzone received little formal training, but went on to become one of the most prolific and best loved, quintessentially English illustrators of the 20th century.*

books for younger children are concerned, the book is becoming a complete concept, created by an artist and author who are one and the same person. Here, words and pictures can have complex and subtle relationships.

ABOUT THIS BOOK Most illustrators shy away from writing and talking about their work, being happy to let their pictures speak for themselves. Consequently, most writing about the subject emanates from people who are trained in word-writing rather than in picture-writing. Similarly, most academic research into "visual literacy" (a much used but little understood term) in children has come primarily from word people, and there can be a tendency to look for literal meaning in images—decoding them into words. Artists, however, see and think in pictures. Happily, during the preparation of this book, many artists have been kind enough to find the time to speak with me about their personal working methods.

This book examines the techniques and skills (both practical and conceptual) required to illustrate books for children. It draws on my own experience as an illustrator and as Course Director for the U.K.'s first MA program in Children's Book Illustration at APU Cambridge School of Art. It is not a "how to" book: I don't believe that there is a "way" of drawing that is particularly suitable for, or appropriate to, children's book illustration.
It aims instead to help readers understand how they might progress to a level of work that is satisfying and maybe even publishable. I make no apologies for the fact that the chapters on drawing and the use of media make up a significant proportion of the text. Although you will not find quick and easy steps to stylistic tricks or wizardry, I hope that, by examining the work of a range of specialist students and professionals, you will gain some insight into their ways of observing and working that are specific to the illustration of children's books.

There are those who believe that illustration—indeed, art in general—cannot be taught and that the ability to draw or paint is an innate gift. I am increasingly suspicious of the concept of "talent," having been constantly surprised over the years by the different ways in which students learn and develop. I believe that most of the skills can be taught. The passion, of course, cannot.

MARTIN SALISBURY

checklist • chap books • Bishop Comenius • Thomas Bewick • technological developments • William Blake

Introduction

This book is concerned primarily with practical and conceptual aspects of children's book illustration, but it is important to have at least some knowledge of the history and current status of the craft. Over the next few pages we will take a distinctly unscholarly look at the world of illustrated children's books, past and present.

THE VERY FIRST ILLUSTRATED CHILDREN'S BOOKS Although the idea of illustrative art aimed specifically at children is relatively recent, academics and historians point to a few key moments in the history of the subject. The first European prototype of the illustrated children's book is *Kunst und Lehrbüchlein*, published in Frankfurt in 1580, the title page of which declared it to be, "A book of art and instruction for young people, wherein may be discovered all manner of merry and agreeable drawings." The charming woodcut illustrations were executed by Jost Amman (1539–91).

CHAP BOOKS *The chap books of 17th- and 18th-century Europe were crudely printed little books that were sold by "traveling peddlers."*

The second key example is *Orbis Pictus*, published in 1658 and devised by a forward-thinking Moravian cleric who became the Bishop of Leszno in Poland. Bishop Comenius held strong views about the need to make the process of learning more attractive to children. "For children, pictures are the most easily assimilated form of learning they can look upon," he proclaimed, and his book was designed to lighten the tedium of studying Latin.

KUNST UND LEHRBÜCHLEIN Kunst und Lehrbüchlein *was one of the earliest children's books, published in 1580. Jost Amman's woodcut illustration from the book shows a child reading a hornbook ("reader").*

TECHNOLOGICAL DEVELOPMENTS The history of children's book illustration is, of course, inextricably linked to developments in reprographic technology, but long before the arrival of the first crude printing processes, children would surely have enjoyed and learned from adults' compulsion to communicate stories visually. Exquisitely illuminated manuscripts from many parts of the world precede Gutenberg's invention of movable metal type. There exist illustrated fragments of Virgil and the *Iliad* from classical Greece and there are references to herbals from ancient Rome that contained detailed, naturalistic colored drawings of plants. But it is the medieval illuminated manuscript, with its highly detailed miniatures and decorated initials, that is generally seen as the direct precursor of the modern illustrated book.

The division of labor between various artists and scribes working on sections of these hand-rendered books can be seen as an early version of the relationships that exist today between designer, illustrator, and printer.

Early printing methods revolved around the use of wood to transfer an image and text onto paper. The areas not to be printed were cut away, leaving a raised surface that was then rolled with ink and pressed onto paper, producing a reverse impression of the original. This is known as "relief printing." This crude process was used to produce the popular printers' "chap books" of 17th- and 18th-century Europe. With their crude, vigorous illustrations to ballads and stories, these were the forerunners of today's tabloid newspapers and were hawked around the countryside by sellers. The anonymous illustrations were often randomly or approximately applied to texts, just as today stock imagery is used for some editorial illustration. This practice was prevalent in the 18th century when, for the sake of saving money, various engravings of limited relevance to the text, and of varying sizes and shapes, were recycled from the publisher's stock.

An artist who transformed the prevailing attitudes to woodcutting as a crude and cheap process was the Englishman, Thomas Bewick. He developed a method of cutting into the end grain of very hard, dense types of wood, such as boxwood, rather than cutting into the long or plank side. This allowed for a much finer range of textures and tones in the printing. Bewick also introduced the concept of white lines on a black background. This process is now known as wood engraving, and it continues to be an important, albeit rather esoteric, branch of book illustration. Bewick's work first appeared in the latter part of the 18th century at around the same time as the presence of another key figure, William Blake. Blake was the first artist to really explore the integration of text and image on a page. His children's books, *Songs of Innocence* and *Songs of Experience*, were written and illuminated in his highly distinctive hand-rendered way.

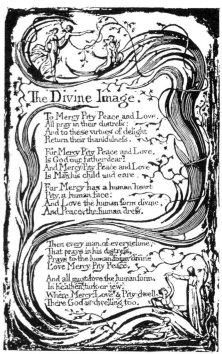

A brief history

10 The 19th century and the Golden Age

It was not until the 19th century that children's book illustration truly began to flourish. Lithography was a form of printing that first appeared in France at the beginning of the century. This process, based upon the mutual antipathy of oil and water, was eventually to lead to books appearing in full color, something that was previously achievable only by hand coloring each individual print.

The selling power of good-quality illustration was now becoming apparent, and children's books—or "toy books," as they were known—proliferated. Black-and-white illustration still dominated, and artists such as H. K. Browne (better known as Phizz) and George Cruikshank were gaining in reputation, primarily through their work with the texts of Charles Dickens. Cruikshank had an extraordinarily long career, spanning most of the century. He was a true professional, tailoring his drawing style to suit the craft of the engraver. Cruikshank's name on a book was a powerful selling tool.

Two important figures emerged around the middle of the century. One of these was Edward Lear, whose *Book of Nonsense* came out in 1846. Lear, rather like William Blake, defies attempts at classification. He was a painter of landscapes and birds by profession, but his exuberantly zany limericks and drawings seem to bear little relation to this or any other contemporary work. Sir John Tenniel's drawings will be forever considered in relation to Lewis Carroll's *Alice*. *Alice's Adventures in Wonderland* first appeared in 1865, at about the time that color printing was first beginning to take off, ushering in what has become known as the "Golden Age" of book illustration in Britain and America. The printer Edmund Evans was a key player in England, working to improve standards of printing and production, and nurturing the careers of artists such as Walter Crane, Kate Greenaway, and Randolph Caldecott.

EDWARD LEAR *The standard for the genre was set by Edward Lear's* Book of Nonsense, *and it continues to be much imitated. His drawings and writings help make perfect sense of nonsense.*

KATE GREENAWAY *Generations have grown up with the graceful innocence of Kate Greenaway's illustrations. She remains very popular. Her bonneted and bow clad children exude the fragrance of a rose garden in a bygone age.*

WALTER CRANE *Strongly redolent of the decorative arts of the period, Walter Crane's illustrations have come to be synonymous with the Arts and Crafts movement.*

HOWARD PYLE *was possibly the most important figure in American illustration in the late 19th century. His realist approach to painting became a signature for the period, both through his own work and that of his many students.*

SYNERGY OF TEXT AND IMAGE The importance of Caldecott's work cannot be overstated. He is often described as the father of the modern picture book, being the first to really explore and experiment with the relationship between text and image. Before Caldecott, illustration generally duplicated the story conveyed by the words, but the two became fused together, making complete sense only when viewed as a whole. This harmony is perfectly summed up by Maurice Sendak, in an appreciative essay on Caldecott, as "a rhythmic syncopation of words and pictures."

RANDOLPH CALDECOTT *Caldecott's influence on the development of children's book illustration was immense. As well as being a gifted draftsman, he brought a new, more sophisticated approach to the relationship between image and text.*

The influence of Caldecott, Crane, and Greenaway spread, and their work with Edmund Evans played a considerable role in defining what became known as the Arts and Crafts movement. These influences spread to America, where illustration was burgeoning. A major figure was Howard Pyle, whose work both as illustrator and teacher created a dynasty of artists, collectively known as the "Brandywine School," of great technical skill. His strong views were impressed upon pupils such as N. C. Wyeth, Jessie Wilcox Smith, and Maxfield Parrish.

By the end of the century, the rather overblown effects of chromolithographic printing were being replaced by the newly emerging four-color process.

12 The 20th century

A new printing technology for a new century encouraged an outbreak of lavish watercolor illustration. For a time the colorful "gift book" was commonplace, and Arthur Rackham, Edmund Dulac, and Beatrix Potter were among the major contributors to this period of infatuation with the possibilities of four-color printing.

The half-tone screen had been invented in Philadelphia in 1896, allowing continuous tone to be printed in black and white. Howard Pyle made it clear to his students that they now needed to learn to paint: Within a few years, he said, the demand for line drawing would be gone. But despite this "Golden Age" of color illustration, black-and-white line reproduction continued to be an important and a far less expensive alternative to the grand "plates" that appeared in books illustrated by N. C. Wyeth, Maxfield Parrish, and others.

QUALITY DRAFTSMANSHIP William Nicholson revived the woodcut as a medium for illustrating books with his bold, simply colored, and beautifully designed shapes. E. H. Shepard is largely remembered for his work illustrating the texts of A. A. Milne, but his prolific career spanned much of the 20th century.

CROSS-CULTURAL INFLUENCES As the century wore on, the English pre-eminence in illustration was increasingly under challenge from the Americans. Robert McCloskey's *Make Way for Ducklings* won the Caldecott in 1942, and is still very popular today: It has a genuine sweetness and humor that transcends time.

Idiosyncratic artists began to arrive from diverse cultural backgrounds. Ludwig Bemelmans came from Austria in 1914. He is best known for

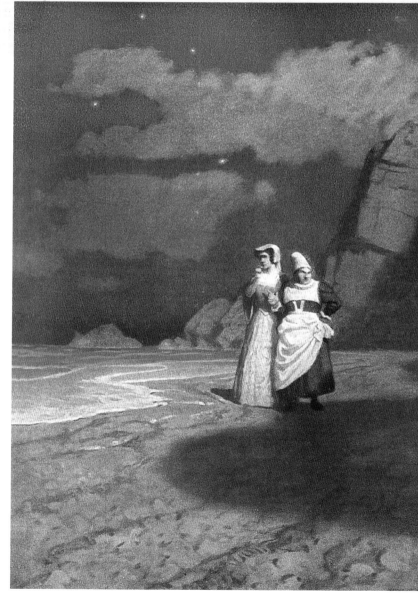

N. C. WYETH *continued the Howard Pyle tradition of illustration well into the 20th century. His highly accomplished paintings accompanied such classics as* Treasure Island *and* Westward Ho!

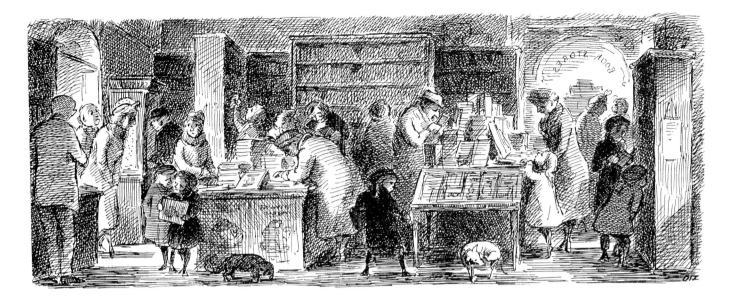

EDWARD ARDIZZONE'S *illustrations first appeared in the 1920s. His mastery of tone is demonstrated in this image. His cross-hatching technique never becomes intrusive; it simply describes the dusty light of the bookshop. Every figure, human or animal, is totally alive and convincing.*

his awkward, rather childlike, and totally engaging drawings that were used for the *Madeline* stories. Antonio Frasconi's ground-breaking *See and Say* was produced a decade or so after he arrived in the U.S. from Uruguay.

Strong traditions were also emerging, albeit in isolation, in Eastern Europe. The extraordinary constructivist children's books of the Russian artist, El Lissitzky, are fabulous art objects in their own right. There were also successful illustrators who relied on a more traditional folk art approach. Barbara Cooney lived into her nineties illustrating books for decades. In 1959 her *Chanticleer and the Fox* was awarded the Caldecott. Alice and Martin Provensen, a husband and wife team, also created images with a folk art feel. They worked with a limited palette in a primitive style.

ANTONIO FRASCONI'S *vigorous and playful woodcuts make just the right companion to the text in his wonderful* See and Say. *The book introduces children to a basic vocabulary in Spanish, Italian, and French.*

NEW DEVELOPMENTS The 1950s and 1960s saw a flurry of more expressive and painterly illustration facilitated by further improvements in printing technology. The work of Brian Wildsmith and Charles Keeping was particularly noteworthy. The vibrant collage color of Eric Carle exploded onto the scene, and Richard Scarry's busy, busy world of animals,

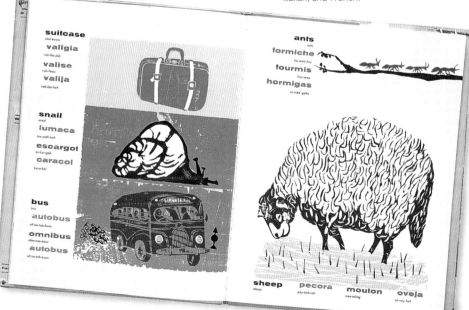

A brief history

Winsor McCay's
*contribution to the
development of
sequential art for children
is immeasurable. His* Little
Nemo in Slumberland *is
widely recognized as a
work of genius that paved
the way for much
subsequent invention in
comics and children's
books. The strip first
appeared in the* New York
Herald *in 1905, and over
the years McCay became
increasingly daring with its
design, structure, and
content.*

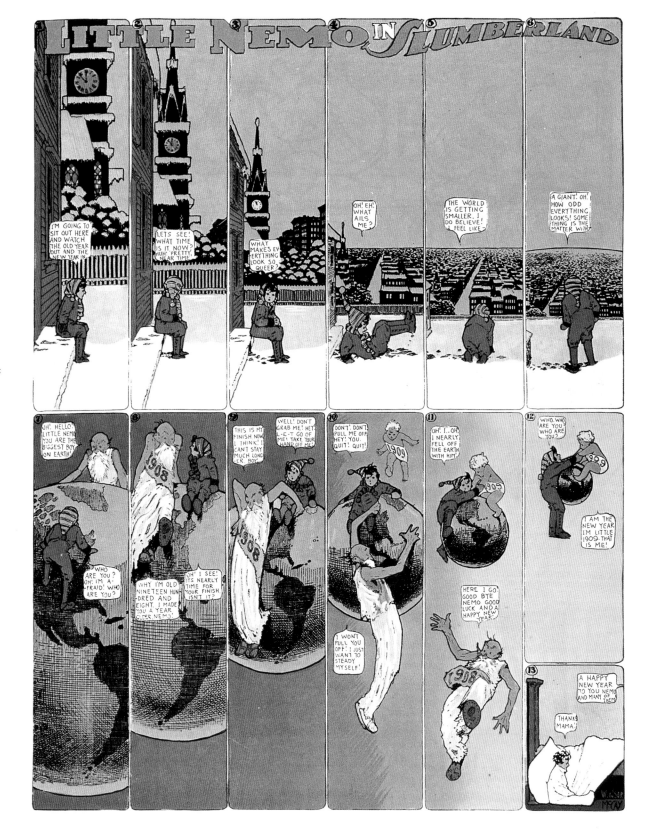

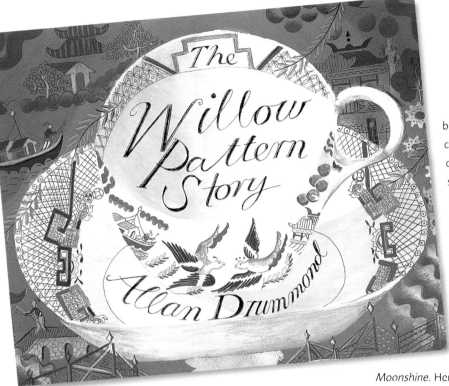

ALAN DRUMMOND'S The Willow Pattern Story *revives older traditions of hand-rendered lettering and the effects of stenciled color.*

boats, cars, and towns, captivated generations of small children with its highly successful formula for explaining visually the mechanics of everyday living.

Evaline Ness was a studio artist before moving into children's books. She used the mediums of woodcut, ink, and color. In the 1960s Evaline won awards for *Sam, Bangs, and Moonshine*. Her work was distinctive and experimental. She was admired for her craftsmanship and range of technique.

Ezra Jack Keats created urban themed books of the 1960s and early 1970s. His work is known for two distinct styles. The first makes use of strongly graphic collages. The second uses acrylic with dramatic light and dark contrasts. He is best known for *The Snowy Day*. One of the first books with a minority character, it has strong design, and beautiful color and texture.

Leo and Diane Dillon won Caldecotts in 1976 and 1977. Their work is prolific in children's books and book covers. They use diverse media and are still active in the field today.

No overview of 20th century children's book illustration, even one as brief as this, would be complete without a mention of the artist whose work set new standards in every sense. Maurice Sendak's books are profound works that cannot be viewed only in terms of their illustrations. These include *Where the Wild Things Are* and *In the Night Kitchen*.

JOHN LAWRENCE *is one of the "senior" picture book artists of the 20th century. His book,* This Little Chick *is highly contemporary while at the same time firmly rooted in the engraved chap book tradition.*

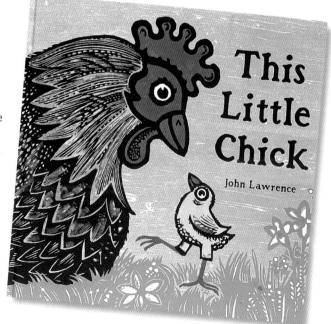

A brief history

16 Children's book illustration now

Several periods have laid claim to the title "Golden Age" in children's book illustration. Although we do not yet have the benefit of hindsight, the variety and quality of work available in today's increasingly international market seems to merit just such a description.

Deciding precisely where to start when reviewing (and necessarily skimming) the extraordinary spectrum of artistic excellence on display in children's books today is something of a challenge. At the present time, artists trained in the formal disciplines of drawing and design are working alongside people who, although they might seem less well equipped in these traditional skills, are overflowing with exuberant, sophisticated, and ever-inventive approaches to book illustration. It seems unlikely that, in years to come the early 21st century will be remembered as having been dominated by a particular style, as the Art Nouveau movement held such sway a hundred years previously. A world where J. Otto Seibold, Lane Smith, Kvĕta Pacovská, and Gennadi Spirin can coexist so comfortably suggests a broad spectrum indeed.

Children have never been offered so rich and diverse a choice of imagery through which to enter the world of stories and knowledge. The expanding range of communication media means that young people are exposed to more imagery than ever before. Artists are increasingly attracted to the medium of the picture book as a creative outlet. This may be attributable to a growing awareness of the creative opportunities in this field for those whose work demonstrates an interest in sequence, narrative, design, and communication.

INFLUENTIAL ILLUSTRATORS OF TODAY Controversial though it may be to highlight individual artists in so abundant a field of talent, it is nevertheless possible to pick out a few key contemporary influences.

THE DIGITAL REVOLUTION *has meant that in some instances there is now no such thing as an original artwork on paper. Images can be partially or entirely generated on screen as with this design by Debbie Stephens.*

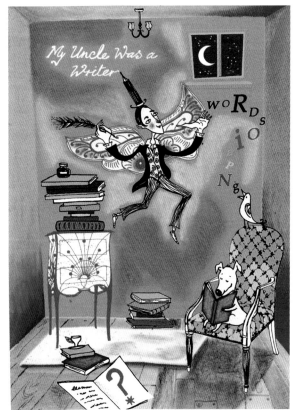

LANE SMITH'S *illustration manages to combine an ironic wit with affection and humanity.*
His books are always produced with careful attention to design, through collaboration with Molly Leach.

The Czech artist Kveta Pacovská is a hugely influential figure. Her books for children form only a part of her overall output as an artist. She studied fine art at the Academy of Fine Arts in Prague in the 1950s, and her work shows the same depth and intensity whether in the form of a mass-market book or a gallery installation.

Another Czechoslovakian artist, Peter Sis, came to the U.S. in 1982. He burst onto the scene in the 1980s with a distinct pointillist style that is very original. David Wiesner also came on the scene in the 1980s and still produces award winning books today. He is known for his wordless, sequential watercolor illustrations that are detailed and full of mystery—they are very imaginative. Simms Taback is quirky and imaginative with funny characters and lively action. His mixed media collages mostly have black backgrounds.

J. Otto Seibold's books are hilariously funny and highly inventive. He was one of the first artists working in children's books to generate his imagery entirely digitally and has been much imitated.

Lane Smith's books have been very successful, both those written and illustrated by him and those produced in collaboration with the writer Jon Scieszka. The sophisticated humor of artist and writer combine seamlessly to create fast-moving, film-influenced picture books. Smith's early technique of spraying acrylic varnish onto oil paint, which then bubbles up to create texture (a technique created accidentally), has been gradually superceded by the computer, allowing him to layer and organize his textures more flexibly.

The Austrian artist, Lisbeth Zwerger, combines extraordinary technical skill and draftsmanship with a

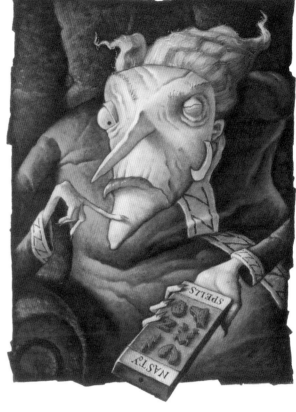

STEVE JOHNSON'S *surreal illustrations bring a touch of somber menace to* The Frog Prince Continued *written by Jon Scieszka. The illustrative style is both stylized and sophisticated.*

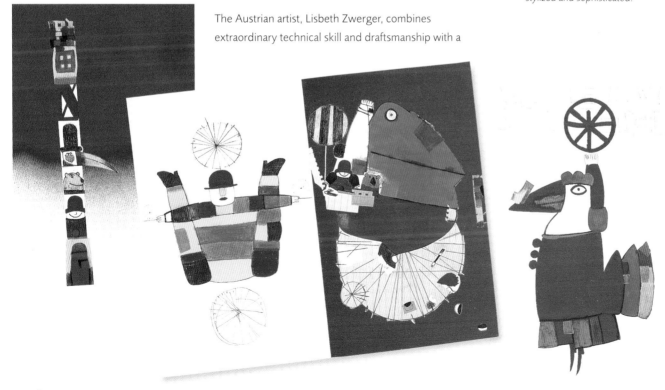

KVETA PACOVSKÁ'S *richly graphic page designs have begun to be appreciated by a wider audience beyond her home country of the Czech Republic. Her ebullient color and uplifting subject matter appeal to all ages.*

QUENTIN BLAKE is very popular with children, and is perhaps best known for his collaborations with the writer, Roald Dahl. But his oeuvre ranges across many ideas and approaches, including the beautifully lyrical The Green Ship.

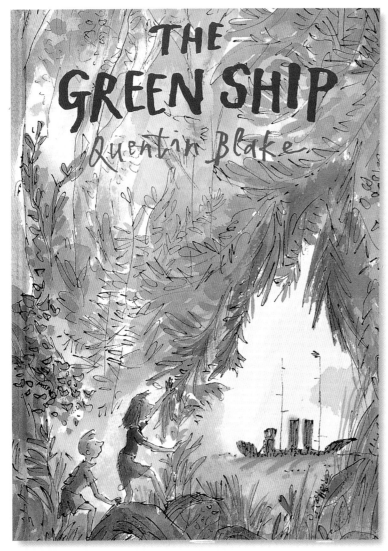

fabulously dark, very European vision that is particularly effective in the interpretation of folk tales. Russian-born Gennadi Spirin's work is similarly rooted in European cultural traditions, but his voluptuously detailed compositions contrast with Zwerger's cool and considered use of empty space.

Quentin Blake has delighted children with his books for several decades now, and continues to experiment and innovate across a wide range of texts and ideas. His apparently effortless drawings are capable of conveying every emotion through his extraordinary ability to get inside the characters that he draws. His themes can vary from the surreal and fanciful to the deeply lyrical. Blake's work has considerably raised awareness of the art and craft of illustration.

Angela Barrett continues to produce exquisite illustrative work for a range of texts. Her painstakingly executed watercolors are driven by a darkly enchanting vision. Italian-born Sara Fanelli's consistently inventive illustrations inspire art students everywhere. She possesses that rare gift of a childlike approach to shapes, colors, and mark-making combined with a deeply sophisticated sense of design and a passionate and cultured mind. Books like Sara's, which in many ways can be seen as true artists' books, can invite criticism from publishers and librarians, some of whom feel that the books are aimed "over the heads" of children. We know from history, though, that what is

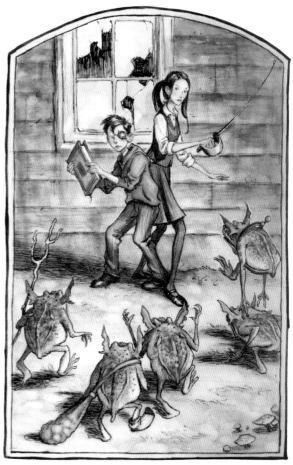

TONY DITERLIZZI The late 20th/early 21st century craze for mixing retro boarding school literature and Tolkienesque fantasy is exemplified by Tony DiTerlizzi and Holly Black's *The Spiderwick Chronicles*.

EMERGING TALENT *New artists/authors are constantly emerging from art schools with new ideas and approaches. Alexis Deacon's Beegu combines skilled draftsmanship with a sophisticated but sensitive concept.*

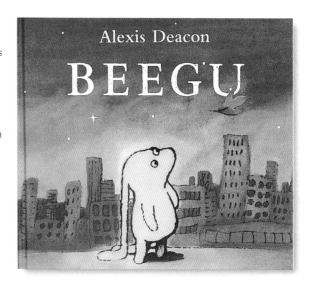

regarded as radical or cutting-edge can quickly become mainstream and much imitated. One should be wary of making pronouncements on what children want: Work taking place on the boundaries of any creative discipline is essential for its all-around vitality.

THE EUROPEAN APPROACH In many parts of Europe, children's books are conceived, designed, and illustrated in ways that assume that children expect and demand a visual diet more substantial and satisfying than the purely sentimental. Particularly exciting graphic work is emanating from Spain, Portugal, France, and Germany. The Eastern European countries, notably Poland, continue a rich tradition in children's book design, and a quirky approach to content and illustration is maintained in Scandinavian countries. In Denmark it is not unusual to see books for children covering subjects like death and sex, illustrated in original and sensitive ways. As creativity and cross-cultural influences grow, perceptions of what constitutes an appropriate visual diet for a child will continue to be challenged.

SARA FANELLI has been an inspiration to art students with beautifully designed and illustrated books. Every spot on the page is carefully considered in terms of its graphic weight and impact.

Introduction

Drawing is the fundamental language of the illustrator. If your work is not underpinned by convincing drawing, then no matter how many techniques you develop, there is always the danger that it may become mannered or bland. Carrying and using a sketchbook habitually is an important way of developing your own perspective on the world around you.

VISUAL VOCABULARY *Anecdotal drawings and notes of everyday things, including your own domestic surroundings, are invaluable in helping to build up a personal visual "vocabulary." This sketchbook study by Hannah Webb was made directly from life, at home in the kitchen.*

Most successful illustrators are fascinated by the day-to-day, apparently mundane activities of people. The great graphic artist, Ronald Searle, was once asked what he would like to have been had he not been a successful illustrator. "A professional voyeur," he replied. Searle also recalled, "At the Cambridge School of Art it was drummed into us that we should not move, eat, drink, or sleep without a sketchbook in the hand. Consequently, the habit of looking and drawing became as natural as breathing."

There were far fewer visual distractions in Searle's time, however. Today's students are bombarded with imagery from film, television, video, advertising, computer games, and so on—and so the temptation to employ second- or third-hand imagery is much greater. Drawing directly from life allows you to process first-hand visual information in a uniquely personal way. Many illustration students inquire early on in their studies, "when do we learn about style?" The answer is, of course, that we don't. Style is a word that other people use when talking about your work. If your drawing is to develop naturally and with integrity, it is vital that you do not consciously pursue a "style." The process of working honestly, and with a passion for

THE IMPORTANCE OF THE SKETCHBOOK *The sketchbook is an important tool for illustrators. It is the place where ideas, notes, doodles, and observational studies can coexist in an intimate and unselfconscious mix. These typically busy pages are from the sketchbooks of Pam Smy.*

your subject matter, will allow your work to evolve and develop its own identity. We will see later on in this chapter how observation can feed the imagination, and how drawing from life will inform creative drawing. For the moment, we are concerned primarily with looking and learning to see. It is not until you draw something, whether it is an object, a building, or an activity, that you really begin to understand it. The Victorian artist and philosopher John Ruskin once said "... I believe that the sight is a more important thing than the drawing; and I would rather teach drawing that my pupils may learn to love Nature, than teach the looking at Nature that they may learn to draw." This was his way of stressing that the activity of drawing can lead to a great deal more than the mere acquisition of skills. A real commitment to *looking* will be invaluable in your artistic development. At this stage, you should banish any thought of drawing in a way that you perceive to be aimed at, or suitable for, children. It is debatable whether there is such a thing as a way of drawing for children, but "drawing down" to children—in other words, patronizing them—is to be avoided at all costs.

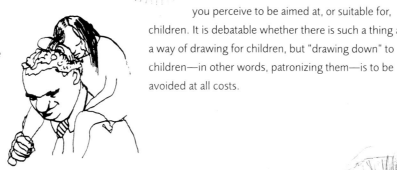

OBSERVATION AT CLOSE QUARTERS
People interacting in various ways, with each other and with objects, make useful subjects. Close study through drawing helps to build understanding of the way shapes and comparative proportions relate to each other. These sketches by Alexis Deacon show a keen interest in such matters.

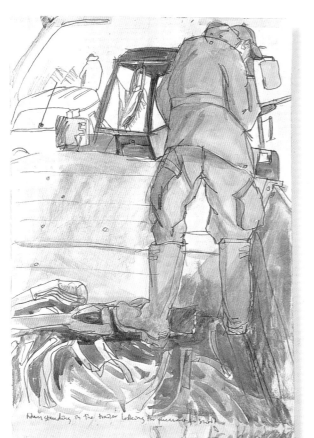

SKETCHING ON LOCATION *The workplace can be another rich source of material for the sketchbook (left). Hannah Webb's study of a farmworker comes from a series of sketches made on location at a farm during the harvesting of leeks.*

SELF-PORTRAITS *The self-portrait is perhaps the most readily available subject, allowing for lengthy self-contemplation (right). It is possible to be compositionally inventive by using more than one mirror to create unusual angles, as in this beautiful drawing by Julia Davies.*

The life studio

Edward Ardizzone once observed that "born illustrators" do not like to draw from life (he felt that they were more interested in drawing "living"). This may or may not be true, but unless you are lucky enough to be blessed with this particular gift, it is dangerous to neglect the discipline of drawing from life.

In most towns and cities you will find that life-drawing groups or classes are available. It is a good idea to attend one of these as regularly as possible. Drawing the unclothed human figure has long been seen as an important discipline for all kinds of artists. The process of studying the human form in a detached, objective way helps you to build a thorough understanding of the topography of the figure and its potential for movement. There is a common misconception that objective drawing leads to a "realist" approach to illustration. In fact, the stronger the drawing, the greater the foundation for experimentation. It is perhaps true that the illustrator tends to be more interested in the character of the model, and is therefore possibly less objective in approach than the sculptor, who explores pure form in relation to the space in which it exists. Studying in the life-drawing studio can become something of a story-telling activity. Drawing the people who are drawing the model, as well as the model him- or herself, introduces a sense of time and place, and perhaps an implied narrative. It is a good way to improve your drawing skills while also developing an eye for character, mood, and story.

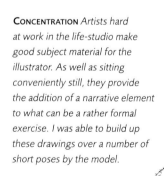

CONCENTRATION *Artists hard at work in the life-studio make good subject material for the illustrator. As well as sitting conveniently still, they provide the addition of a narrative element to what can be a rather formal exercise. I was able to build up these drawings over a number of short poses by the model.*

QUICK SKETCHES *A pencil study of a standing figure by John Lawrence beautifully establishes the sturdy solidity of the model. This was a short (10-minute) pose, which needed to be captured with swift, bold strokes and a broad indication of tone.*

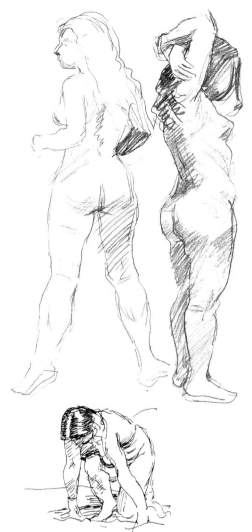

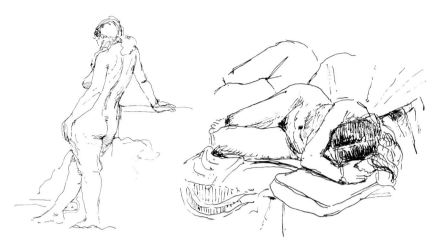

COMPOSITION The term refers to the way we balance pictorial elements within a given space. Think of this as you might the arrangement of props or characters on a stage—your aim is to create a sense of balance and order. Once you introduce more than one element, or figure, a composition of some sort is created. When drawing a group of figures, you may wish to take liberties by moving a figure or piece of furniture to create the desired sense of balance. Composition is often the skill that students find most difficult. It is only by experimenting that you can see what works, and getting used to working in a sketchbook helps you to think naturally about the very shapes that relate to a double-page spread.

SHORT POSES *The model can be asked to adopt a more dynamic, harder-to-hold stance. The speed with which you need to work forces you to look hard for the salient shapes and does not allow for any time wasted on rubbing out or "fiddling." I drew the two larger standing figures with a soft pencil and the others with a technical pen.*

SUSTAINED COLOR STUDY *A tint and wash sketch such as this can be made over the length of a life-drawing session. This one took me the full two-hour duration of the class. People move about but tend to repeat the movements and shapes that they make so that you can come back to them. Each person has a particular and distinct way of sitting or standing.*

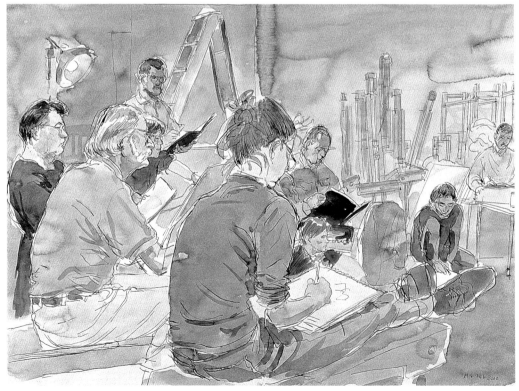

Drawing

Drawing children

Needless to say, the ability to draw children is extremely useful for the aspiring children's book illustrator. Once again, it is a good idea to begin by looking at the real thing in as objective a way as possible, in order to really get to know your subject matter.

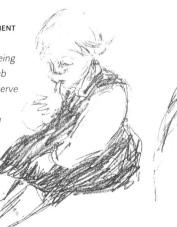

Once you start to look closely at children through drawing, you will realize, if you did not already do so, what a strange species of beings they are. Everything about them is different—their physical proportions, their movements and gestures, their social interaction with each other and with adults, and, of course, their unspeakable habits. (For confirmation of the latter, see Charles Schultz's Pigpen character from *Peanuts*, or *Dirty Bertie* by David Roberts.)

Drawing them from direct observation is a challenge, because of children's disinclination to sit still. But, as with all observational drawing, it is the intense *looking* that is so beneficial. Don't be afraid to end up with page after page of unfinished scribbles. Each mark, and each brief act of committing a line or contour to paper, will add to your store of knowledge. This process is part skill development (developing your own ways of processing and recording information) and part social/anthropological study (learning about behavior).

POCKET-SIZED SKETCHBOOKS
These are handy for taking advantage of unexpected opportunities to draw children (or anything else for that matter). You never know when snippets of information in words and pictures are going to be useful.

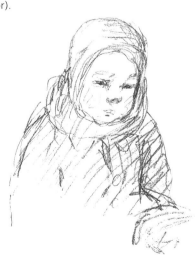

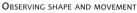

OBSERVING SHAPE AND MOVEMENT
Unguarded moments when children are concentrating, being distracted, fiddling, and thumb sucking are fascinating to observe through drawing. Pam Smy's sketches reveal her interest in the shapes children's bodies make through their idiosyncratic movements.

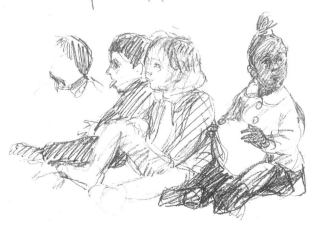

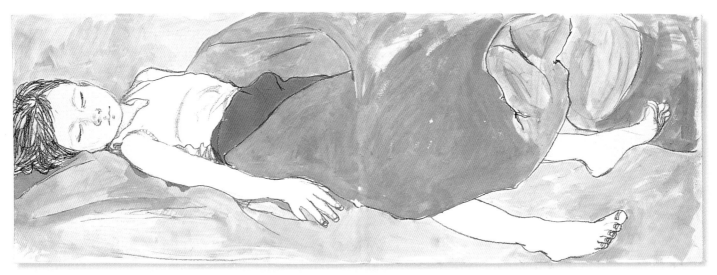

EFFECTIVE FORMAT *A landscape format is used effectively here by Hannah Webb to capture the magic of a child sleeping.*

Look for unguarded, unselfconscious moments, a child engrossed in play, or a group interacting—adults and children together. Try not to be put off by the constant movement— you can always "cut and paste" figures into groups and swap characters around from one group to another as you go along. Anything goes, provided you can fill your pages with some sense of what you were looking at.

As your confidence grows, you may wish to think a little more about composition, something that has perhaps not been a priority until now. Begin to look at figures a little more in terms of the space that they are in, and in relation to the edge of your page, giving a sense of scale to the scene. One way of approaching this is to create a rough spatial composition and to map out the position of different elements within the

OBSERVATION AND IMAGINATION *This sheet of studies by Hannah Webb was made primarily from memory and shows a growing familiarity with the child's personality and movements.*

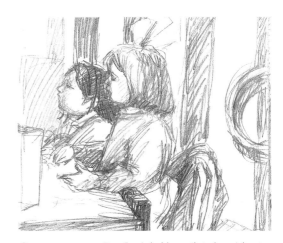

CLOSE-UP PORTRAITS *Pam Smy's bold pencil strokes pick out the important elements of body shape and character.*

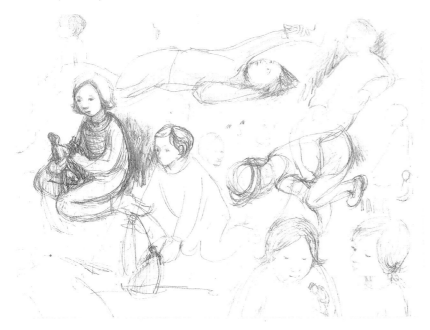

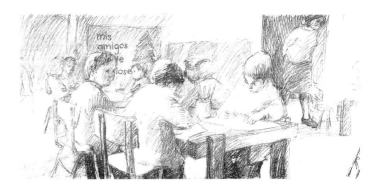

GROUP SCENE *A more sustained drawing can be made by putting together various observed moments and gestures in a more tonally developed background.*

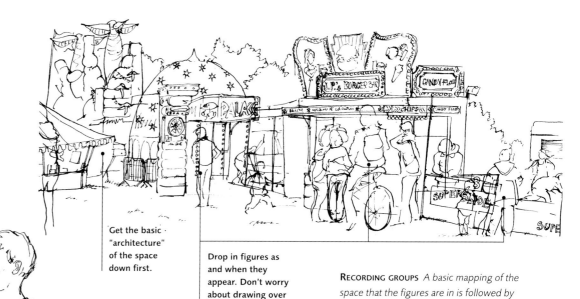

CHANGING BODY PROPORTIONS *As we grow, the relative proportions of the various parts of our bodies change significantly.*

In the first few months of life, babies' heads are very large in relation to the overall length of the body. The limbs are short and chubby.

At three to four years old the head size is still noticeably large in relation to body length, the limbs are beginning to lengthen.

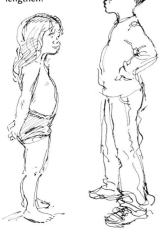

Get the basic "architecture" of the space down first.

Drop in figures as and when they appear. Don't worry about drawing over the lines.

RECORDING GROUPS *A basic mapping of the space that the figures are in is followed by the gradual introduction of the figures as they stop for long enough to be drawn.*

As children reach seven or eight years, proportions are getting close to those of adults, though the head is still proportionally slightly larger.

The full adult proportions.

space that you are observing. Sketch this out, stopping every now and then to add figures when they do something that catches your eye. You will have only a few seconds to get those bits down, but you can return to the general architectural details at any time to continue the composition.

In many medieval European paintings, it is noticeable that on the occasions where children or babies are represented, they appear strangely like miniature adults. In fact, the proportions of children's bodies are very different from those of adults. In infancy, the size of the head is very much greater in relation to the body as a whole than it is in adulthood. Drawing children of various ages directly from observation is the best way to familiarize yourself with the changing proportions of children as they grow, but there are some basic rules on the panel on the left of this page.

MOVEMENT AND PLAY Watching and drawing children at play is a great way to get to understand their movements and shapes. The drawings on these pages were produced by students who were working on a long term location/observation project. The sense of movement is captured by a necessarily brief and fluent line, sometimes based on only the most momentary glimpse of an action.

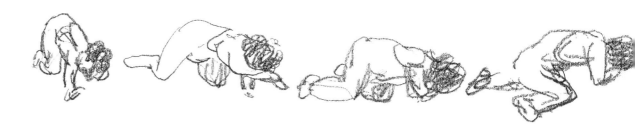

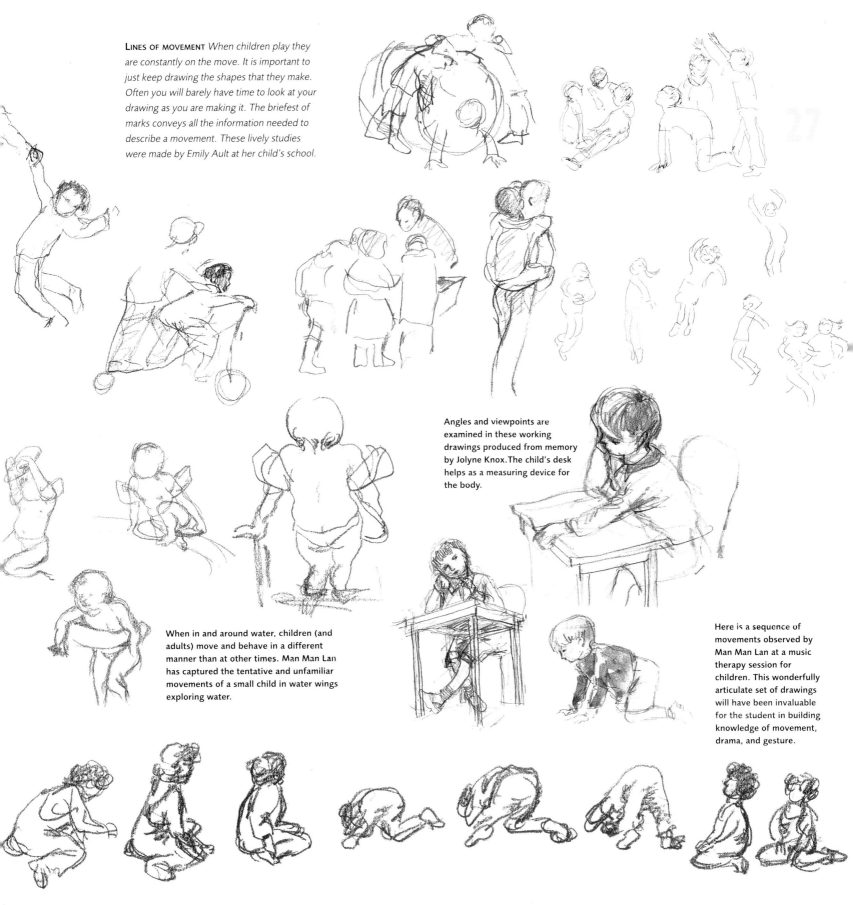

LINES OF MOVEMENT *When children play they are constantly on the move. It is important to just keep drawing the shapes that they make. Often you will barely have time to look at your drawing as you are making it. The briefest of marks conveys all the information needed to describe a movement. These lively studies were made by Emily Ault at her child's school.*

Angles and viewpoints are examined in these working drawings produced from memory by Jolyne Knox. The child's desk helps as a measuring device for the body.

When in and around water, children (and adults) move and behave in a different manner than at other times. Man Man Lan has captured the tentative and unfamiliar movements of a small child in water wings exploring water.

Here is a sequence of movements observed by Man Man Lan at a music therapy session for children. This wonderfully articulate set of drawings will have been invaluable for the student in building knowledge of movement, drama, and gesture.

Drawing

Drawing animals

Animals are an important source of inspiration in children's books. Drawing them directly from life is a good way of ensuring that any animal characters that you may develop are well informed by the real thing.

Over the years I have often noticed that art students who have been having difficulty with drawing, in particular with drawing the human figure, have produced their best drawings when taken on a trip to the zoo. I have come to the conclusion that this is probably due to the fact that when drawing the human figure, or more particularly the human face, we are constantly deceived by our brains which are trying to tell us that we know what a human being looks like (because we are looking at them all the time). Consequently, our objectivity is impaired by expectations of particular results and likenesses. But when drawing animals, even the apparently familiar ones, it is somehow easier to surrender ourselves to the fact that we are in unknown territory, exploring unfamiliar and exotic shapes with a sense of wonder. I remember when I was a student, a tutor arranged for a chicken to be brought into the drawing studio. We all concentrated hard, trying to get something down on paper, while she seemed somewhat nonplussed. At the end of the session everyone had produced good drawings.

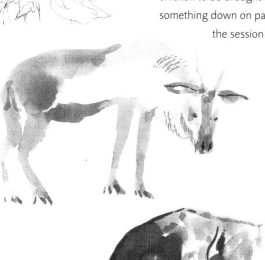

EXPLORING FORM AT CLOSE HAND
Sketches made at a zoo by Charles Shearer demonstrate the intimacy that first-hand experience of exotic animals can give to the artist in understanding their anatomy and movement. Such knowledge makes for a convincing approach to characterization.

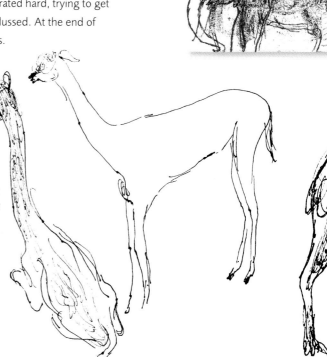

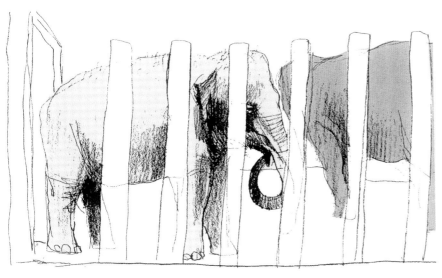

ANIMALS AS CHARACTERS
This drawing of zoo elephants from observation helped Alexis Deacon to develop ideas for his first picture book (see the Case Study on page 38).

Now, of course, we would have an army of health and safety inspectors to get past before such a thing could happen, but most of us have access to pets or a nearby zoo, so a drawing session shouldn't be too difficult to arrange.

Once again, the prime value of this exercise is in learning to see. Looking hard at the unfamiliar through drawing helps us to understand a thing more fully than we would otherwise have done. When it comes to drawing animals, this generic benefit is augmented by its specific significance in relation to characterization in children's books. This has a bearing not just on the creation of animal characters. A better understanding of animal behavior and movement will help you to convincingly infuse characters of any sort, human or otherwise, with appropriate feline, canine, or bovine characteristics.

As with drawing children, you will be faced with the problem of movement, in other words the need to get marks quickly down on paper to capture a sense of the shapes made by a highly active creature. More sustained drawing is possible with lazy well-fed pets and the inhabitants of the zoo's nocturnal house during the day. As we shall see on page 38, there are ways in which this kind of subject matter can feed into ideas for picture books.

SELECTING SUBJECTS
Chickens make excellent subject matter for drawing. Their shapes are fairly simple to observe, as are their repetitive, "staccato" movements.

On location

Drawing on location is an important part of building up your
personal visual vocabulary, whether this takes place close to home
or further afield. A convincing sense of place is often a key element
in successful illustration for children.

One of the most rewarding,
stimulating, and productive projects
for illustration students is invariably
the group drawing trip. The chance
to take off to another place for a
week or so and explore an unfamiliar
city or culture with a sketchbook is a
great learning experience. However, it is surprising how much can also be gained from
an intensive block of drawing in your own locality. Drawing apparently familiar things
often makes you feel as if you are really seeing them for the first time. Drawing on
location helps your work to develop in all sorts of ways. The more you draw, the more
your particular visual preoccupations and concerns will begin to assert themselves—
and, of course, no two artists will see or draw a given subject in the same way.

It can take a while to recognize these recurrent themes in your work, or to gain the
confidence to pursue them. On the first day of a group drawing trip, it's common to
observe bemused or overwhelmed students positioning themselves in front of the

CAPTURING ATMOSPHERE
*Markets are wonderful
places to draw, teeming
with life, color, and human
interaction. A marketplace
is "food and drink" to the
illustrator as subject
matter. In this drawing by
Jon Harris an equivalent
interest is shown in the
"architecture" of the space
and the characters
inhabiting it.*

NOTES ON COLOR AND ACTION *Scribbled
notes, written to augment drawings
produced on location, often help to
complete the picture. They may contain
information about color or a record of who
was saying what to whom. These sketches
by John Lawrence are full of a sense of
urgency, a need to get things down before
they escape.*

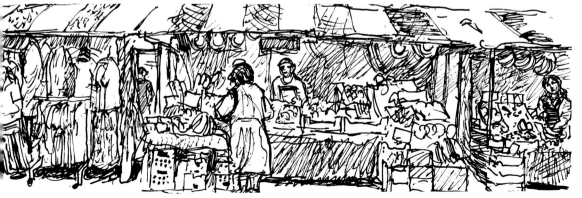

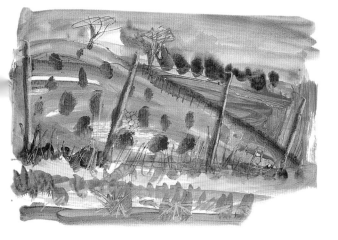

SKETCHING TONE *Working in the landscape helps you to see and understand color, tone, and space. Sue Jones' color sketch is executed in acrylic on paper, scratching out highlights here and there.*

most dramatic or picturesque buildings and then slavishly transferring the front elevations into their sketchbooks. But it doesn't usually take long to break through this phase, to look behind these buildings and into the heart and soul of the place and its everyday life. As illustrators, it is likely that we will be instinctively drawn toward people somewhere in our subject matter. Places in which people congregate—markets, shopping malls, parks, and so on—usually make excellent starting points.

COMPOSITION Getting used to making decisions about composition, and allowing this to become second nature, is extremely important to your development as an illustrator. If you are drawing intimidating looking crowd scenes, try to map out the basic architecture of the space and then add figures as and when they obligingly stop for long enough to be sketched in. All the while you will be "standing back" from the drawing, assessing what needs to go where to balance shapes within the frame. Don't be afraid to draw people over other people, or over background lines. Remember a drawing, unlike a photograph, is a synthesis of the time it took to evolve, full of decisions about what goes where. Try not to use an eraser. All those uncertain, exploratory lines are part of what gives the drawing its life.

PRACTICAL HINTS There is one big drawback to working on location in busy urban areas: you will be constantly bothered by people standing behind you, watching you draw or asking you, "Are you an artist?" This will be irritating to some artists and can make it impossible to concentrate. You will need to seek out concealed places to draw from. Above street level is ideal. You will really notice the difference in your drawing when you are able to focus on what you are doing without fear of disturbance.

OBSERVING PEOPLE *A small sketchbook is manageable and inconspicuous. I made these drawings in Central Park, New York City, quietly watching scenes of everyday life: a man dozing on the bench, portrait artists going about their business.*

PRE-PLANNING YOUR NEEDS *Materials and equipment for working on location need to be considered in advance. A good lightweight folding stool is a great advantage. If you are using water-based media, you will need a large bottle of water and smaller jar into which to dispense small amounts.*

EXPLORING SCALE
The fairground is another subject for location drawing. Contrasts of scale become a focus for interest as large and unfamiliar shapes gather to dwarf the human presence in this drawing by Judy Boreham.

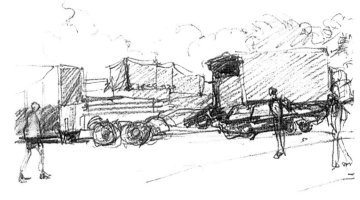

A sense of place

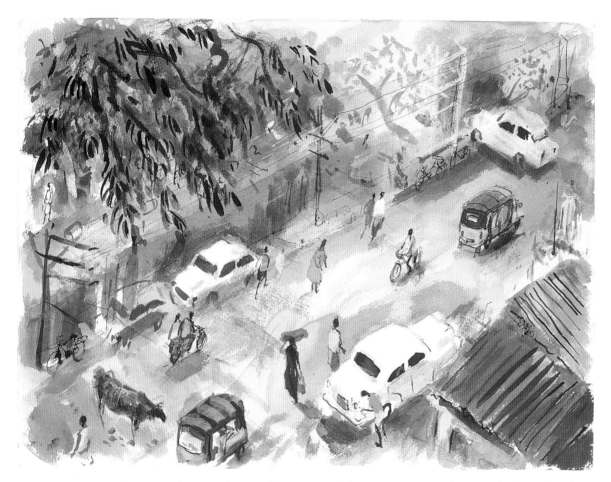

Working entirely on location, Dan Williams made this painting from his hotel room, high above the street in Madurai, India. Using watercolor, gouache, and inks, he freely lays down the predominant colors and then works pockets of anecdotal detail into the composition as things come and go from his field of vision.

Dan Williams is an illustrator whose work appears regularly in newspapers, magazines, and the world of advertising, as well as in children's books. His paintings tend to be characterized by a strong sense of place. This is no accident.

As an art student, Dan Williams was always off with a sketchbook, seeking out new visual experiences and documenting his travels. Among his many destinations at this time were Amsterdam, West Africa, Egypt, India, and Nepal as well as numerous locations closer to home. Now, as a busy working illustrator, he still aims to make at least one major drawing trip a year. "I find that working for too long in the studio can make me become stale," he says. "Every time I return from a trip, I feel refreshed and full of new ideas. The location drawing feeds the studio work but it works the other way round, too. The disciplines of applied illustration help to inform decisions about composition and structure when you're out and about."

This passion for working on location distinguishes Dan's work in children's books, giving his pictures an atmospheric depth and convincing setting that can often be lacking in work that is not regularly "fed" in this way. The benefits of frequent location work range from the primarily technical (namely, the ability to draw many things and from many angles) to less tangible ones associated with inspiration and atmosphere. It's not often, though, that an artist gets the chance to use a body of location work quite as directly as was the

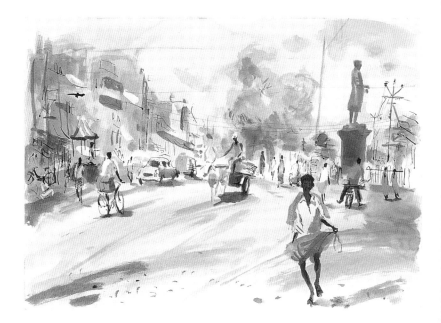

These finished illustrations for Fine Feathered Friends *retain the freshness of direct observational work, but the line and color are a little crisper, neater, and brighter for reproduction. The scale of the book, a small paperback, meant that the images needed to be produced much smaller than those done on location.*

Blurring the boundaries between drawing and painting, Dan Williams created this image partly on location and partly back in the studio. The essentials of color, shapes, and sense of place were quickly established on a street in Thattekkad, Southern India. The image was then developed in the comfort of the studio/hotel room, taking care not to lose the freshness of those first marks. In this picture the edges of shapes are sometimes defined by line, sometimes by blocks of color, a method of working that somehow captures perfectly the bustle of the scene.

case with Dan's commission to illustrate the book, *Fine Feathered Friend* by Jamila Gavin. This text, in the *Yellow Bananas* series for newly fluent readers, tells of a young boy from Bombay who has to stay with an aunt and uncle on a country farm while his parents are away. Dan was able to use his experience of a recent drawing trip to India to infuse the illustrations with a vibrant sense of a real place. He captures the rich colors and teeming life of a Bombay market, the ochers of parched earth in the country villages, and the angular shapes of the ubiquitous oxen.

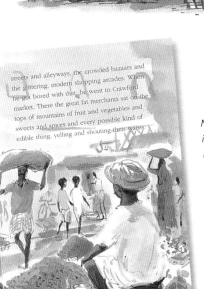

Note how little of the immediacy of the location work is lost in this final illustration in the finished book.

Drawing

From observation into imagination

In many ways, the activity of drawing from observation is merely a means to an end. The really important thing is how you process the visual information that you have absorbed, and how you use it imaginatively in relation to a text or personal flight of fancy. Over the next few pages we will look at the various ways in which different artists have made the link.

For many illustration students, this is the biggest challenge. Staring at a blank piece of paper can be like preparing to jump into the void. You have all those sketchbooks full of wonderful drawings, but suddenly you are faced with the prospect of creating an image without the subject in front of you. The easiest thing in the world is to make the mistake of forgetting everything you have learned and choosing to leap into a convenient stylistic box. Ways of merging reality with fantasy will vary enormously from one person to another and, of course, over the years it can become a completely unconscious process. Those who work in a more figurative or representational way may use sketchbook work quite directly as a reference source. In highly representational work such as historical nonfiction illustration, sketches, and photos of appropriately dressed and posed models in the studio may be used. But for most interpretative illustration in, for example, picture books and story books, the artist will find a way of drawing (note that I carefully avoid using the word "style"!) that is informed by all that experience of looking, however indirectly.

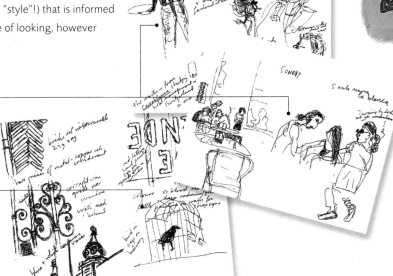

A diner and a waitress, observed and recorded separately, form the focus of a lyrical, imaginative design

A caged bird, noticed in the streets of Seville, is incorporated into a heraldic motif at the top of the composition

RECYCLING INFORMATION *These busy notebook pages by Julia Davies contain a mass of information noted during a visit to Seville, Spain, the priority being the accumulation of visual material as an aide mémoire rather than a concern for good drawing. In the color image we can see how details from the notebook have been incorporated into an imaginative composition developed a little later in the studio.*

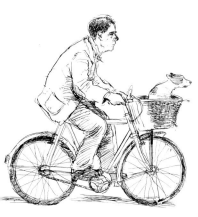

MIXING MEMORY AND OBSERVATION *These two drawings were versions of a character that I see from time to time in my neighborhood. He rides his bike very slowly, sometimes with his dog in the basket, sometimes with him following on a lead. I tried drawing him from memory, and played with the idea of two dogs. I won't pretend that I can draw a bicycle from memory, I used my own bike as reference!*

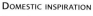

DOMESTIC INSPIRATION
Everyday scenes can provide plenty of subject matter for imaginative drawing and painting. Working from a mixture of sketchbook sources and memory can produce surprising and pleasing results, as in this color sketch by Julia Davies.

Busy professionals may find that they have fewer and fewer opportunities to draw from life. Nevertheless, in order to avoid becoming over stylized or mannered, it is important to return to the real world occasionally. Even Edward Ardizzone who, as we heard earlier, believed that illustrators hate to draw from life, felt that "having learned to draw the symbols for things, he must still have recourse to life using his eye and his memory to augment and sweeten his knowledge." But to return to the task of developing your own "symbols" for things, the following is a useful project to help you retain visual information and process it in a personal way.

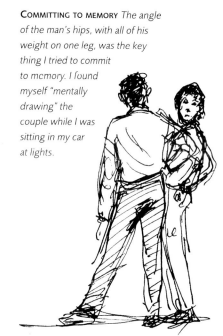

REMEMBERING BODY SHAPE
This very stooped man was also drawn a few hours after observing him. I tried to concentrate on capturing something of the character through an approximation of his body position.

MEMORY DRAWING Trying to draw something entirely from memory is a difficult and often demoralizing experience. This is because it invariably demonstrates how cursory our everyday "seeing" is. If, however, you make a point of going out without any drawing materials with the specific intention of committing something to memory and drawing it shortly afterward, you may be surprised by the results. This process requires a completely different approach to looking. You need to mentally draw your chosen subject, allowing your eye to follow the outlines and contours, remembering the salient visual features. These may have been architectural, organic, or human—the way a figure was standing or a particular gesture, for example. When you put these things down on paper after the event, you may find that the drawings, though often cruder and less confident than your observational work, have a character to them that you had not anticipated. You may feel less in control, but rather excited by the results. If you do this often enough, you will find yourself mentally drawing things as you go about your daily business (and you may get some funny looks). All of a sudden, you are seeing in a different way.

I have observed these seeing and interpretation skills evolving at different speeds and in very different ways from student to student.

COMMITTING TO MEMORY *The angle of the man's hips, with all of his weight on one leg, was the key thing I tried to commit to memory. I found myself "mentally drawing" the couple while I was sitting in my car at lights.*

Drawing • From observation into imagination

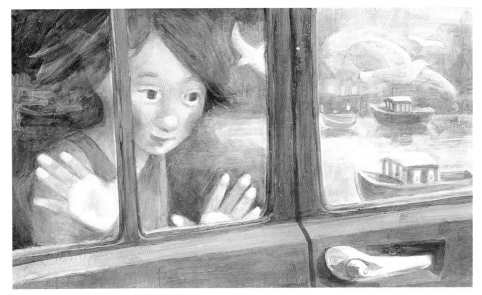

As you will see from the examples shown on these pages, the route from the seen to the imagined varies greatly. Some illustrators instinctively draw in an expressive, gestural way, while others put things down with a more considered, detailed approach. It is my firm belief that there is no inherent superiority in either a "loose" or "tight" approach to drawing, despite all those tutors who exhort their students to "loosen up" in the belief that this will release them from some perceived repressed tendencies. There are good and bad "loose" drawings, just as there are good and bad "tight" drawings. The important thing is whether or not the approach serves the drawing's purpose. As someone once said, form follows function.

INTERPRETIVE DRAWING *A finished painting for Hannah Webb's picture-book story,* Journey. *Compare the lyrical approach to Hannah's observational drawings on pages 20 and 25.*

DOODLES Never underestimate the importance of doodles: the process of doodling ideas and notes in a pocket sketchbook or notebook plays a vital role in the development of an illustrator's visual language. These notebooks can be many things, but they are most usefully a memory aid for ideas that appear from nowhere and need

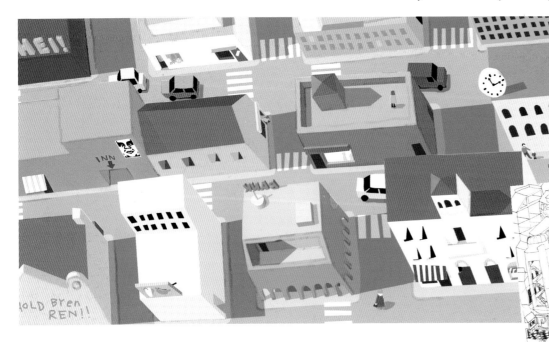

NOTEBOOK REFERENCE *Notebook studies directly inform the finished computer-generated illustrations for* Alt Vi Ikke Vet (All That We Don't Know) *by Kristin Roskifte. This artist's unique visual language and pre-occupations emerge through habitual use of the sketchbook as an ideas base.*

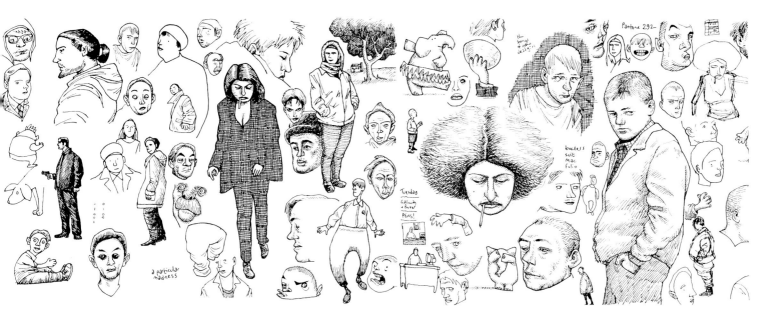

FROM IMAGINATION *Doodles and random sketches provide an important reference source. These pages come from the notebooks of David Shelton, and are a good example of the slightly obsessive visual meanderings that can inspire all sorts of ideas for stories or characters. David Shelton's finished character designs for A Gangster and a Flapper for a children's magazine, show clearly the relationship between the doodling process and finished artwork.*

to be filed away for possible future use before they are lost. These ideas can range from narrative possibilities, characters inspired by someone you have seen, to random abstract visual thoughts that do not seem to make any particular sense at the time—"visual musings," for want of a better term. Some illustrator's notebooks can appear somewhat obsessive. This is all to the good, of course. These books are also great places to try out new media and to be as expressive or as experimental as you wish.

For some lucky individuals an imaginative visual language seems to be a completely natural extension of their thought process; the images appear to flow freely from the mind to the paper, with little interference from the hand. But most of us, whether our aim is to evoke humor, romance, or magic, or simply to convey information, fight a constant battle to circumvent all the fear and self-consciousness that coincides with the moment the pen hits the paper. This is why it is so important to keep drawing—not in order to show off your skills, but in order to convey meaning in as seamless and uninterrupted a way as possible.

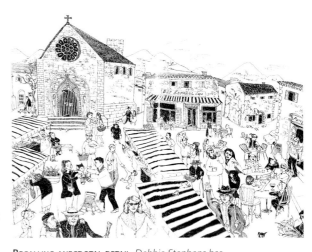

RECALLING ANECDOTAL DETAIL *Debbie Stephens has sketched a market square on the island of Menorca entirely from memory, having known the location since childhood. The characters are full of life and everyone is convincingly going about their business in an extremely subjective drawing.*

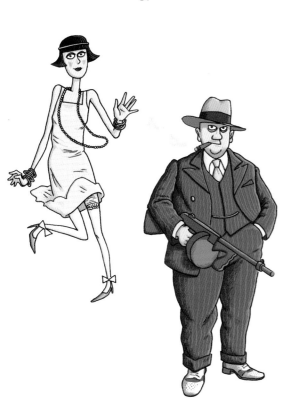

Nature feeds imagination

Alexis Deacon is one the most exciting talents to arrive on the children's book scene in recent years. His first picture book, *Slow Loris*, was originally developed as a college project. His second, the extraordinary *Beegu*, has an elegant and moving simplicity. Both books are characterized by strong draftsmanship and demonstrate a clear relationship between the observed and the imagined.

One of the things that impresses me most about Alexis's work is the humility in the drawing. He doesn't impose a flashy technique on the pictures but seems to quietly allow the characters and the story to speak through them. *Slow Loris* emerged through a project he was working on while studying illustration in college. "I was trying to do a book about monsters, but found that I really needed to look at live animals if I was to create convincing monsters. My imaginary creatures and buildings were looking a bit sterile. I spent a week drawing every day at the zoo and found the real animals to be more interesting and more bizarre than anything I had dreamed up. The slow lorises were

Close observation of the habits and movement of the slow loris are revealed in a sheet of studies like this. It is clear from the intensity of the drawings how the picture book character, Slow Loris, emerged. Beegu also evolved as a character in the sketchbook, and the very direct relationship between the first sketches and the final artwork can be seen.

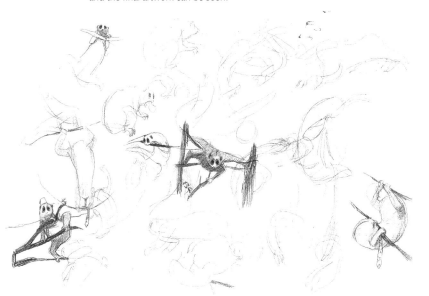

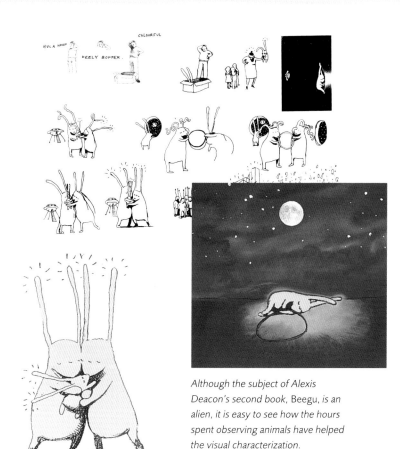

Although the subject of Alexis Deacon's second book, Beegu, is an alien, it is easy to see how the hours spent observing animals have helped the visual characterization.

particularly fascinating. They are not that slow, but they are one-paced. The idea for the loris as a character came when I was watching an altercation between two of them. One of them very slowly and deliberately drew back his arm and cuffed the other round the ear. The book idea seemed to fall into place fairly easily after that."

Alexis is a strong advocate of drawing, and the need to incorporate observation into your work. "Your brain cannot create in isolation. It has to be fed. I suppose it is possible in theory to draw passively, like a camera, but I'm not interested in that. When I started to look at

people, through drawing, a whole new world opened up. It's all out there. Through drawing you find your own voice. I love sketchbooks."

In fact, Alexis Deacon's sketchbooks find their way into his picture books in a surprisingly direct way. "Sometimes it's difficult to tell where observation ends and imagination begins," he says. He uses his original, often small-scale pencil studies from the sketchbook in many of his finished illustrations. They are photocopied, enlarged, moved about, and used alongside other passages of drawing that are done from memory and imagination. This is increasingly the case in *Slow Loris* as the animal's behavior becomes more and more "humanized." It all holds together beautifully because of the artist's intimate knowledge of the animals, gained through direct observation and drawing, avoiding the pitfalls of second-hand stereotyping.

The second picture book, *Beegu*, did not come to him so easily. "I had been given a two-book contract. I had a brief break after Loris and had no idea what I was going to do next. I suppose the starting point was the idea of being lost." (Beegu is an alien who tries to find friends in a world that is indifferent or hostile.) "I had recently moved to London and was feeling a little lost myself." The book is a masterpiece of economy and understatement that works on many levels.

TECHNIQUES Alexis Deacon uses his own photocopier to enlarge and rearrange drawings, some originally done in pencil, some in pen (ordinary fiber-tips). The recomposed drawings are copied onto good-quality drawing paper. These are then colored with watercolor and gouache. Sometimes Alex adds a layer of linseed oil to lift the color and seal it, allowing him to add further layers. These techniques have evolved, he says, as a result of the frequent experience of showing sketchbook drawings and characters to publishers and being asked to work them up to a greater level of finish, only to be told "make it more like the original sketch." He then resolved to keep as close to the first "doodle" as possible. "I've learned that the tiniest variation in a line can greatly alter the way someone reacts."

IDEAS THROUGH OBSERVING AND DRAWING

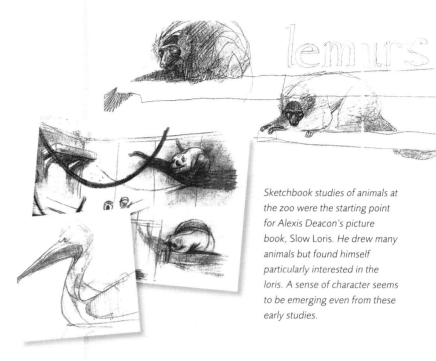

Sketchbook studies of animals at the zoo were the starting point for Alexis Deacon's picture book, Slow Loris. *He drew many animals but found himself particularly interested in the loris. A sense of character seems to be emerging even from these early studies.*

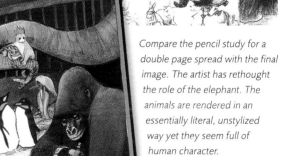

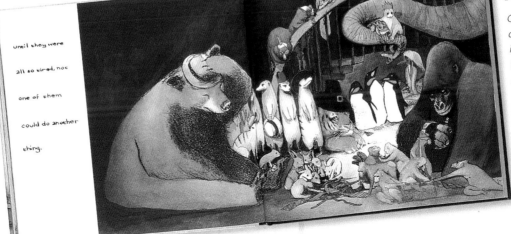

Compare the pencil study for a double page spread with the final image. The artist has rethought the role of the elephant. The animals are rendered in an essentially literal, unstylized way yet they seem full of human character.

MEDIA, MATERIALS, AND TECHNIQUES

checklist • print • acrylic • oil • pastel • black and white line • digital • watercolor • line and wash • collage

Introduction

In these times, when reprographic technology has reached new heights of sophistication, it is probably fair to say that almost any medium, two- or three-dimensional, can be suitable for children's book illustration. Knowing something about the various properties and limitations of individual media will help you to make your choice, and perhaps go on to break the rules.

As we saw in Chapter 1, the evolution of book illustration has been closely linked to developments in technologies for mass reproduction. The woodcut was synonymous with illustration until printing techniques moved on. Throughout most of the history of printing, indeed up until only a few decades ago when letterpress printing finally bowed out as a commercial process, illustrators have needed to work closely with printers. The aesthetics of the imagery and of the book itself were largely dictated by the way in which artists could adjust their work to suit the printing process. Nowadays, offset lithography and laser scanning allow for excellent reproduction of most forms of artwork, so the choice of media would appear to be limitless.

This is, of course, a liberating state of affairs for the artist—but it has its dangers and pitfalls, too. The limitations of less advanced printing technologies can

PRINTING TECHNIQUES *Print media such as linocut give a hard-edged, graphic quality where powerful, bold shapes are needed. I produced this image in two colors, but many more can be used.*

DRAWING IN BLACK AND WHITE *Pen and ink drawing has a timeless quality and is still an important medium for book illustration, especially fiction for older children. This one is by Tom Morgan-Jones.*

Combining hand-rendered washes or textures with scanned-in elements and computer-generated color is increasingly common. This approach can be less "hard" and more human than the purely digital. In this image, Mathew Robertson has scanned in collaged torn paper and other hand-made sections and then developed the color and shadows through Adobe Photoshop.

concentrate the mind on content. With too much choice, the temptation to use a medium or mixture of media for purely gratuitous effect is that much greater. This has been a particular problem with the arrival of the computer with its multitude of available effects, and has inevitably led to a period of all-singing, all-dancing illustration styles. Like any other medium or tool, the computer is only as good as the person using it and, thankfully, is now beginning to settle into its rightful place, with some wonderful work being produced wholly or partly digitally. In this chapter we take a look at the range of media available to the illustrator and concentrate on the tools of the trade, their particular characteristics and properties, and how they can be understood and exploited.

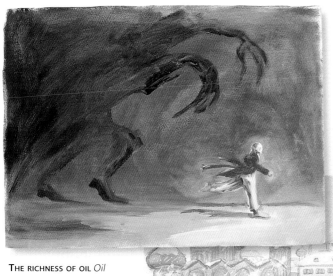

THE RICHNESS OF OIL *Oil paint gives an unequaled richness and depth of color and is workable for a long period of time, but it takes a long time to dry. Judy Boreham's painting for The Tales of Hoffmann is deeply atmospheric.*

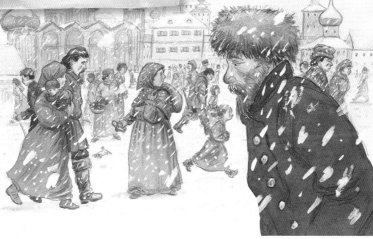

WATERCOLOR *A popular medium for illustration, watercolor has a soft, transparency. The white of the paper can be "allowed through" as much as is needed to create tone. In this painting for Baboushka, I used watercolor with a little gouache and colored pencil.*

Media, materials, and techniques

Watercolor

There are many misconceptions about watercolor, the most common being that it is a medium suitable for spontaneity. In fact, using watercolor in the way in which it is intended demands plenty of forward planning.

The first thing to bear in mind is that watercolor is a transparent medium and the density of any color is dictated by the extent to which the white of the paper shows through that color. Consequently, you cannot apply a light tone over a dark tone. In other words, when using the medium in its traditional way, you have to work from light to dark—hence the need for forward planning. A few book illustrators, notably P. J. Lynch and Lisbeth Zwerger, use watercolor in this traditional way, and in the hands of such highly skilled artists the results can appear deceptively effortless and fresh.

A common mistake when starting out is to try to put too much paint on the brush. This is especially likely to happen if you use tubes of color rather than pans. Always use a mixing palette that has little reservoirs, which allow you to mix the color with water until you have the required inky, colored liquid. The more water you add, the more transparent, and consequently the paler in tone, the color will be. Working "wet on dry" means laying down successive washes of color over others that have dried. Each wash darkens the tone and can create new colors. For example, if you lay a yellow wash over a blue one, you will create green.

EQUIPMENT It's a good idea not to skimp on materials with watercolor if you can possibly help it. Good-quality brushes are important: Sable, or a

VARYING THE TONE *Transparency is the key property of watercolor, allowing for the creation of softly graded tones that let the white of the paper show through to varying degrees.*

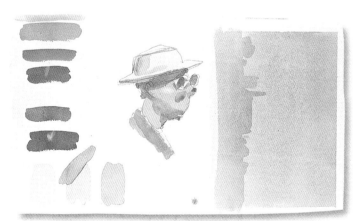

"WET ON DRY" *Successive layers of watercolor wash are applied and can be built up. A hair dryer is a useful tool for speeding up the drying time of washes, especially when working to tight deadlines.*

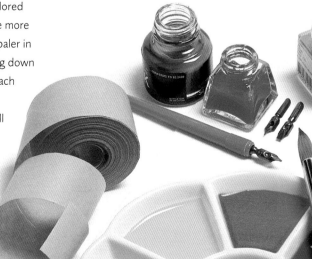

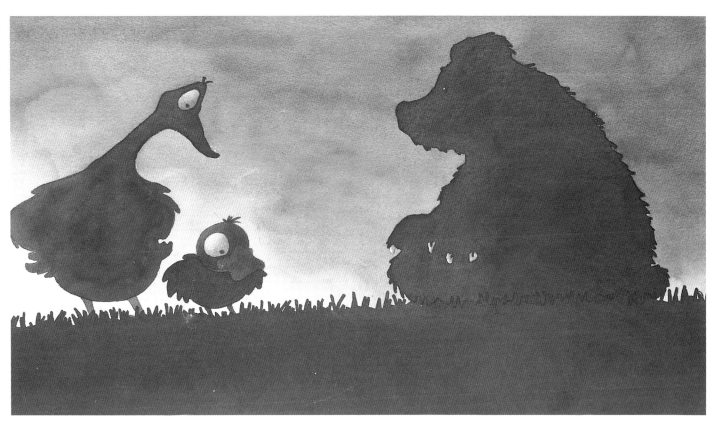

mixture of sable and nylon, are best. You shouldn't bother with very small brushes, this will tempt you to "draw" with the paint. As long as it is of good enough quality to retain its point, a medium-sized brush (a no. 6, for example) can be used for most things, alongside a larger wash brush.

Watercolor paper usually comes in three types of surface and in different weights. The surfaces are called Rough, Not, and Hot pressed, Rough being the most textured surface, Not being semi-rough, and Hot-pressed being smooth. Hot-pressed paper tends not to take a wash quite as well as the other two, but is good for finer detail. The standard weights of paper refer to the weight of a ream (500 sheets). A 72-lb paper is a light paper, 500 sheets of which weigh 72 lbs. A metric equivalent of grams per square meter (gsm) is now common. Lighter paper (less than 140 lbs/300 gsm) needs to be stretched to prevent it from wrinkling when washes are applied. Heavier grades (200 lbs/410 gsm, 300 lbs/600 gsm, 400 lbs/850 gsm), do not need to be stretched.

STRETCHING YOUR PAPER Stretching the paper ensures that you have a taut surface to work on, and that your washes will stay flat and even rather than swimming into the "valleys" created by the wrinkling of wet paper. You need a drawing board and a roll of gummed brown-paper tape. Cut four pieces of tape, two of which are a couple of inches longer than the length of your paper and two which are a little longer than the width. Thoroughly

TOOLS AND EQUIPMENT
From left to right: gum strip, watercolor paper, pen holder, ink, nibs, liquid watercolor, tubes and pans, gouache, brushes, and palette.

DARK TONES *Dark tones can be achieved with watercolor, as can be seen in this painting by Adrian Reynolds from* Silly Goose and Daft Duck Try to Catch a Rainbow *by Sally Grindley. A small amount of line work has been used to accentuate some of the edges.*

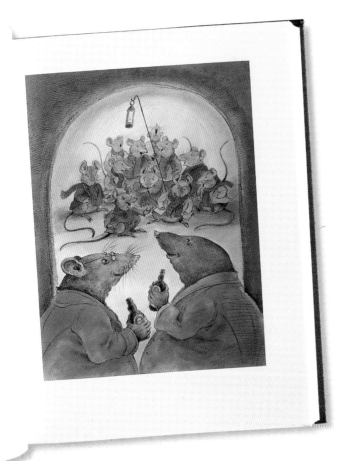

soak the paper (under a faucet or in the bathtub), lay it on the drawing board, and smooth it out from the center, making sure that it is completely flat. Sponge off the excess water across the whole paper with a sponge. Quickly wet the lengths of gum strip and stick the paper to the board. The paper may look crumpled when it is wet, but it should dry completely flat; it should be left to dry naturally. When it is dry, it is ready to work on. The gum strip is left in place until the painting is completed and dry.

CONCENTRATED LIQUID WATERCOLORS Concentrated liquid watercolors usually come in little bottles with droppers on the tops. As the name suggests, they are highly concentrated and need to be mixed with plenty of water. The colors are extremely intense and difficult to control, but can give lovely effects. One advantage is that it is possible to lift the color off by using a brush dipped in bleach. You can't do this with watercolor. Concentrated liquid watercolors are not light fast and will fade over a period of time.

INKS Colored inks, such as those in the Winsor and Newton range, contain shellac, a resinous varnish. They can be used with a dip pen and with a brush, giving strong reflective color.

GOUACHE OR BODY COLOR Gouache is an opaque, water-based paint, traditionally associated with landscape sketches. White gouache is also often used with watercolor to pick out highlights. Gouache has a milky, chalky feel. It dries quickly and is quite brittle if built up in layers. As a medium for book illustration, it seems to be regaining popularity.

LINE AND WASH This is probably the most common combination of media in use in children's book illustration, allowing as it does for so many different approaches to drawing and color. The balance between the respective roles of the line and the wash will vary greatly from one illustrator to another. In some instances the line

LINE/COLOR BALANCE *Line and wash with some cross-hatching to accentuate areas of tone is used by Adrian Reynolds to create big, bold shapes to illustrate* Harry and the Dinosaurs Say Raahh! *by Ian Whybrow.*

GOUACHE *I used gouache with a little pen and ink for this cover illustration to* Midnight Fox *by Betsy Byers.*

will be used to convey most of the information, including tonal values, with color being used as a flat background that would make little sense on its own. By contrast, other artists will describe most of the form of the image with washes and use the line only to strengthen and clarify. It is important to be clear about the balance between these roles as they can duplicate each other, leading to an image becoming fussy and overworked.

The color of the line is important, too. It may be black, if you intend to give the drawing greater prominence, or you might choose to use a neutral-colored line to play it down a little in relation to the colors in the washes. Alternatively, you might use different-colored ink lines for different areas of your design, blurring the boundaries between drawing and painting, and bringing elements forward through the use of warmer colors.

A perennial problem with line and wash is what sort of paper to use. A surface that takes a line really well is rarely ideal for a wash, while a good watercolor paper is usually too soft and absorbent to take a line well. I find that the best compromise is a stretched hot-pressed watercolor paper, or a thick, good-quality drawing paper.

Pog the Dog

Pam the Lamb

Wonkey the Donkey

BRINGING VITALITY AND FRESHNESS *Line and wash, when used loosely makes this a popular medium for children's book illustration. Leonie Shearing's charming character studies are executed with a dip pen, waterproof ink, and a wash of diluted watercolors.*

Media, materials, and techniques

Acrylic paint

Acrylic paints appeared in the 1950s, and were the first major development in paint technology for hundreds of years. They are made by adding an acrylic binder to the pigments, which dries into a transparent, reflective film. The arrival of this medium meant that there was now a fast drying, water-based alternative to oil paints.

Acrylic paint colors are bright and vibrant, and the fast drying time makes this an important and popular medium for contemporary illustrators, although some artists dislike the slightly "plastic" finish.

Acrylics are highly versatile; they can be used thickly and opaquely or in thin, transparent layers. The type of brush you use depends on the way you like to use the paint. For example, if you are using it in thin washes like watercolor you will probably want a soft-haired brush, synthetic or sable. If you are painting in the traditional way, you might prefer a stiffer hog's hair type of brush. As always, you need to wash brushes thoroughly after use if they are to last.

Acrylics can be used on a range of surfaces, including papers, canvas, wood, and anything that is not too shiny or glossy. There are also acrylic papers and pads that have a surface texture similar to canvas and various types of primer, for putting a solid surface onto paper or canvas. Artists painting in the traditional, oil-painting manner often prefer to use canvas or primed papers. There are also substances that can be added to the paint to change its performance or finish in some way—for example, acrylic medium in both matte and gloss finishes, and drying retarders.

SEMI-TRANSPARENT WASHES *Thinning the color with plenty of water allows you to use acrylic paint in semi-transparent washes. In this illustration for a proposed picture book, Sue Jones has used acrylics in thin layers, the washy brush strokes creating texture within larger areas of color.*

ACRYLIC AND COLLAGE *Acrylics can be combined with other media to good effect. Here, Graham Handley has used layers of collaged newsprint underneath the paint and worked over it, allowing the text to break through in places, creating texture and breaking up the brush strokes.*

TEXTURAL BASE *Underpainting with a layer of white acrylic gives an overall textural base on which to work. You need to use a fairly course bristled brush to cover the paper. The paint seals itself so it is not dislodged when you work over it. The added texture shows through the image, giving it a little more depth. This painting by Lisa Evans employs this technique effectively.*

TOOLS AND EQUIPMENT *From left to right: liquid acrylic, mediums, brushes, tube paints, acrylic paper.*

Media, materials, and techniques

Oil paints and pastels

There are pros and cons to any medium, but in the case of oil paints these are particularly extreme. No other medium can give the richness and depth of oil paint, but few media can present as many practical drawbacks for the illustrator. Consequently, oil paint is not commonly used in children's book illustration.

The most obvious drawbacks are the time the paint takes to dry and the toxic nature of the solvents. While the length of drying time can be a positive thing for the painter, allowing time to scrape off areas and rework them, for the illustrator this is often an unaffordable luxury. There are ways around these problems, of course; the paint can be mixed with various solvents and mediums, such as Liquin, to speed up drying, but this can change the look of the paint surface, giving it a little less texture. Some artists like to build up the paint in thin layers, using varnishes between each one.

All sorts of brushes can be used with oil paint, but it is likely that you will want to use a range of bristle or hog's hair brushes to start with. Sable and nylon brushes can be used for more finely detailed work. Surfaces for painting on with oil are also a personal choice. Canvas stretched across a wooden frame is the best-known option, but some artists prefer to work on board or paper. All of these surfaces can be primed, to separate the paint from the surface, but you may prefer to work directly

TOOLS AND EQUIPMENT *From left to right: linseed oil, palette, tubes, brushes, canvas board, oil pastels, soft chalk pastels, pastel paper, pastel pencils.*

SPEEDING DRYING TIME *Liquin, used as a thinner, allows the artist to work in a looser, slightly more washy way, and also speeds up the drying time. In this color sketch for a proposed picture book, Jane Human has thinned the oil paint considerably, the brushy paintwork giving the image greater sense of movement.*

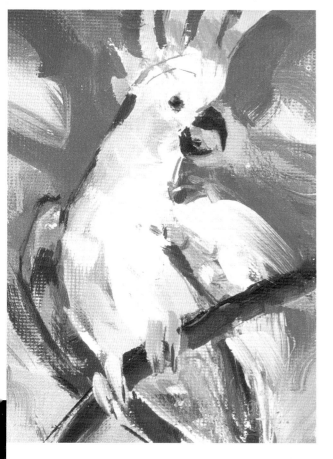

OIL PAINTING *Using the paint more thickly, Jane Human gives this colorful image of a cockatoo a rich, painterly depth.*

onto the paper, allowing the paint to soak in, giving a more muted effect. Underpainting in monochrome with a thinned neutral color can be a useful way of setting out the tonal range of a picture at the start.

It is now possible to buy a range of water-based "oil paints" which mimic many of the properties of oils but without the problems mentioned previously.

PASTELS There are two kinds of pastel: oil pastels, and chalk or soft pastels. Both types are used in children's book illustration, though the soft pastels are more commonly seen, being perhaps capable of more subtle blending effects. It is a good idea to work on a colored pastel paper, which gives you a mid-tone to start with so that you can work from light to dark and dark to light. The oil pastels are much richer in color and more difficult to control. One unimpressed student of mine described the experience of working with them as "like trying to paint with lipstick."

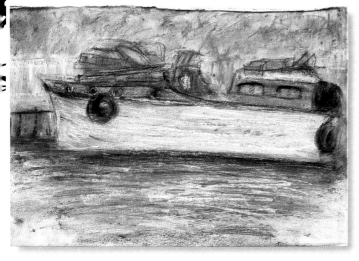

LAYERS OF COLOR *Oil pastels have a heavy, waxy feel and are rather difficult to control. In this early student work by Jane Simmons, the pastels are used thickly, applied in heavy layers so that the final piece is almost three-dimensional.*

BLENDING COLOR *Soft or chalk pastels have a dusty texture, allowing you to rub and blend the colors with the fingers or a blending tool. Paul Robinson's still life shows this clearly.*

From oil to acrylic

One night when Jamie was wide awake again, Lucy said to him, "Bear can't sleep either. We need to find the Dreamtime Fairies - they'll help us."

Jane Simmons is the creator of the successful *Daisy* books, the simple tales of a free-spirited duckling that are much loved by small children the world over. The success of these books is based on the author's ability to communicate aspects of the relationship between mother and child in a universal and enchanting way. Jane Simmons' images are created using acrylic paints.

There is always a strong sense of place in Jane's work, and an unusually strong sense of character in her figures for such a painterly approach. The tiny features of the children and animals seem to float in a sea of paint, but somehow she uses the acrylic to successfully combine the illusion of real space and depth in landscape with highly stylized figures.

A spread from The Dreamtime Fairies. *This was a change of direction for Jane Simmons. Her "chunky," no-nonsense approach to painting did not naturally lend itself to such subject matter, but she pulls it off brilliantly with this charming bedtime story.*

While an illustration student, Jane lived and worked on a leaky old river barge near her art college. Her subject matter has always been dominated by the water that surrounds her, and the creatures and people that inhabit it. As a highly successful author and illustrator, Jane still lives and works on a boat, but on a rather less leaky one on the Mediterranean Sea.

While her identity as an artist was evolving during her student days, Jane was adamant about the superiority of oil paint over acrylic. She enjoyed the richer, deeper colors and also the way that the paint could be allowed to soak into the paper. "I had to give up using oils, primarily because I couldn't cope with the fumes when working in a confined space. But now I'm a complete convert to acrylics. I love them and find that I can do everything I want with them. It is important to me that the paper is part of the painting. I like to build things up in washes that soak into the surface. I can't work with a primed paper where the painting is "floated on the surface.""

Jane gets around the problem of the acrylics' fast drying time by spraying the paint with water on a regular basis, extending the time that it remains workable. "I keep it in plastic food containers," she says. "But you can still paint over it and rework things when it's dry. It seals itself so you can carry on working in layers."

As well as the *Daisy* series, Jane Simmons has written and illustrated numerous other picture books with Orchard Books, including the *Ebb and Flo* stories, about a dog and a little girl who inhabit a boat, and *The Dreamtime Fairies*, a surprising but successful change of direction for her.

FLOATING ON WATER

These early student sketchbook studies by Jane Simmons were executed in oils. Jane was particularly drawn to the way the oil paint soaked into the drawing paper, allowing the paper to become part of the painting.

Come on Daisy was the first of this highly successful series. Jane switched to acrylic paint for this project, and found that she could still soak washes into the paper, and build up the color in layers. Her colors are by now much brighter.

With her series of Ebb and Flo books, Jane Simmons was a complete convert to acrylic paints. The water-based paint is layered in subtle, semi-transparent washes. Her overall painting technique is still bold and robust, yet she manages to convey nuances of character and expression.

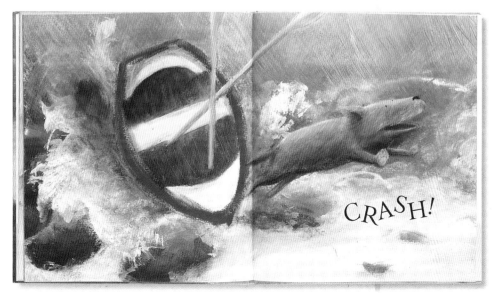

CRASH!

Media, materials, and techniques

56

Collage and mixed media

Artists are finding increasingly ingenious combinations of media in order to realize their visions. Almost any combination can be used in children's books today, particularly with the advent of computer technology.

The medium of collage has long been prominent in children's book illustration, notably through the vibrant designs of Eric Carle. The term refers to the piecing together of various materials to create an image. This is still a popular approach, and with digital technology it can be done more quickly and with the debatable benefit of being able to rectify mistakes at the touch of a button. Because of the gradual "fusion" of the handmade and the digital, it is often hard to tell whether a published image has been produced entirely by hand or not.

COLLAGE *Simple torn paper collage can create strong graphic shapes and bold colors. This crocodile by Rachel Butler incorporates a line that is copied onto acetate and then placed loosely over the color.*

MIXED MEDIA *Acrylic paint and collaged paper are combined in this image by Sue Jones. The incorporation of an element of collage introduces sharper edges and richer contrasts.*

Ultimately, when settling on a choice of medium, we come back to the question of "why?" If the technique or medium is there to serve a clear intention, to appropriately convey an idea, it will probably work. If it is employed purely for effect, it won't.

Collaged imagery is most commonly produced through the use of simple paper and glue, but you may wish to experiment with fabrics, wallpapers, and other found materials. The torn edge and the cut edge create very different effects, as contrasting as the difference between a pencil line and that of a brush, so it needs to be considered. Having said that, much of the charm and fun in collage, as with so much exploration of media, can be in the harnessing and exploitation of accident. This is what I mean when I refer to the "debatable" benefit of being able to change almost anything when working with

PHOTOCOLLAGE *This technique can create surreal and disturbing "landscapes." The familiarity of the photographic image is disturbed by the juxtaposition of shapes and scale. Shelley Keight's images effectively exploit these possibilities.*

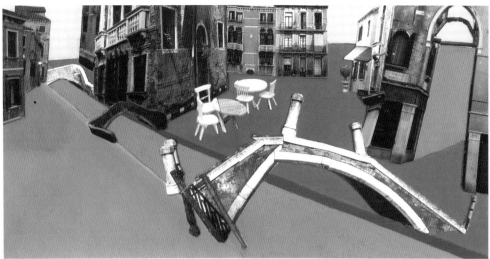

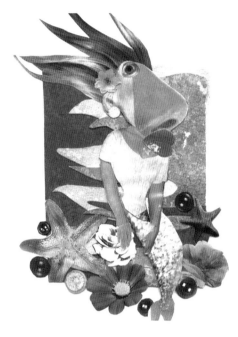

computers. There can be a temptation to reverse something unintended before you have had time to come around to the idea that this unexpected accident might, after due consideration, be incorporated usefully into the design.

You may wish to experiment with painting a range of textures and colors on separate pieces of paper and then tearing or cutting them according to your design. With this method, your image is made up entirely of your own painting, only rearranged. With photographic collage, you might acquire a large collection of old newspapers and magazines from which to extract anything from flat colors to facial features. Many artists who specialize in this approach will keep huge files carefully separated under headings such as "eyes," "ears," and "hands." It is important, though, that when using photographic material for collage, you "dismantle" and rearrange it sufficiently for it to fall under your creative ownership rather that of the original photographer. In children's books it is sometimes felt that photographic collage tends to be too grotesque to be suitable for children. Such accepted truths are there to be challenged!

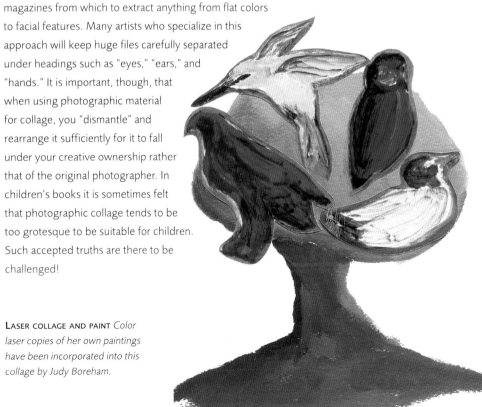

TOOLS AND EQUIPMENT *From left to right: cutting mat, scissors, fabric shapes, colored paper, scalpel, brush, liquid glue, glue stick, tissue paper, newspaper cuttings.*

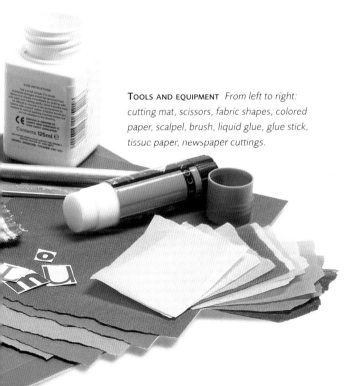

LASER COLLAGE AND PAINT *Color laser copies of her own paintings have been incorporated into this collage by Judy Boreham.*

Media, materials, and techniques

58

Computers

Illustration students tend to fall into two distinct groups when it comes to attitudes toward computer technology. They are either pathologically terrified of it or hopelessly seduced by its evil charms. It is important to remember that the computer is just another tool, only as good as the person using it.

I have often felt that my ideal illustration course would be one that forcibly kept students away from computers until about two thirds of the way through their studies. Up to that point their learning would be dominated by drawing and thinking. In reality of course, one cannot be deprived of access to a particular medium or process.

The "problem" with computers, or rather the various illustration/graphics software suitable for illustration, is that the multiplicity of available effects can all too easily lead to a belief that technology will solve those age-old problems of drawing, composition, and color. It can be hard to convince yourself that the machine itself is not an artist when confronted with the dazzling possibilities at your fingertips. A healthy combination of disrespect and curiosity is perhaps the right approach to computer programs. They play a vital part in the children's book illustration world now, and there is an increasing amount of exciting and innovative work being produced digitally.

GETTING STARTED It is not, of course, possible to give detailed technical instruction in the context of a brief overview such as this, but there are some basic items of

DIGITAL COLOR *One of the many advantages of digital technology in terms of image making, is the fact that you can view a menu of colors without first having to mix them. Here Kristin Roskifte creates a subtle blend of pastel shades.*

TOOLS AND MATERIALS *From left to right: graphics tablet and pen, mouse, mouse pad, CD, ZIP disks for information storage.*

CONSTRUCTING IN PHOTOSHOP *For her book* Alt Vi Ikke Vet *Kristin Roskifte gradually built up layers of colors and shadows over her initial biro line drawings.*

Buildings are initially drawn with ballpoint pen, as in these early sketchbook studies

Scanned-in ballpoint line

Colors, shadows, and textures are added in Adobe Photoshop, keeping the line in a separate transparent layer, and then a color layer is added behind it

Using the eraser tool the line is gradually removed with an opacity level of 30 to 40 percent, allowing the line to be retained if it seems appropriate

In places the original line is retained, with flat color behind

In some buildings, the full 3-D effect of color and shadow is used

equipment that you will need to get started. The Apple Macintosh is the industry standard, so when working professionally with designers and publishers, this is preferable to a PC. But if you just wish to get started and experiment, a PC is perfectly adequate. You will also want a scanner and a printer, and it is worth spending a little extra to buy large format versions of each.

The major expense is the software itself. Adobe Photoshop is ideal for most basic illustration work; Illustrator, for work that involves drawing on the computer; and QuarkXPress for page layout. The most common use of the computer by illustrators is probably still the process of adding flat color to a scanned in, hand-drawn line. In other words, a line drawing is made on paper, scanned, viewed on screen, and then developed by adding colors and/or textures. Generating the line itself on screen can be achieved by using a graphics tablet or a mouse. The main difference between drawing on paper and drawing on screen, is that when drawing with a graphics tablet, you are looking at the screen and seeing the line emerge there, rather than looking at it at the end of your "pen." Also, there is no "resistance"—that reassuring scratch of pen on paper. Some find this impossible to come to terms with—others love it.

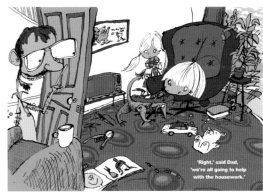

LINE AND FLAT COLOR *Scanning in line drawings and adding flat color is a good way to get started with the computer. These images by Tom Morgan-Jones were created by scanning pen and ink drawings and using the paint bucket tool to add color.*

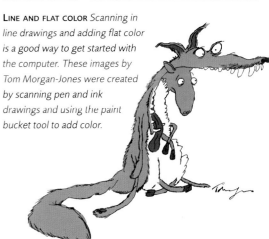

60 Going digital

Bee Willey works with conventional media to put down the key visual information (left), which is then scanned and developed in Adobe Photoshop to gain a shimmering translucence in the final image (below).

Bob Robber was a thief.

He could steal honey from the bees and the scent from flowers. He could steal the truth from a promise and make it into a lie.

Bob Robber lived alone in a dingy old cottage down a back lane.

Bee Willey's distinctive illustrative work has been a familiar and popular feature of the children's book scene for some time. Her richly colored images have, until now, been created through a mixture of acrylic washes, oil pastel, and pencil crayon. But with the appearance of the book *Bob Robber and Dancing Jane* by Andrew Matthews, it was clear that dark and sinister digital forces were at work.

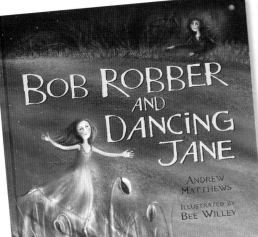

Bob Robber and Dancing Jane is illustrated through a mixture of "old" media and new. The underlying pastel work can be clearly seen, but areas of softer, smoother tones and colors sit over it.

Bee's usual working method involved putting down an area of acrylic wash, sometimes with colors merging and flowing together, and then working into this with pastel and crayon, allowing the irregularities of the wash to be incorporated into the design. She works on Arches Aquarelle hot-pressed paper. "It's very tough and can take the battering I give it." She says that laying down the color washes helps her to get over the fear of being faced with a blank piece of paper.

She felt, however, that she was having something of a crisis with her work. "I've always enjoyed the freedom that the materials I have used have given me, the element of accident," she told me, "but I was finding that with the kind of work I was getting—collections of myths and so on—because of the scale, my work was getting tighter and tighter. I was having to work larger and larger in order to get the kind

of detail that was needed. I also suffered from a wrist injury caused by the sheer physical strain of laying down large areas of texture with crayon or pastel, and I was having problems with the strong fixative which I was having to use. This was actually giving me health problems. So I was tinkering with the computer, scanning images in at various stages, and teaching myself to use Photoshop to develop them. I went to see Ian Craig at Random House with these very basic attempts at digital work and, to my surprise, he offered me the text of *Bob Robber*."

Andrew Matthews' stunning text tells the tale of the sinister Bob, who steals Dancing Jane's shadow in the hope that it will teach him to dance. Bee's illustrations perfectly capture the spirit of this dark tale, with its uplifting conclusion of redemption (in what Bee describes as her colorful "Bollywood" style). The book marks a real turning point for Bee. It is perhaps fortuitous that such an inspiring text should have presented itself at a time of transition in her work, but she has used experimentation to great effect with this shimmering series of images.

Her new way of working starts in the same way, with laying down washes and establishing the basic bones of the image using traditional media. This is then scanned and the process of building on to the image in Photoshop takes over. Sometimes textures are scanned from fabric or even the grain of a wooden tabletop and imported into the image. And, of course, whole areas can be lightened and darkened at the touch of a button. "The computer allows me to get rid of a whole area of pure labor. I can cover large areas quickly. There are also certain other practical things that I just couldn't have done in the old way. For example, the image of the tiny teardrop in Bob's hand; with the computer I was able to get the sharpness and transparency that it needed. I couldn't have done this with crayon. There was also the need to show Jane's shadow with her face staying exactly the same in several images as if time was suspended. I couldn't have achieved this manually. I am still learning all the time. I love exploring new techniques. Working with the layers that Photoshop gives you, you feel like you are in 3-D space."

As with many illustrators who have gone digital, there is one aspect of the experience that Bee finds difficult to get used to: the fact that there is no longer an original piece of artwork on paper. "I find that quite upsetting actually."

BUILDING TONE

In the early stages the book is planned as normal with rough thumbnail sketches in pencil.

Part of the image is created using traditional media: oil pastel, pencil crayon, and acrylic paint on paper. The portrait of Bob Robber is established and the spider and web are drawn as dark on light.

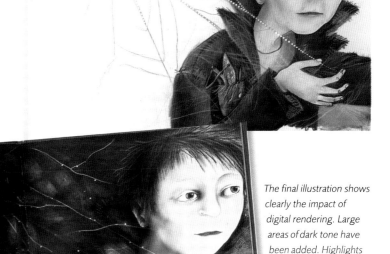

His hair was black as bats and his eyes were the colour of the new moon. Bob Robber could stand so still that spiders didn't notice him and spun webs across his clothes. When he moved, he was quieter than moss. His thieving fingers were as nimble as fish and he could run faster than morning to be back in his cottage before the sun came up.

The final illustration shows clearly the impact of digital rendering. Large areas of dark tone have been added. Highlights have been brought back and edges softened. Much of the original artwork is obliterated and reworked.

checklist • gesture • body language • angles • bringing characters to life

Introduction

The creation of convincing characters is fundamental to the success of a visual narrative. No matter how well other aspects of the book have been developed, they will count for nothing if the reader cannot believe in the "actors" on the stage. This realism, of course, can only be achieved if the artist believes totally in the characters.

ESTABLISHING CHARACTER *Gesture and body language can be as important as facial features in establishing character. This page of studies by Pam Smy is for the character of Vassilisa from the Russian folk tale Vassilisa and Baba-Yoga.*

The way an individual character is "born" varies greatly from one artist to another. When an existing text needs to be illustrated, the starting point may be detailed written descriptions of the individual's habits, movements, physical appearance, clothes, and so on; the artist may, consciously or unconsciously, base his or her interpretation on a real-life acquaintance. Where the artist is also the author, specifically in the case of picture books, the emergence and evolution of character and story line can be an indivisible process. For instance, the way in which a personality appears and grows through the initial process of drawing may well influence or even dictate the direction of the narrative. I know of at least one leading artist/author who, when stuck for an idea for a new picture book, sits at the drawing board and doodles away, creating all manner of characters, animal and human, until one of them "speaks" to her, insistently demanding a leading role.

Successful character development requires a combination of two things: first, a keen and slightly voyeuristic interest in the vagaries and eccentricities of human nature, and second, the ability to represent these eccentricities through a drawn line. The first may be inherent; the second can be learned.

FIRST STAGES *Pencil studies (far left) begin to form these elfin characters for Little Fella Superhero by Sarah McConnell. These eventually translate into the colorful finished artwork for the main characters (left).*

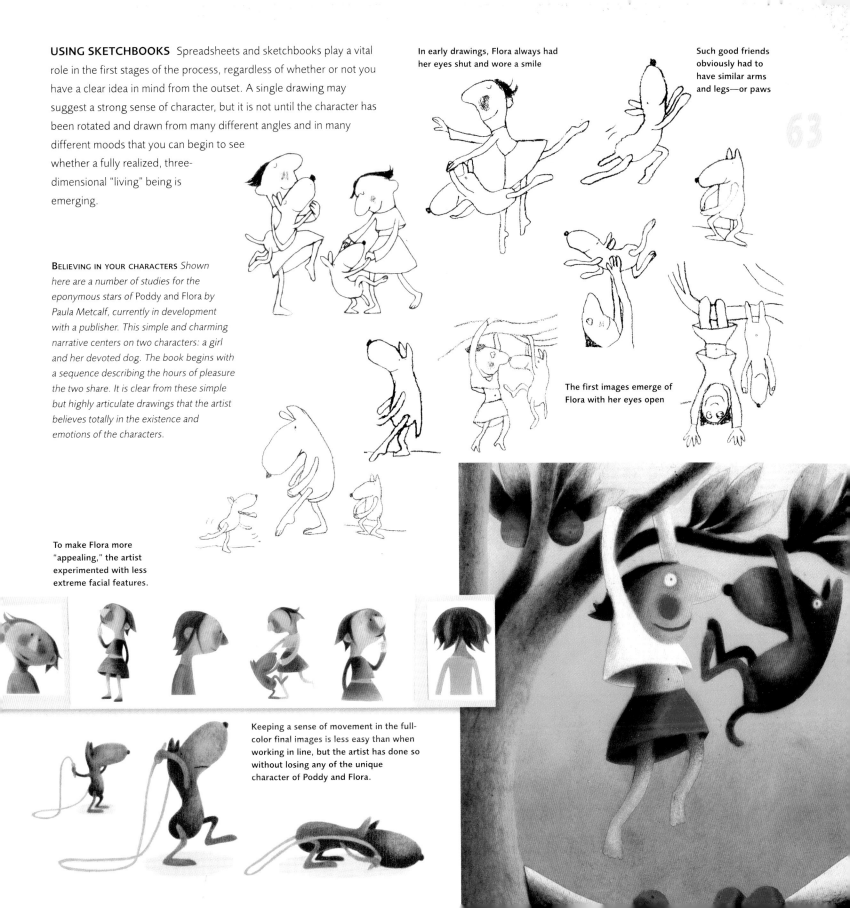

USING SKETCHBOOKS Spreadsheets and sketchbooks play a vital role in the first stages of the process, regardless of whether or not you have a clear idea in mind from the outset. A single drawing may suggest a strong sense of character, but it is not until the character has been rotated and drawn from many different angles and in many different moods that you can begin to see whether a fully realized, three-dimensional "living" being is emerging.

BELIEVING IN YOUR CHARACTERS *Shown here are a number of studies for the eponymous stars of* Poddy and Flora *by Paula Metcalf, currently in development with a publisher. This simple and charming narrative centers on two characters: a girl and her devoted dog. The book begins with a sequence describing the hours of pleasure the two share. It is clear from these simple but highly articulate drawings that the artist believes totally in the existence and emotions of the characters.*

In early drawings, Flora always had her eyes shut and wore a smile

Such good friends obviously had to have similar arms and legs—or paws

The first images emerge of Flora with her eyes open

To make Flora more "appealing," the artist experimented with less extreme facial features.

Keeping a sense of movement in the full-color final images is less easy than when working in line, but the artist has done so without losing any of the unique character of Poddy and Flora.

Character development

64 Getting to know your characters

In many ways, this process is a combination of drawing and acting. We have seen the importance of drawing, but very often the route to truly believable representation of character lies in the illustrator's ability to get under the skin of the individuals on paper, however unlikely they may be (a dancing elephant, for example).

Some illustrators are lucky enough to have this ability in abundance. Maurice Sendak for example, or Quentin Blake. Blake's deceptively simple drawings are imbued with a totally convincing sense of the uniqueness of each individual character. He has spoken of his need to physically "be" the character, temporarily, in order to draw it. Blake's apparently effortless and spontaneous drawings are often the result of several attempts.

This process of "acting out" the movements and mannerisms of your character may be an entirely internal, mental process, or it may be a literal one. The latter conjures up images of illustrators all over the world (famously shy, retiring creatures) performing extravagant theatrical movements in the privacy of their studios. Movement is very important to character. We all hold ourselves and move ourselves around in totally different ways, ways that often reflect our personalities and moods. Edward Ardizzone's theory that the empirical approach of the illustrator revolves around "drawing a thing over and over again until it looks right" is perhaps the one to follow here.

Consistency is the key. Illustrators of stories are often asked how they manage to make a character look like the same person in every picture. This is one of the

APPROPRIATE STYLIZATION
A dark, highly stylized approach is taken by Lisa Evans for a traditional European folk tale undertaken as a student project. There is a haunted, almost ghoulish feel to the child in these studies.

GETTING TO KNOW YOU *Pencil studies of a character performing various movements help the artist to get to know way the character behaves. Pam Smy's drawings here are early studies for a picture book project with a strongly lyrical tone.*

most difficult things to pull off successfully and, once again, the answer lies in a combination of draftsmanship and a sense of conviction in relation to your character. If you are working in a highly representational, realistic idiom, you may be using photographic references (see page 110). Or you may make a series of studies directly from life of a particular individual that you feel fits the bill for the story or sequence. Getting to know the character visually in this way can be the starting point for more subjective drawings, where you put him or her into a range of situations with appropriate responses, emotions, movements, and gestures.

FACIAL EXPRESSIONS Everyone is familiar with the basic formula for representing facial expression: the upturned mouth equals happy, while the downturned mouth represents sad. Most of us are even aware of how slight changes in the shape and position of the eyes and eyebrows can cause us to read the mood and emotion of a character in very different ways.

From this crude, formulaic starting point you can build up an extensive repertoire of visual representation of emotions. This knowledge, combined with on-going observation of the world around you and a desire to tell stories, make up the basic ingredients for successful character development.

A useful project to set yourself is to invent your own character and then make a series of studies of that character in different situations and moods. He or she needs to be well thought out, in terms of age, upbringing, temperament, and so on. Of course, you might use a character from an existing piece of fiction. Then imagine a series of incidents and try to visualize how your character would behave. Imagine how he or she would respond when given various kinds of news, good and bad. Remember that these reactions and moods will manifest themselves in the character's overall body language as well as in close-up facial expression. Creating spreadsheets is the best way to go about immersing yourself in the personalities of these characters. If you can completely lose yourself in the process, you are probably halfway there.

CHARACTER BUILDING
Interaction between characters is an important area to consider, as seen in this wonderfully fresh sheet of studies by John Lawrence.

65

INDIVIDUAL GESTURES *Gestures often bring the character to life as in these studies by Judy Doreham.*

MOVEMENT SEQUENCE *Putting a character through its paces, as in this series by Jon Harris, requires the strongest draftsmanship. Here there is little in the way of detail, but each gesture and movement is totally convincing and clearly belongs to the same character.*

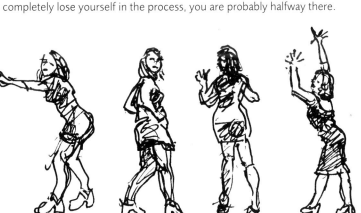

CHILD-FRIENDLINESS This is a rather tricky issue. One of the most important aspects of being an art student is that it gives you the opportunity to experiment artistically, within the broad parameters of your particular discipline. There is little point at any level of study in allowing the development of your creative work to be led entirely by what you perceive to be the needs of the market, as it will only lead to imitative illustration. At the same time, it is important to be aware of the likely reaction of publishers. In my experience, the commonest response from editors in children's book publishing to new picture book proposals from students or graduates, is "brighten up your colors and make the characters more 'appealing'." Whether or not any genuine research has been carried out into the way children respond to the various stylistic approaches to character representation is unclear, but there is an army of editors, managers, salespeople, and parents to get past before the child has a say on this one! In an age when it is universally accepted that minorities of all kinds should be represented positively in images for children, it is surprising how frequently artists' character studies are rejected as being "too ugly," or "not pretty enough."

It is, though, important to strike a balance between what is artistically satisfying, and what is clearly readable for the child, but the latter is a matter for further research!

BALANCING THE APPEAL
*This Jane Simmons'
character study was
thought too extreme by
the publisher.*

**The nose was
regarded as too
long and the eyes
too close together**

STYLIZED FACES *Before her success
as author and illustrator of the
Daisy series, Jane Simmons
experimented with a range of
stylistic approaches to human
characters.*

REPRESENTATIONAL APPROACH
*Illustration for older children can
be approached in a more
representational and literal way. In
these drawings for Bungee Hero by
Julie Bertagna, I based the
character on the brother of a
student of mine, and drew him
directly from life.*

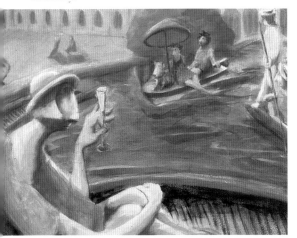

**Once again this
student painting of
"river life"
employs extremely
stylized faces.**

**The character sketch
that was less extreme
and closer to the
approach used in the
published series.**

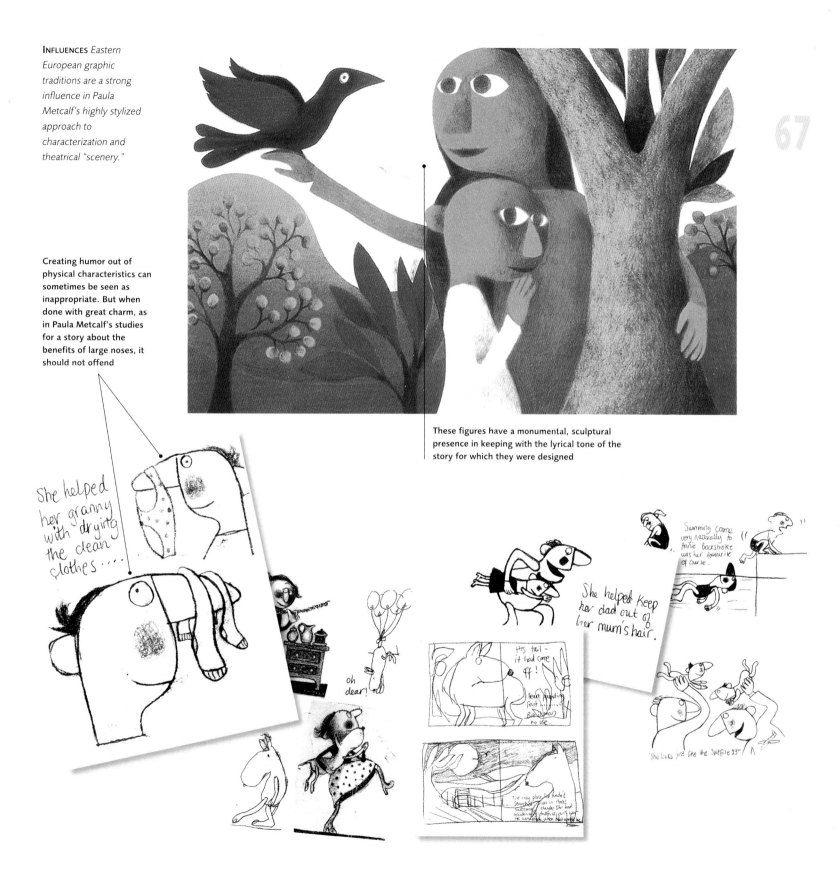

INFLUENCES *Eastern European graphic traditions are a strong influence in Paula Metcalf's highly stylized approach to characterization and theatrical "scenery."*

Creating humor out of physical characteristics can sometimes be seen as inappropriate. But when done with great charm, as in Paula Metcalf's studies for a story about the benefits of large noses, it should not offend

These figures have a monumental, sculptural presence in keeping with the lyrical tone of the story for which they were designed

She helped her granny with drying the clean clothes.....

oh dear!

His tail - it had come off!

heart pounding fast ... Buddican no use

The only place he hadn't searched was in Floras suitcase

She helped keep her dad out of her mum's hair.

Swimming came very naturally to Annie. Backstroke was her favourite of course.

"She looks just like the Spitfire 23"

Character development

68 Animals as characters

Our relationship with the animal kingdom goes back to our earliest traces. Human qualities have been ascribed to or projected onto various species through myth, fable, and folklore. Some animals have been given the role of the good guys, while others are labeled the villains, but it is clear that the animal as surrogate child plays a particular role in engaging the child's imagination.

There are many theories and ideas about the roles animals play in children's literature and illustration, notably from the writer Marina Warner, who has explored such matters in depth. Certainly, it is possible to introduce children to all kinds of issues through animal characters without needing to be too literal about things like safety or parental presence. Animals can be used to represent most of the extremes of human characteristics and behavior. The cunning fox, the cruel wolf, the imperious lion, and the lowly worm are familiar stereotypes. The use of animal characters also frees the artist or author from needing to be explicit about age, gender, class, or race. Domestic animals have always featured prominently as characters, perhaps because of their comforting familiarity, but also for reasons of scale. As the writer Perry Nodelman has observed, "It is not surprising that the animals most frequently depicted in picture books are rabbits, mice and pigs; rabbits and mice are small enough to express the traumas of small children in a world of large adults and pigs have a sometimes disturbingly childlike pink chubbiness."

The ways in which different artists deal with this anthropomorphism are infinitely varied. We have seen how Alexis Deacon's zoo drawings led to the creation of *Slow Loris*, and how Jane Simmons created *Come on Daisy* from her riverboat home. Such first-hand observation played a key role in these instances, helping to avoid the trap of second- or third-hand stereotyping. But the manifestations of these creatures can vary from almost

INTRODUCING ISSUES
A flat, graphic approach is used here by Jenny Samuels to create an animal character whose checkered coloring is cleverly used in a story that deals with the issue of mixed racial origin.

The little boy put Brian into his new hutch. Brian stretched out and sniffed the air. "That's funny," he said, and he sniffed the air again.

COMING TO LIFE *Initial studies of guinea pigs from observation led to the development of the characters, Brian and Bob and the story, My Best Friend Bob by Georgie Ripper. Although Georgie's characterizations have not strayed far from the original sketches, somehow, with minimal facial expression, they have come to life as individuals.*

SIZE MATTERS *Tiny Mouse was sketched many times at small scale before John Lawrence was satisfied with him.*

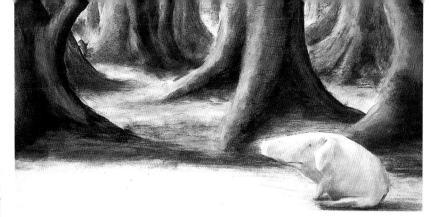

HUMANIZING ANIMAL CHARACTERS *These two lugubrious characters were created by Jane Simmons while at art school. The dog was based on her pet and, having grown up on a pig farm, she was well equipped to develop Beryl the pig.*

zoologically accurate representations, in which human characteristics are conveyed primarily through the text, to upright walking biped versions, who are really humans with animal faces. Beatrix Potter's animal characters, for example—Peter Rabbit, Mrs Tiggywinkle, and the rest—are almost entirely naturalistically rendered, with few, if any, liberties taken with their anatomies, whereas DeBrunhoff's Babar is a human with an elephant's face and hands. The only visual concession to humanizing in the case of Beatrix Potter is that the clothes are ingeniously adapted to the animals' bodies.

For most artists, whatever stylistic approach they use, their characters tend to be "born" on the page, in the sketchbook, or in the form of evolving doodles. As they are drawn over and over again, the characters begin to take on a life and personality of their own. Sometimes they may begin in response to a narrative idea that only existed in the form of words. Obviously this is the case when working with an author or an existing text. But very often the actual process of drawing releases new ideas and new stories through the characters themselves, rather like the old idea that every block of stone contains a beautiful sculpture waiting to be released.

HAVING CONVICTION *Early studies by John Lawrence for* This Little Chick. *These drawings are full of the kind of conviction necessary to create believable animal characters. Each animal already seems to have a distinct personality.*

WORKING OUT THE CAST
Thomas Taylor sketches his characters on paper in a mixture of drawing and scribbled notes to draw up the "cast" for a new picture book.

From the rear, the great bulk of the hippo is more apparent

Bringing the feet together makes the hippo particularly endearing

An idea for a chirpy aardvark character

Exaggerating the size of the head and eyes of this tiger cub character gives him instant appeal

Kitamura's creatures

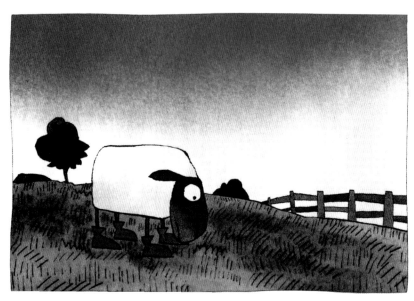

In Sheep in Wolves' Clothing *Satoshi Kitamura introduces a fairly literal, if simplified sheep. The very basic anatomy allows for a range of more human movements as the story unfolds.*

Satoshi Kitamura's books are enormously popular with young children. His distinctive drawings are full of humor and sympathy, and are executed with delicate craftsmanship. He works with a dip pen, waterproof ink, and watercolor washes on a rough-surfaced Arches watercolor paper that he stretches onto a board.

A nervous, sensitive line is characteristic and supported by skilfully applied flat color washes. In *Children Reading Pictures*, children were invited to comment on Kitamura's "wobbly"' line and, to Satoshi's great amusement, their responses presented theories

The sheep in this wonderful spread are now existing in a very different kind of reality, but are no less believable.

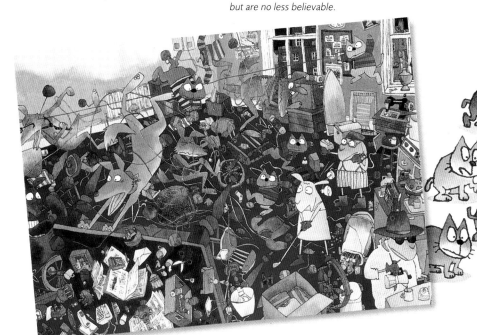

In this title page image from Comic Adventures of Boots, *Kitamura's cats are entirely convincing. All of them appear to be murmuring cantankerously to themselves and one another.*

ranging from the suggestion that he was "worried that he's going to do it wrong, so he's a bit shaky" through the possibility that he had lost his ruler, and finally to the simple fact that he's Japanese.

Kitamura uses animals abundantly in his stories to great effect, his favorite species appearing to be sheep and cats. The sheep, he tells me, arrived in his work through an initial idea for a counting book. This of course involved the incidental representation of sheep being counted, but somehow the idea completely changed and the characters of the sheep took over, eventually appearing in the highly successful book *When Sheep Cannot Sleep*. Sheep have continued to feature prominently in Kitamura's work. In *Sheep in Wolves' Clothing* these creatures seem to be equally convincing whether they are grazing sheep-like in a field or, more improbably, cruising through the country lanes in Gogol's open top 1930s' classic car. Drawn very simply to a basic anatomical formula, each character takes on a completely individual

The cat happily operates as a real cat, and as a humanoid one as he is here. The joints of the rear legs are subtly adapted to allow for this totally human pose and gesture.

personality by the merest addition of an article of clothing or a nuance of facial expression. A wide-brimmed hat and sunglasses gives us Elliot Baa—Private Detective. Ultimately, the great charm of these drawings comes from Kitamura's unique, gentle sense of humor.

In *Comic Adventures of Boots*, Kitamura exploits his interest in the comic format. Boots is a cat, and once again a deceptively simple anatomical form allows the artist to give Boots both human and feline characteristics when the narrative dictates. The independent nature of cats makes them a highly suitable species for creating a whole society, with its own groups, gangs, and oddball characters.

A complete confidence in his particular approach to cat anatomy allows Satoshi Kitamura to create this tour de force *of tumbling felines, described from multiple angles and viewpoints.*

Character development

72 Animating the inanimate

Almost anything can be brought to life in the hands of the illustrator. If the artist believes in a talking slice of toast, it is likely that a child will too. This kind of irrational conviction is an important ingredient in the process of injecting life into the most unlikely of inanimate objects.

ONLY THE NAMES STAY THE SAME *Straw and Matches exchange words. In this image from* Squids will be Squids, *Lane Smith has cleverly combined matchbox and matches as torso, limbs and head to give them life. Straw has been given singed limbs.*

COLLABORATIVE CREATIONS *Basic indications of facial features in the context of Lane Smith's beautifully textured artwork, allow us to believe in the unlikely characters of Froot Loops and Toast in* Squids Will be Squids *by Jon Scieszka.*

It is hard to think of an illustrator better equipped to tackle the anarchic texts of Jon Scieszka than the wonderful Lane Smith. The two have become a hugely successful double act over the years, Smith's bizarre and exquisitely rendered designs perfectly complementing these witty, heavily ironic texts. Molly Leach's typography plays an important part in completing this satisfying collaboration. One wonders what Smith's reaction was when first presented with Scieszka's *Squids Will be Squids*, a hilarious updating of the traditional fable; the book's opening blurb tells us it is a collection of fables Aesop might have told if he were alive today and sitting in the back of class daydreaming and goofing around.

Among the characters Smith was required to visualize are Rock, Paper, and Scissors; Straw and Matches; Piece of Toast and Froot Loops; Beefsnakstick; and Hand, Foot, and Tongue (not to mention the slug, squid, gnat, and blowfish). The illustrator rises to the challenge superbly with various ingenious visual tricks. The arrangement of the Froot Loops in the cereal bowl is just enough to give us the self-satisfied face of the character who is bragging about his nutritional content. In Rock, Paper and Scissors, the scissors are cutting into the paper to give Paper his scowling mouth shape.

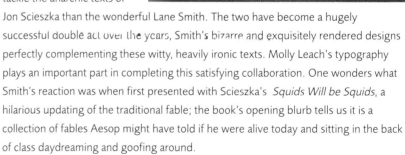

Occasionally, arms and legs are added to anchor the character and to allow a little more in the way of gesture and body language.

The Very Persistent Gappers of Frip, a surreal moral tale by George Saunders presented another interesting challenge for Smith. The gappers are little, parasitic, multi-eyed creatures that appear from the ocean from time to time to infest goats (not, you might think, the most propitious outline for a story). This little book brings together a profound tale of neighborly relations and some of Smith's finest artwork.

Generally speaking, if done with sufficient conviction, almost any inanimate object can be given life in picture books. If the character appears in a sequence, and therefore has to be seen from various angles, plenty of preliminary drawings will be needed to ensure that it will work successfully as a two-dimensional rendering of a three-dimensional object.

TURNING SHAPES INTO CHARACTERS
A "gapper" eyes up its intended victim. Lane Smith's gappers are simple spherical shapes, but with judicious placement of features, Smith invests them with a considerable amount of menace.

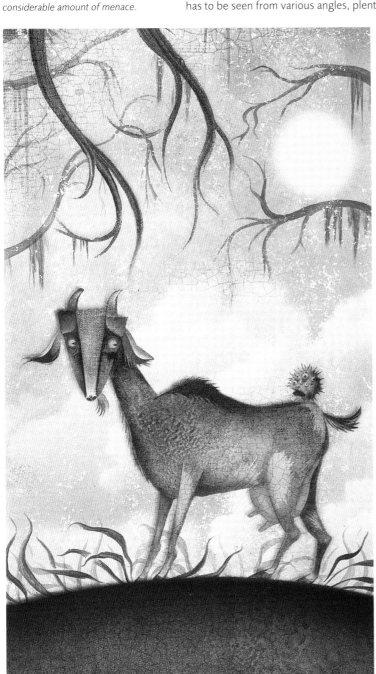

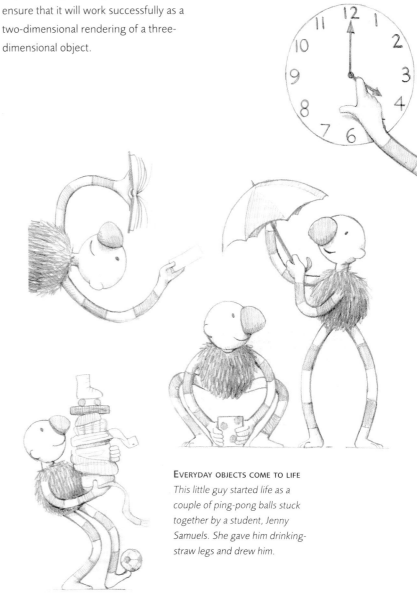

EVERYDAY OBJECTS COME TO LIFE
This little guy started life as a couple of ping-pong balls stuck together by a student, Jenny Samuels. She gave him drinking-straw legs and drew him.

Introduction

Many regard the picture book as the ultimate showcase for the illustrator. Creating a picture book is in many ways closely akin to directing a film, with all the elements of pace, suspense, and rhythm that are involved. A successful synthesis of words and pictures needs planning, and it is often, though not always, the case that the best picture books are written and illustrated by the same person.

LEARNING THROUGH HUMOR
A sophisticated concept such as Jon Scieszka and Lane Smith's Maths Curse *is made accessible to children through its humor and wonderful illustration. It is described on the dust jacket flap as being suitable for ages 6 to over 99.*

The term "picture book" is normally applied to those books that tell the story predominantly through pictures, with a few lines of supporting text. A children's picture book usually comes in the form of 24 or, more usually, 32 pages. This is dictated by the way books are folded and bound in multiples of 8 or 16 pages, called "signatures." Publishers currently consider picture books as suitable for children up to the age of only five or six. This age limit has crept down recently, and there seems to be something of a vacuum in terms of illustration for six to nine year olds. This could be fertile ground for illustrated collections and anthologies. Perhaps attitudes to pictures for older children will change, and their importance will be appreciated again.

For the smallest children there are board books, in the form of a few pages mounted on heavyweight cardboard, and even "stroller books" for the tiny ones, which are usually made of plastic and designed to be attached to the stroller.

Most picture books are inspired by a simple narrative idea, processed in such a way as to engage the interest and capture the imagination of the child. Some books may be based on traditional rhymes (though these can present problems of translation) or, in these increasingly sophisticated times, a quite abstract idea that

EXPLOITING FORMAT
Dramatic use of the full double-page spread is used by Sara Fanelli in her book, Mythological Monsters of Ancient Greece. *In this instance the book has to be turned on its side in order to read the image. This is a "concept" book rather than a narrative. Each page is devoted to a monster from Greek mythology.*

Martin Waddell is the author of more than one hundred books for children, including the Little Bear books; Farmer Duck; A Kitten Called Moonlight; and Hi, Harry! Of the inspiration for Tiny's Big Adventure, he says, "I saw a rusty old tractor nestled in high grass on a farm. It looked like an exciting thing to play with, but who would play there? The idea of a small field mouse, who had never been to the field, came to me—and Tiny was born."

John Lawrence is the illustrator of many books for children, including This Little Chick, which he also wrote, The Mysteries of Zigomar, and A Year and a Day. His signature wood engravings also grace the pages of many classic novels and anthologies. Of Tiny's Big Adventure he says, "I've enjoyed going on this outing with Tiny Mouse and his big sister, Katy. I hope, perhaps, they might ask me again sometime."

Jacket illustration copyright © 2004 by John Lawrence
RESINFORCED TRADE EDITION
Printed in China
www.candlewick.com

$15.99 U.S.
$22.99 Canada

Martin Waddell
Tiny's Big Adventure
illustrated by
John Lawrence

When Tiny Mouse wants to go to the cornfield for the first time, his big sister, Katy, says she'll take him. They play cornfield games, and Tiny sees lots of new things. New things can be exciting, but they can be scary, too. It's a good thing Katy is always right there when Tiny needs to feel braver!

This big adventure—from a small mouse's point of view—captures all the excitement and fear of a first experience. Beloved author Martin Waddell's newest heroes, Tiny and Katy, appear to leap off the pages, each charmingly illustrated with John Lawrence's detailed engravings.

ATTRACTING THE BUYER
A wrap-around dust jacket like this one by John Lawrence is an attractive selling point. This is designed with the front cover primarily in mind, yet the whole is what draws the potential buyer in for a closer look.

is best expressed through this particular synergy of words and pictures. Perhaps the best description of this phenomenon is that coined by the great illustrator and author, Maurice Sendak. His term is "visual poem."

Picture books are primarily intended to be read to a child of pre-reading age by a parent. This means that the audience is effectively "reading" the pictures while listening to the soundtrack, and learning to fill in the gaps between the two things (sometimes referred to as "closure") in order to fully experience the book. As picture books become increasingly sophisticated, this closure becomes an ever more important part of the reading process, and the consequent intellectual and imaginative development of the child. Only recently has the importance of the picture book in this development begun to be fully appreciated.

Because word and image are so closely intertwined in the picture book, it is increasingly the case that the author and artist are one and the same person. In this chapter we will be looking not at particular ways of drawing, but at the way the process of authorship of words and pictures unfolds, how words and pictures combine, and how the "drama of the turning page" is created.

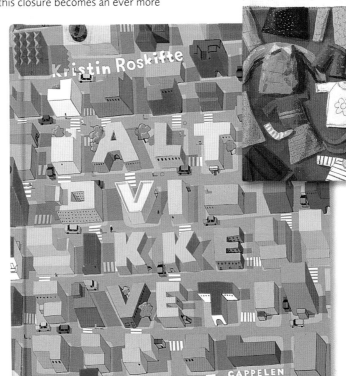

INTEGRATING TEXT AND DESIGN
Hand-rendered text in picture books is increasingly common. When it is done well, the book's design has a totally integrated feel. Kristin Roskifte (left), Frédérique Bertrand (above).

The picture book

76 Concepts and ideas

It is said that there are only six stories and that all stories are a variation on one or other of these. James Fitz-James Stephen via Uri Shulevitz in his *Writing with Pictures* said "originality does not consist in saying what no one has ever said before, but in saying exactly what you think, yourself."

A student of mine worked for several weeks on a picture-book idea that was highly original, inspired by a particular approach to graphic shapes on the page rather than a narrative idea, only to discover that the exact same idea (albeit executed differently) had been published 40 years previously. The student had never seen the original book, and the experience left her feeling that there are no original ideas any more.

A SIMPLE THEME
Shyness is the theme of Paula Metcalf's book, Norma No Friends. *The book deals allegorically with the difficulties children may have making contact with others. This spread sensitively captures the moment when one child plucks up courage to say to another, "I like your shoes."*

In fact, of course, there is no limit to the way things can be interpreted and new and fresh ideas are appearing all the time. It is important, though, that your ideas originate from within you, the author. There can be a tendency to think that in order to be original, a picture book must contain wild fantasies, monsters, aliens, or dragons. There is nothing wrong with any of these as subject matter, but it is worth bearing in mind that magic is at least as likely to be found in the apparently banal world of your own intimate experience.

A simple story well told is a lot harder to achieve than it sounds. If you are to believe in what you are creating, it makes sense that it should come from a place that you know, whether it be a physical or an emotional place, external or internal. We have seen already how important the sketchbook or notebook is to the illustrator, and how the flow of drawings, doodles, and sequences

PARODY AND PASTICHE
Irony can play an important part in modern picture books. In The Happy Hocky Family, *Lane Smith parodies the Dick and Jane books of the 1950s. The concept cannot be divorced from the form, Molly Leach's design being an important part of the joke.*

UNIVERSAL THEMES
Independence and mother/child relationships are the themes of Jane Simmons' Daisy stories. The use of animal characters allows any child to identify with Daisy and her universally familiar struggles against mother's rules.

Something big stirred underneath her. Daisy shivered.

can prompt ideas. But it is not always easy to spot these ideas or to see the narrative potential in apparently abstract jottings or purely observational drawings. Sometimes a theme can be inspired by a place, or it may be motivated by a concept such as anger, loss, or friendship. An example of the former is Maurice Sendak's masterpiece, *Where the Wild Things Are*.

Ideas for picture books are almost always initially visual, rather than textual. Sometimes the underlying meaning will not materialize until the images are explored and the process begins to put them on paper.

Increasingly, artists are using the picture book to deal with such issues, but the book must work on a simple level of story-telling entertainment as well. Jane Simmons' *Come on Daisy* lets children relate instantly to Daisy's simultaneous need for adventure and mother's wing. Paula Metcalf's *Norma No Friends* explores the problems of shyness through the story of two girls plucking up courage to make friends. Anthony Browne favors the use of puzzles and metaphors in his artwork to deal with all manner of issues. Consequently, his books are much in use as a subject for academic study. But picture books can just be fun, too—and at their best they can be all these things at once.

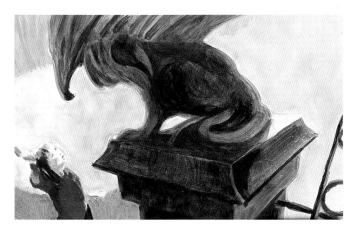

INSPIRATION *Lyrical or poetic ideas are often inspired by no more than a "feeling." Getting these ideas down on paper and structuring them into a book can be akin to the process of composing music or writing a poem. This idea by Judy Boreham was inspired by the magic of her childhood memories.*

VISUAL IDEAS *The ambiguities of visual reality are explored in Kristin Roskifte's Alt Vi Ikke Vet. This is a wordless book that can be enjoyed on many levels and by all ages. Each page presents a surprising visual twist in relation to the previous one.*

The picture book

78 Form

Form follows function. You have your sketchbooks, notebooks, your favored medium, and a story to tell. Do the methods you have developed sit comfortably with the idea you have for the book, or the text you are to illustrate?

"Hold on tight Zeldo," said Jim, "The Big-Wheel is getting faster!"

"What a strange planet!" thought Zeldo.

GRAPHIC WORK *Sam McCullen's image for his picture book idea was generated digitally, color being added to a scanned-in line drawing. This approach suits the content of the book which is a guessing game for the child, who is invited to see our everyday world through the eyes of a visiting alien from outer space. The elements in the image needed to be clearly identifiable.*

An acquisitions editor will take pride in choosing just the right illustrator for a book and its concept. Finding the artist whose work has exactly the right "feel" is not easy. It is probably easier as the illustrator to be objective about this if the illustrator is not, also, the author. It may be that as a student your main concern is to locate and retain stylistic consistency in your work, in which case the above issues will seem all the more confusing. It is inevitable though, that your work will have its own "signature," even if you are not aware of it yourself. If things were falling into place too comfortably at this stage, there would be a danger of becoming stale, mannered, or slick. So the "form" of your work should be appropriate for the concept. It may be useful to ask yourself one or two questions. You might ask, for example, whether your work is primarily lyrical in its tone or whether it leans toward the graphic; in other words, are you inspired by the poetry of pictures or more by the formal dynamics of shapes on the page and their power to communicate? Does your drawing naturally contain a strong element of humor, or is there perhaps an obvious leaning toward the fantastic and magical? The answers to these questions do not, I'm afraid, lead to an instant formula for choice of technique or media, but they may help to crystallize some thoughts about whether the way you are

FORM REFLECTS CONCEPT
The lightness of touch of John Lawrence's pen perfectly captures the playful spring in the steps of the lambs in this delightful drawing.

Baa Baa Baa

TONE AND RHYTHM *The poetic content of this story is suitably reflected in the dreamy, lyrical style of the imagery. Paula Metcalf's illustrations have an unforced sense of "other worldliness."*

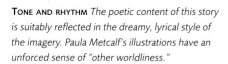

working at the moment suits the ideas that you want to develop. As a very broad generalization, it could be said that humor is often best projected through a simple, economical linear approach. More lyrical ideas may need a softer, more fully tonal way of working and sometimes the more graphic ideas tend to be shown through harder, bolder shapes—collage or digital, perhaps.

It is an interesting phenomenon that illustration students often come up with excellent ideas for story lines and picture books which they are ultimately forced to conclude are best farmed out to another artist. The idea simply doesn't seem to be compatible with the student's own way of working. This can happen to professional artists, too, and it can be a painful experience to hand over your "baby" to another illustrator. It does, however, all help to develop your own sense of identity. On the other hand, you may be one of those artists who refuses to be put into a box of any kind and can turn his hand to a broad range of subject matter and mood, while remaining stylistically consistent—in which case you will be the envy of your peers!

LINEAR STYLE *Humor is often best conveyed through a relaxed line. This sketch by Leonie Shearing has an abundance of life.*

FORMAT The form of the book itself, its size and shape, is something we experience before we have any sense of its contents. This must be given careful consideration, too. Every now and then, a book appears that breaks all the rules of physical format. An example of this is Eva Tatcheva's *Witch Zelda's Birthday Cake* (see page 87). This book has a normal spine but no other sides, being in the shape of a half-circle which opens out to create a full circle, which is in fact a pumpkin. More usually, due to the considerations of stacking and presentation in bookshops and libraries, the decision is limited to whether the book should be portrait shaped (tall), landscape shaped (wide), or square. The shape of the page, always remembering that the shape of the opened-out double-page spread is what we experience, is crucial to the way our eye travels around and through the book.

The picture book

80 The sequential image

Reading images in sequence is a complex skill, most of which is learned unconsciously in early childhood. In the Western world, we learn to read from left to right, and from top to bottom, for both words and pictures. This section looks at how some picture book concepts were planned and developed into successful visual sequences.

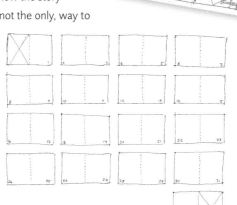

When you are planning a book, you need to work out how the story develops over a sequence of pages, and the easiest, if not the only, way to do this is to produce a form of storyboard. For books, this is a two-dimensional plan laid out so that all the pages of the book are visible at the same time. The best way to make one is to draw up a series of outline miniature pages (see example, right), and make plenty of photocopies of it. This will allow for the inevitably numerous

Sequences of the book begin to be clarified, alongside further doodles and character studies

FLATPLANS AND THUMBNAILS
In the early planning of a picture book, draw out a blank flatplan (shown here is a 32-page outline), photocopy it many times, and work your first scribbles over and over until you can form your ideas into sequence. Very often the first jottings are intelligible only to yourself.

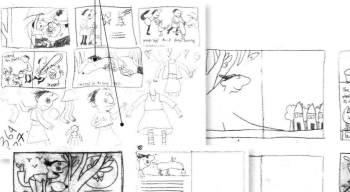

More considered page designs are formulated and described through simple, clear line drawings, always bearing in mind the position of the central "gutter"

FINAL FRUITION *A finished spread from Paddy and Flora by Paula Metcalf.*

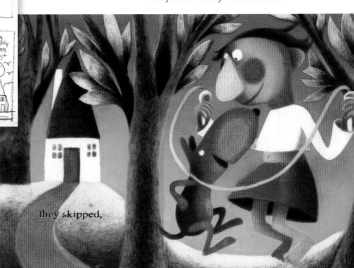

they skipped,

LAYING OUT THE PAGE *Like many picture book ideas, this began with a mental image—in this case the image of monkeys swarming over a car like bees. The narrative, based on the concept of collusion, followed fairly easily. The developing storyboard shows how the illustrator captured her thoughts and gradually refined the sequence of pages so that a variety of angles, viewpoints, and compositions were used to give pace and drama to the story.*

attempts to plan and structure a book with thumbnail sketches and rough text. Most picture books come in a 32-page format, of which about 12 double-page spreads are available for illustration and text, plus a right-hand first page and a left-hand last page.

EDITING THE INFORMATION Very often, the biggest challenge is to edit down from an excessive amount of words and pictures to a ruthlessly trimmed, manageable, and well-structured sequence. Your initial plan need only use the roughest of drawings, paying no attention to the design of shapes on the page, or even the format of the page itself. At this stage, your priority is to establish what goes where. What are the key elements of the story and how do they fit into the number of pages? What are the quintessential images? As things progress, you'll find that an appropriate page format is likely to suggest itself. Gradually, the designs for each spread will become more resolved in relation to the page format and the book as a whole.

Whatever the size of the illustrations—whether they stretch over a whole spread or not—it is important to realize that we experience the two pages visually at the same time. So the shapes and colors need to balance in relation to each other across the gutter of the book. Images that are designed independently of each other and then placed in close proximity are unlikely to sit comfortably together.

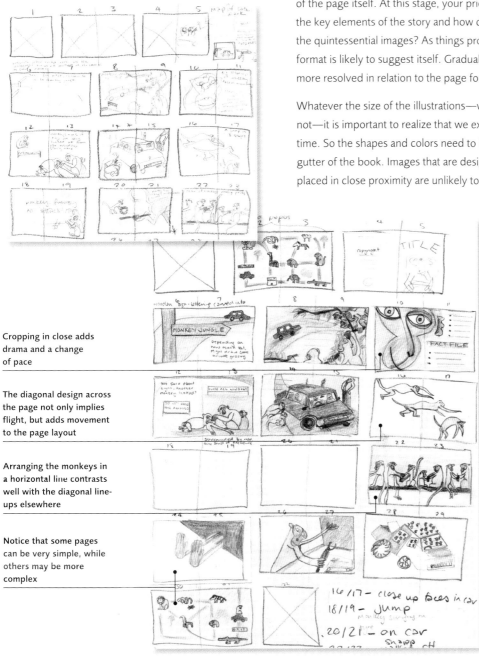

Cropping in close adds drama and a change of pace

The diagonal design across the page not only implies flight, but adds movement to the page layout

Arranging the monkeys in a horizontal line contrasts well with the diagonal line-ups elsewhere

Notice that some pages can be very simple, while others may be more complex

TO CONCLUSION *Two finished illustrations from Grease Monkeys by Joanna Walker.*

ADDING DRAMA AND PACE The pace of the narrative is critical in keeping the young reader interested in the story. This is controlled in various ways: by varying the size of the images, by changing the viewpoint, or by altering the actual design of the image on the page. These changes create an ebb and flow and enhance visual interest. Cropping tightly on the image can also add drama and can be used as a means of punctuating the story.

"Pace" is a word that comes up often in any discussion about the development of a picture book, and not without good reason. The pacing of a book is often a key factor in its success or failure. But what exactly is meant by pace in this context? In the case of poetry, film, or a piece of music, it is clear that the rate or speed at which we experience or read passages of each will vary within the whole. Of course, if the picture book is telling a story, the rate at which that story

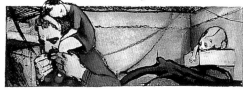

The white of the page is exploited in the first few images with the text itself becoming part of the picture

VISUAL PACE Varying the camera angle can help keep the reader's interest. It is important to avoid repetitive compositons if you are to effecively pace the sequences. Lisa Evans has given careful consideration to the shapes on the page and their impact on the pace of the book as a whole.

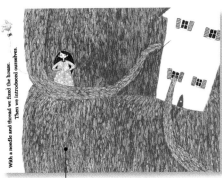

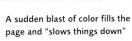

A sudden blast of color fills the page and "slows things down"

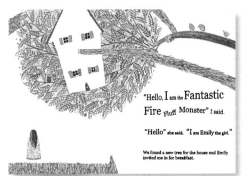

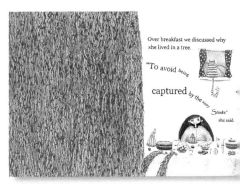

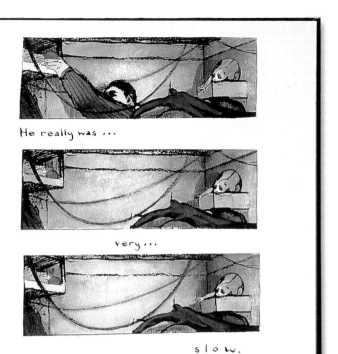

He really was ...

very ...

s l o w.

ESTABLISHING TIMEFRAME *Time is cleverly represented in this spread by Alexis Deacon from* Slow Loris. *The spread appears early in the book and it establishes the painfully slow movement of the eponymous Loris. We are given an almost filmic sequence of Loris attempting to reach his food. The "camera" remains static while people come in and out of frame as Loris inches toward his prize. The spread also serves to vary the visual pace of the book as a whole, providing an alternative layout to the full-bleed, single image format.*

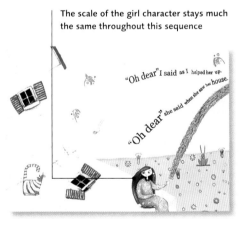

The scale of the girl character stays much the same throughout this sequence

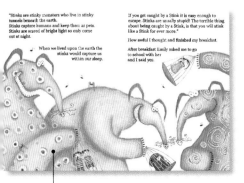

A complete change of color on the page brings a shift of emphasis

unfolds and at which its elements are revealed to the reader is important to its overall symmetry. In most stories there is a problem to be solved, an obstacle to be removed or overcome, and an element of suspense precedes the solution. But regardless of whether or not the picture book is telling a story, there are still issues of pace to be resolved if the book is to succeed. Visual pace needs to be considered if the reader's attention is to be maintained. The urge to turn the page can be weakened if the images or spreads feel repetitive in terms of shape, color, or scale. Each spread must be designed with its relationship to the preceding and following pages in mind, and indeed its relationship to the flow of the book as a whole. In film-making terminology, this means thinking about camera angles, and such things as panning, zooming, and close-ups. At certain points in the progress of the sequence, it may be necessary to speed up the action, or to show an event or whole series of events in condensed comic-strip format. This could be because a lengthy journey or complex experience needs to be described quickly in order to move on to the next stage.

It is very easy to automatically draw an object, scene, or event from eye level and at a standard "snapshot" distance. In a picture book sequence, unless there is a specific reason for it, such an approach would quicky become dreary for the reader. So it is important to think about these issues as you plan your sequence. You might ask yourself whether your characters need to be represented in "real space"; in other words, through the western tradition of creating the illusion of a three-dimensional world, or whether they would work better in a "schematic" way, where the shapes exist primarily in relation to the two-dimensional surface of the page.

FRAMING *A natural instinct is to contain a figure or figures within a frame, but a figure walking into or out of the frame creates a sense of time and an obvious link with the preceding or following page of the book.*

The picture book

84 Words and pictures

In picture books, the relationship between words and pictures is a unique and sometimes complex one. The respective roles of each need to be considered and balanced, complementing rather than duplicating each other's statements.

At the beginning of this book, we heard how Randolph Caldecott is often regarded as the father of the modern picture book because he was the first to see that pictures could do more than just illustrate words in a book. Since Caldecott's time, picture books have become more sophisticated. Children brought up with television and film are equipped to read the nuances and ironies in pictures that are now commonplace in most visual media.

When putting together a picture book, the final form of the words is often the very last piece of the

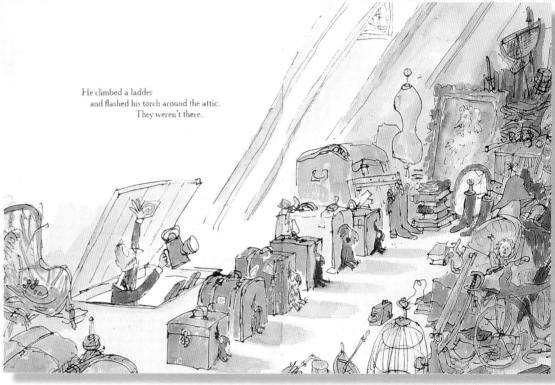

He climbed a ladder and flashed his torch around the attic. They weren't there.

jigsaw. Most of the time, the words and picture are "speaking" simultaneously, so we need to constantly shift and rearrange the balance between them. This synthesis is at the heart of the picture book's character. The way this relationship between word and image can be stretched and challenged is nicely exemplified by Quentin Blake's book, *Cockatoos*. Through the pages of this delightful book we watch Professor Dupont searching for the elusive birds. Each illustration is constructed with a viewpoint that allows the reader to see the birds while they are obscured from the view of the hapless Professor. From our position in the corner of the attic we see a row of suitcases, each one with a cockatoo hilariously pressed up against it in hiding, while Dupont shines his torch from the hatch behind. The text reads, "He climbed a ladder and flashed his torch around the attic. They weren't there."

DÉCALAGE *A French word used to express the disparity of meaning between word and image. In* Cockatoos, *Quentin Blake exploits this phenomenon beautifully and hilariously.*

BALANCING WORDS AND PICTURES

Economy is the key to the succcessful balance of the respective roles of words and pictures in this sequence from Alexis Dcacon's Beegu. Neither the words nor the pictures would make total sense on their own, but they come together to give us the full picture. The words are never wasting time telling us what we already see. The child listening to or reading the words is given an opportunity to make all the connections.

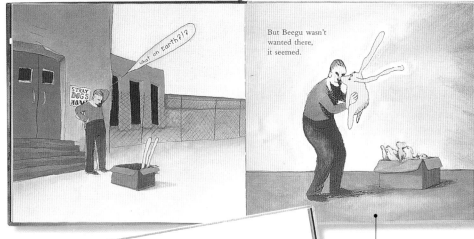

The text augments the content of the picture without duplicating it

No text is required. Beegu's despair is clearly described by the image, and made all the more evident by the contrast of scale, color, and direction between Beegu and the oblivious crowd

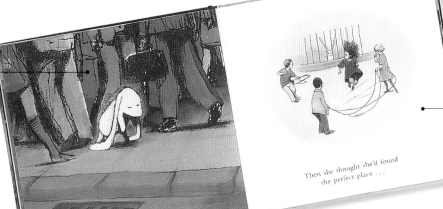

The image completes the sentence begun in words. Throughout the book, the warm yellow is used to express hope

The text confirms Beegu's thoughts, but as we read the picture from left to right we register the arrival of the disapproving schoolteacher

In his book *Words and Pictures*, Blake explains how the French have a word for this kind of disparity, *décalage*, and how *Cockatoos* is built around this concept. *Cockatoos* is an extreme, but highly successful, example of this balancing act—and of course, in this instance it allows the child to be thrilled and amused by being in on the joke, the reader of the words presenting one reality while the pictures give another.

If your picture book idea originally evolved in the form of words, it is likely that in its final form the book will retain little of the original text, with much of the weight of information now being carried by the pictures. You should aim for economy, allowing the text to be a prompt, or an aid to the perhaps more intellectually demanding activity of reading pictures.

The picture book

86 Novelties and pop-ups

Young children love to play and interact with books and pop-up books and novelty items are designed to respond to this. Children can pull the tabs, turn the wheels, and lift the flaps. For the illustrator, this presents the need for a well-planned approach to the artwork process.

The term "paper engineer" is used to describe a person who designs the mechanics of pop-up or novelty books. Occasionally, the paper engineer may be the illustrator of the book too, but more usually this is a specialist who will work with a range of different artists to help them realize their particular three-dimensional vision. This can include anything from the design of a simple tab-pull or flap-lift to the creation of a fully rigged galleon that sails off the pages as a book is opened. Of course, the more complex the mechanics of these designs, the more expensive the book will be to produce.

Once the workings of the book have been designed, and tested in the form of a blank, paper dummy, the illustrator will be required to create the artwork to the strange shapes that may not make a great deal of sense outside of the context of the working book. These will be printed, cut out and assembled at the production stage. The level of complexity here will vary according to how "busy" the pop-up aspect of the book is.

SOFT BOOKS *For very young children, books come in a variety of user-friendly forms. This one is made of soft cotton and comes with velcro labels for the child to stick on and fits snugly into a pouch.*

SLIDE-ALONG-THE-SLOT
The Busy Digger *by Helen Stephens and Anna Nilson provides young children with a simple way to engage physically with the content of the book.*

WHEELS AND FLAPS *Amanda Loverseed's robots rotate around the page by the turn of a wheel in* The Count-Around Counting Book.

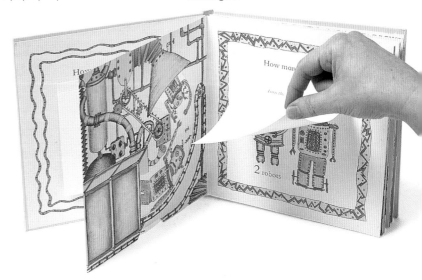

In Eva Tatcheva's *Witch Zelda* books, the infant reader is invited to open drawers, doors, and envelopes (usually to discover something creepy), as well as engage with all manner of wheels, tabs, mirrors, and flaps. As each page is opened, a swirl of shapes leaps out, witches, tables and chairs, pumpkins, and pots. Eva worked closely with the paper engineer Richard Ferguson, on an initial idea for the project from the publisher, Tango Books. "They wanted a Halloween pop-up book, but left the rest to me. I storyboarded the idea and they approved it. I decided that I wanted to make the book open out into the shape of a pumpkin. I was nervous that they might think this too complicated or unconventional, but they let me go ahead. I wanted the book to have lots of things happening. I had never been particularly into pop-up books myself because I felt that they were often a little predictable. I wanted this to be very interactive. You do need to have a good working relationship with the paper engineer. With Richard, we would meet and I would come up with all these wild ideas and say to him, 'can you do this' —he would never say no! I think he likes a challenge. It was wonderful working with him."

INTERACTIVE CONTENT Witch Zelda's Birthday Cake *was conceived as a pop-up Halloween book and designed by Eva Tatcheva to open out into the form of a pumpkin.*

Rotating calendar wheel

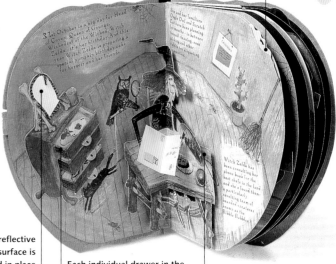

A reflective surface is glued in place as a mirror

Each individual drawer in the cabinet can be pulled out to reveal its contents

A telephone earpiece is attached to its base with string

EARLY WORKING DRAWINGS *Just as with any picture book, the early stages involve thumbnail working drawings to create compositions within the given page shape.*

DIE-CUT PAGES *in this dramatic spread from Witch Zelda's Beauty Potion, Zelda emerges from the cooking pot-shaped pages.*

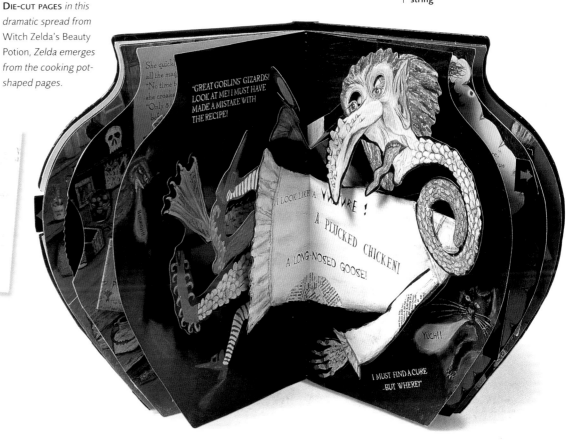

"GREAT GOBLINS' GIZARDS! LOOK AT ME! I MUST HAVE MADE A MISTAKE WITH THE RECIPE!

I LOOK LIKE A VULTURE!
A PLUCKED CHICKEN!
A LONG-NOSED GOOSE!

YUCH!!

I MUST FIND A CURE ...BUT WHERE?

92 A word/image relationship

They were in the cornfield.

"That's a snail," Katy told him. "Look at his shiny bright shell."

"That's a spider," Katy said. "Look at the sun on his web.".

"That's a boot!" Katy told Tiny. "You were clever to find it!"

We have looked closely at the importance of synthesizing words and images in picture books, and how the whole process is often done by one author/illustrator. However, when the author and illustrator are two different people, how does the collaboration actually work? In this case study, we look at a successful teaming.

John Lawrence has been a leading illustrator for over 40 years. His distinctive engravings and drawings have embellished books for all ages. He has authored a number of picture books himself, but also has a wealth of experience in working with a wide range of highly respected writers. In 2003 his picture book *This Little Chick* (Walker Books) was awarded the *New York Times* Certificate of Merit. Walker Books was eager to find an appropriate text for his next picture book and it came in the form of *Tiny's Big Adventure* by top children's author, Martin Waddell. This charming tale tells of two field mice at large in the countryside, their adventures, separation, and reunion. It is a perfect vehicle for John's love of rural subject matter—full of cornfields, old boots, and tractors. But how was the symmetry of words and pictures achieved?

Complementary or parallel visual storylines are created by John Lawrence to avoid an overly literal response to the text. A picture book text that is composed by an author before the images have been conceived can present problems for the artist.

"It comes down to good editing," John says. "In 40 years of illustrating, I have hardly ever had any contact with the author during the time that I was working on a book. Publishers like to keep the authors and illustrators apart." He has come to the conclusion that this is probably a good thing, and concludes, "I suppose it's better that we are each left to get on with our own creative thing. If there was regular contact between author and illustrator, and one of them was a more forceful personality than the other, it might cause problems. Some husband-and-wife teams have managed it very well, though, such as the Ahlbergs and the Provensens."

He feels lucky to be working with such good editors at Walker Books. "They are very good at knitting together text and image as things

develop." In the early stages of the book's development, when John first received the text, the process involved him making rough page designs, meeting with the editors to discuss progress, and hacking away at superfluous text and imagery until things started to feel right.

The kind of problem that can be encountered when illustrating a pre-existing text for a picture book is exemplified by the illustration of the two mice tugging at the shoelaces of an old boot. The text ("That's a boot!" Katy told Tiny. "You were clever to find it!") explicitly identifies the object of the picture. "Of course, I couldn't just draw the mice pointing at a boot," John explains. Instead, he cleverly animates the image by showing the two of them playing a game with the laces, giving the reader a slightly different perspective on things, allowing the text and image to harmonize rather than duplicate. Throughout the book these little visual asides are introduced to bring life to the word/image relationship.

With John Lawrence's print/collage technique, the next stage involves working closely with the designer. He is once again full of praise for the contribution made here. The different colors and textured backgrounds that appear in each image are separate prints that are collaged into the overall design. The designer plays an important role in piecing everything together on the page, including the text that is in the form of a font, each character of which has been engraved on vinyl by the artist.

COLLABORATION BETWEEN AUTHOR AND ILLUSTRATOR

John Lawrence spends a great deal of time on all aspects of preparatory work for a new picture book. The final artwork is produced through the process of engraving on vinyl, but numerous studies of the two mice are made in line first.

An early mock-up spread is put together. This is created by collaging and hand-coloring photocopies. At this stage, the artist was not entirely happy with his characterization.

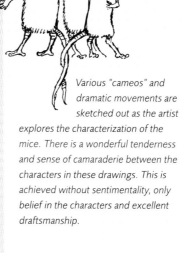

A later mock-up comes close to the approach for the final artwork.

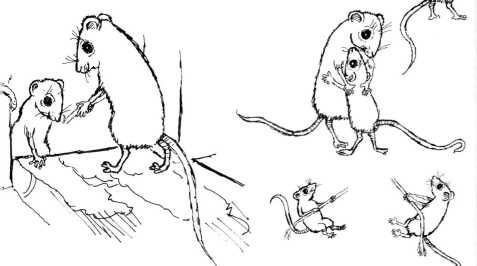

Various "cameos" and dramatic movements are sketched out as the artist explores the characterization of the mice. There is a wonderful tenderness and sense of camaraderie between the characters in these drawings. This is achieved without sentimentality, only belief in the characters and excellent draftsmanship.

checklist • anthologies and story books • what to illustrate • prompting the imagination • setting the scene • book covers • poetry • research • keeping character sketchbooks

Introduction

The illustrated story book differs from the picture book, and consequently it requires a change of approach by the illustrator. Illustrated stories are aimed at an older reading age, and this means the function of the image in relation to the text takes on a completely different significance.

Picture books communicate primarily through images, with the words and pictures being dependent on each other. Story books work in an entirely different way: Here the words come first, and may have been written with no thought of illustration. The absence of illustration in adult fiction is often justified on the grounds that images come between the author and the reader and intrude on the personal process of conjuring up images in the mind. Good illustration, whether it is for adults or children, should provide a visual prompt, a pictorial counterpart to the text; its role is to add to the reader's understanding, appreciation, and

ENHANCING THE EXPERIENCE *In this illustration from Supernatural Stories (chosen by William Mayne) I was concerned with creating a backdrop of a bustling street at dusk.*

BRINGING LITERATURE TO LIFE *Illustrated anthologies, collections, and gift books, such as this one illustrated by James Mayhew, play an important role in introducing children to otherwise purely text-based literature. The illustrations can play a key role in developing a child's visual and cultural literacy.*

front door. She came into the room and stood in front of the girl, gazing at her and nodding her head, and then she turned to the parents.

"I can give her what she most wants," she told them.

"You!" scorned the girl's mother. "How can you cure her?"

"The best doctors in the world have tried, and all failed. What can you do?" the girl's father asked.

"Magic," said the old woman. "Magic."

The parents both turned their backs on her at once.

"You can each have one wish," the old woman said, "but you must keep it in your hearts. Once a wish is spoken the wish is broken. Remember that." And with that she went out of the house.

"What a stupid old woman," the mother said. "There's only one wish any of us can have, and that is for our daughter to walk. What can she do about that?"

As soon as she spoke there came such a rushing of wind that it seemed as if the whole house might fly up into the air. The doors and windows blew open, the carpets were lifted off the floor, the curtains billowed out like puffs of smoke, and all the cups and plates rattled on the shelves like chattering teeth. And with the wind came a voice, shrieking through the open doors and windows like a great cry of pain.

"You have wasted your wish! You have wasted your wish! A wish spoken is a wish broken!"

The girl's mother clapped her hand to her mouth.

"What have I done?" she cried. "Now she'll never be like other children!" Her husband put his arm round her and comforted her.

They both turned to look at their daughter but she was gazing out of the window at the old woman, who had made her slow way to the end of the lane. She saw the old woman sinking down. She saw her hair turning brown and laughed with joy and reached out towards the window, as if for the first time she wanted to be on the other side of it.

The next day she was watching the hillside and saw what she was looking for. She said nothing to her parents. At last the old

enjoyment. Dictionary definitions of the verb "to illustrate" vary, but they tend to include such words as elucidate (to shed light on), explain, and embellish.

In recent years there has been a phenomenon that has been referred to as the "Harry Potter effect." The enormous success of J. K. Rowling's books has apparently led to age groups that would previously have expected to find pictures in their story books now regarding pictures as "babyish." It is hard to know who is leading whom on this one, the publisher or the consumer, but the situation may be rooted in the misguided concept of whether or not a book "needs" to be illustrated. Strictly speaking, no imaginative writing should "need" illustrating: the pictures are not there to reiterate or clarify the words. But pictures can greatly add to the reader's experience and stimulate a child's visual sensibilities.

The artist needs to respect the author's creative intent, responding to it in his or her own way, but without imposing an overwhelming pictorial presence. Most illustrators produce their best work with texts they believe in and are inspired by.

Illustration for older children

96

What to illustrate

Choosing a passage of text to interpret visually is not as straightforward as it might seem. Given a free hand, different artists will choose entirely different passages from, and approaches to, a text. There are, however, some guidelines that are worth considering.

MAINTAINING PACE *On the first reading of the manuscript (The Pedlar of Swaffham in the Faber Book of Bedtime Stories), Pam Smy makes notes and doodles, to arrive at the most suitable elements of text to illustrate. This story takes place on a famous bridge, so it is important to avoid repeatedly showing the same view. She switches to close-ups of characters to overcome this.*

1ST OPTION conversation between John and pedlar

More interesting of two conversations

Use staff and lead and chain of bear to aid composition

Chance to see ugly face— is this important?

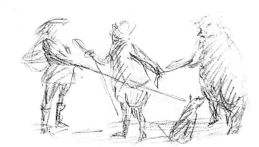

Make more compact image

There John Chapman and his mastiff shared a bed of straw; they were both dog-tired.
Early on the morning of the second day the pedlar and his dog returned to the bridge. Once again, hour after hour went by. But late that day John saw a man with matted red hair lead a loping black bear across the bridge. "Look!" he exclaimed delightedly.
And his mastiff looked, carefully.
"A rare sight!" said John. "A sight worth travelling miles to see. Perhaps here I shall find the meaning of my dream." So the pedlar greeted the man; and he thought he had never seen anyone so ugly in all his life. "Does the bear dance?" he asked.
"He does," said the man. He squinted at John. "Give me gold and I'll show you."
"Another time," said the pedlar. And he stepped forward to pat the bear's gleaming fur.
"Hands off!" snapped the man.
"Why?" asked John.
"He'll have your hand off, that's why."
The pedlar stepped back hastily and called his mastiff to heel.
"He had a hand off at Cambridge," said the man.
"Not the best companion," said John.
"He'll bite your head off!" growled the man, and he squinted more fiercely than ever.
So the second day turned out no better than the first. And on the third day the poor pedlar waited and waited, he walked up and down and he walked to and fro, and no good came of it. "Now we have only one piece of gold left," he said to his mastiff. "Tomorrow we'll have to go home; I'm a great fool to have come at all."
At that moment a man shaped like an egg waddled up to John.
"For three days," he said, "you've been loitering on this bridge."
"How do you know?" asked John, surprised.
"From my shop I've seen you come and go, come and go from dawn to dusk. What are you up to? Who are you waiting for?"
"That's exactly what I was asking myself," said the pedlar sadly. "To tell you the truth, I've walked to London Bridge because I dreamed that good would come of it."
"Lord preserve me!" exclaimed the shopkeeper. "What a waste of time!"
John Chapman shrugged his shoulders and sighed; he didn't know what to say.
"Only fools follow dreams," said the shopkeeper. "Why, last night I had a dream myself. I dreamed a pot of gold lay

No need to include bridge

Dramatic moment. May make more dynamic image

Towering bear over pedlar

But distracting from narrative?

2ND OPTION conversation between John and shopkeeper

Pivotal to story but NOT very interesting!

Shopkeeper shaped like an egg

ATMOSPHERE AND DRAMA *When creating chapter headings for a book as beautifully written as* The Midnight Fox *by Betsy Byers, I was eager to convey a sense of the drama that was building up.*

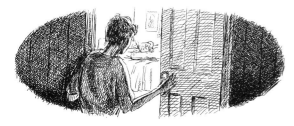

It is not uncommon for commissioning editors to hand over a manuscript in which the key dramatic moments have been highlighted and the word "illustrate" written alongside. There are two reasons why this is not a good way to commission illustration. One is that moments of high drama are not usually the most appropriate for illustration; the other is that, more often than not, better results are achieved if the illustrator is allowed to select the passages to be interpreted pictorially. Why is this?

If a passage of text explicitly describes a dramatic or violent action, any visual interpretation of it is likely to duplicate what has already been conveyed in the words; the result will probably be a rather "wooden," frozen moment in time. The final showdown between Sherlock Holmes and Moriarty, for example, has been represented by countless artists through the years. Left to their own devices, it is likely that most illustrators would choose an implicit, rather than an explicit, approach to a scene, allowing the drama of the setting, the roar of the water, and perhaps a glimpse of a shadowy figure to trigger the readers' imagination.

Places, objects, even empty rooms can elicit an emotional response from readers, allowing them to place their own interpretation on the scene. It is important to bear this in mind when deciding what aspects of a story to illustrate.

A student of mine was recently inspired to make a series of powerful drawings based on the apparently everyday sight of a single glove lying by the side of a road. This kind of ambiguity and suggestion plays an important part in storybook illustration. Ardizzone felt that the best view of the hero or heroine of a story was the back view. He rarely drew close-ups, feeling that "characters should be suggested in their settings rather than fully described."

INTERACTION BETWEEN CHARACTERS *The notes and doodles, shown opposite page, far left, are worked into detailed initial drawings for the publisher. Because the text on this spread is in the form of a continuous dialog, the artist chose to focus on the interaction between the characters, avoiding repeating the background, which appears on another spread.*

Illustration for older children

98 Setting the scene

Earlier in the book we looked at first-hand location drawing and its importance in the process of building up a vocabulary of place. When illustrating a text that is set in a particular time or place, be it real or imaginary, specific research is needed.

Time and place, mood and atmosphere need to be convincingly conveyed by the artist, whether it is by means of architectural detail, costume, or even lighting. This applies whether the text to be illustrated is a gritty, up-to-the-minute piece of adolescent, urban realism or a romantic, gothic fantasy. Many illustrators acquire a collection of second-hand books that "might come in useful one day." These books may include all manner of photographic reference material—especially books on costumes, period furniture or architectural detail, cities, and people from around the world.

The important thing is to make the reference material work for you rather than to allow yourself to be its slave. If the time scale, budget, and nature of the project allow you to visit the place in which the text is set, this is a wonderful advantage. Spending a day or two immersing yourself in a location, making direct studies in a sketchbook, is a wonderful way to start a project. However, this may be unrealistic, and reference will more likely be drawn from libraries or the Web.

One artist who researches his material meticulously is Chris Priestley. This is not surprising as, unusually, he is also the author of most of the books that he illustrates these days. He trained as an illustrator and worked for a number of years in magazines and newspapers.

Producing drawings for your own text is not as straightforward as it might seem. "First" he says, "I don't have an automatic right to illustrate my work. I have to make a pitch to the publisher to convince them that I am the right man for the job." Being both author and illustrator crystallizes many of the issues of what to illustrate. Chris decided to produce small, motif-like chapter headings for *Death and the Arrow*.

Both the text and illustrations for the book required historical research. Chris is

LOCAL INSPIRATION *A nearby museum fitted the bill perfectly for the old house in* Arthur Warrior Chief, *by Mick Gowar. I was able to draw both its exterior and interior.*

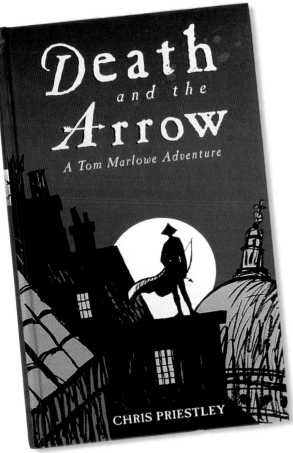

conscious of the dangers inherent in using visual source material. "You have to make sure that your work is your own, not allowing the source material to show through in the drawing. I have a great many reference books, but I try not to get too bogged down. Obviously, your characters must be wearing the right clothing for the period—but it is fiction, and it is the mood and atmosphere that are of overriding importance. It's always a worry when you see in someone else's illustration work the presence of a familiar piece of source material." Chris describes the process of illustrating a text of this nature as being similar to aspects of directing a film. "It's about finding the right angle to make it interesting and establish a mood."

PHASING THE NARRATIVE *For the cover of* Death and the Arrow, *Chris Priestley provides visual indication of the "where and when." Set in London in 1715, both text and illustrations required historical research. The chapter headings subtly suggest a new phase in the story, without giving too much away. He describes his approach as one of creating mood changes.*

Visual "stamps" mark the beginning of each new chapter and are a subtle indicator of mood and the narrative to follow.

This calm image suggests the drama which is to follow. The avoidance of human faces adds more impact.

It is important not to give away the plot. The lead character is shown as an anonymous silhouette, once again avoiding revealing too much of the content of the coming pages.

An atmospheric sketch laden with foreboding sets the scene.

Book covers

Regardless of whether or not the text contains illustrations, most children's story books have illustrated covers. A pictorial cover design needs to promote the book and demand attention, while at the same time being true to the spirit of the book's contents.

The concept of the illustrated book cover is a relatively recent one. Originally, dust jackets were purely for protective purposes and were provided by the bookseller rather than the publisher. There are occasional examples of illustrated dust jackets in the 19th century, but it was not until the 1920s that the book cover really came into its own as a form of advertising or packaging. Now, in the age of the paperback, no book is complete without its own unique cover design.

In recent years the activities of design and illustration have become separated, so it is rare that the designer and illustrator of a book cover will be one and the same person (see Chapter 8). A commission to illustrate a cover normally involves working with a designer and editor who have definite ideas about what should be on the cover. In addition, the publishers' sales team are likely to have input, and may ultimately reject what is an artistically inspired design if it is felt it will not sell the book. Of course, if the commissioner is experienced, the illustrator will have been chosen because his or her style is appropriate to the text in question. In other words, the artist's work is seen to have the right approach to complement and promote a text that is either humorous,

EXOTIC BACKDROP *Jane Human's cover designs for a Heinemann Caribbean Writers' series, provide a subtle indication of narrative content, and a strong sense of place through the rich and exotic colors of the Caribbean.*

SHORT STORIES *A book of short stories will contain many very different individual narratives. The editors suggested that I illustrate the title story, setting the scene for the languid Caribbean tone of the writing.*

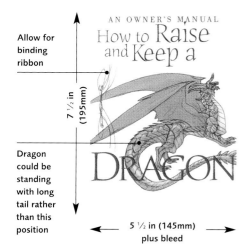

Allow for binding ribbon

7 ½ in (195mm)

AN OWNER'S MANUAL
How to Raise and Keep a DRAGON

Dragon could be standing with long tail rather than this position

5 ½ in (145mm) plus bleed

CONCEPT The concept was to create a book that looked like a genuine old handcrafted notebook, containing advice on keeping dragons. Niroot Puttapipat's very delicate pen and ink style is ideally suited, and he was chosen for this reason. The jacket was to have an illustration of a dragon that could be dropped onto a photograph of a textured notebook. This theme was carried through to the inside pages.

BRIEFS The first brief for the jacket shows the format and size of the book. You may receive a hand-drawn sketch from a designer, or you might receive a digital rough, as here, where clip art has been used to start the concept (left). The text for the inside pages was commissioned to the author by the editor using rough scamps (thumbnails) of the spread (below left). When the text came from the author, it was pasted into a rough layout and the designer drew rough positions for the text scrolls and the dragon's eggs (below). This was sent to the illustrator who worked to those positions when painting his watercolor illustration.

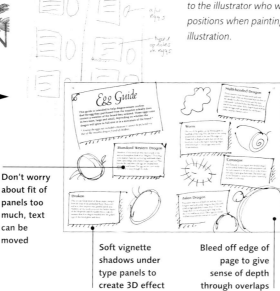

Don't worry about fit of panels too much, text can be moved

Soft vignette shadows under type panels to create 3D effect

Bleed off edge of page to give sense of depth through overlaps

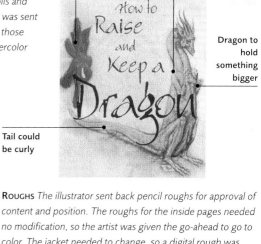

Allow for ribbon

Add wings

AN OWNER'S MANUAL
How to Raise and Keep a Dragon

Dragon to hold something bigger

Tail could be curly

ROUGHS The illustrator sent back pencil roughs for approval of content and position. The roughs for the inside pages needed no modification, so the artist was given the go-ahead to go to color. The jacket needed to change, so a digital rough was produced (above). The digital rough shows the illustrator's pencil sketch with a photograph of the handmade paper notebook and ribbon binding, plus possible positions for the type. The designer's comments (shown in the margin) were sent to the illustrator.

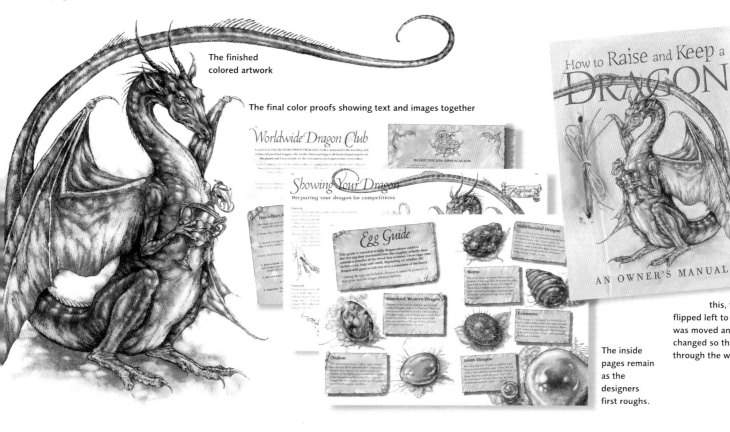

The finished colored artwork

The final color proofs showing text and images together

The inside pages remain as the designers first roughs.

The finished jacket. When the illustration came in, it was used as big as possible. To allow for this, the dragon was flipped left to right, and the type was moved and typography changed so that the tail could twist through the word.

Illustration for older children · Book covers

The designer's choice of typeface echoes the rustic, "distressed" surface of the illustrator's image

INTEGRATED TYPOGRAPHY *Contemporary wraparound jackets for a book aimed at 12 year olds and above. The artist Beppe Giacobbe's typography works perfectly with the robust shapes of the design. His simple, bold figures leap off the covers to attract young readers.*

In both these book covers, the designer has picked colors to work with those of the illustrator, creating a harmonious "wraparound" concept

dark, lyrical, gritty, or fantastical. The cover has to attract the eye of potential buyers. Illustrating a book cover is very different than illustrating the text, and it is not unusual these days for the cover of a book to be illustrated by a different artist from the one who has worked on the text. This may be because the publisher is branding a series with a particular cover look: The need for a compelling cover design often outweighs the need for overall design harmony through the book. The expression "don't judge a book by its cover" has become a familiar cliché in our language. This is presumably the result of a perception that the need to sell a book through eye-catching cover designs can lead to taking liberties with the visual interpretation of a book's actual content.

But a good book jacket design should match the style of the writing and give a flavor of the book's content without giving away the story. The extent to which the stylistic approach should pander to the book's perceived audience, age group, and type is always controversial, raising as it does matters of public "taste," and the pressure for publishers to repeat previous successes or imitate those of others does not militate in favor of innovation. Nevertheless, there are always publishers and editors who are willing to take risks.

Victoria Allen from Walker & Company describes the commissioning process that has led to covers such as *Fifteen Love* (by Robert Corbet) and reveals that she will go through an enormous number of illustrators in her search for potential artists for a cover before everyone is happy. "I have to get the editor's approval before things finally go ahead. In the case of *Fifteen Love*, the artist, Beppe Giacobbe, lives in Italy and was asked to e-mail a first design, and he included the type without having been

EXECUTING AN ASSIGNMENT *I produced this rough for the cover of* The Midnight Fox *after a meeting with an editor. Although this actual scene is not part of, nor described in, the text, it was felt that it suggested the atmosphere and tension of the story.*

CONTEMPORARY FICTION *A cover design by Jochen Gerner for Editions du Rouergue combines bold, brutal shapes with attractive color harmonies and hand-painted type.*

asked. It was so gorgeous we kept it! He sends in work on jpegs, I print them out and show them to the editors. We e-mail our feedback, and he might then e-mail a revised sketch. Finally, he sends a high-resolution jpeg image."

There are problems here of making sure that the final color version of the design is consistent with the artist's intention. "I always ask for a color print-out, which the artist has approved. Every monitor will give a slightly different version of the color, so it's important to have something to work from."

Victoria believes that these days there is little point in illustrators asking to visit the publisher's offices to show their portfolio of work. The designers do not have the time to see them, and there are quicker ways for them to communicate artwork. "We receive lots of mailers, which we keep on file, and it's really important for the illustrators to have their own web sites, which we can browse in our own time."

EVOKING THE THEME *A girl's internal struggle with jealousy is played out before a backdrop of the sea and a violent hurricane. Michelle Barnes' collage illustration appropriately evokes the emotional turmoil of the story.*

The designer's use of color and typography continues the "watery" and emotional motifs of the text and image

The front cover image is repeated on the back, overlaid with a text panel

THE MIDNIGHT FOX

FABER CHILDREN'S CLASSICS

Betsy Byars

Anna Myers is the award-winning author of several novels for young readers including *Captain's Command, Graveyard Girl,* and *When the Bough Breaks.* She is a two-time winner of the Oklahoma Book Award for Children's Books and her book *Ethan Between Us* was chosen as an ALA Quick Pick for 1999. Anna lives in Chandler, Oklahoma.

Jacket illustration by Michelle Barnes
Jacket design by Victoria Allen

WALKER & COMPANY
435 Hudson Street
New York, New York 10014

www.walkerbooks.com

PRINTED IN THE U.S.A.

The phone was on the wall of the parlor. Maggie pushed a footstool over so that she could reach the mouthpiece without straining on her tiptoes. "Hello," she said, but the operator did not answer. "Hello," she said again, more loudly. "Hello, hello." Then she stared at the telephone. It was dead. "You were working just a few minutes ago," she said into the mouthpiece. "Please work," but no sound came to her ear.

Maggie hung up the phone and moved to the parlor window. Amazed, she realized the water was up to the first step. Thank heavens Papa had built the house up high. The water would never reach the house. Maggie was sure of that, but she still felt afraid. She was alone here with Myra, alone and cut off from the rest of the world. Beside her, Bonnie whined, and Maggie patted the dog's head. "We're together. We'll be all right, won't we, girl?"

Stolen by the Sea

Anna Myers

Anna Myers

Stolen by the Sea

WALKER

$16.95
CANADA $26.95

Maggie McKenna loves the sea. One of the best things about living in Galveston is being able to swim in the gulf and walk along the seashore with her father. Maggie wished those special times with her father would never end. She knows she's wrong to be jealous of the new baby that's coming, but the bad feelings keep building inside her like a threatening storm. She even resents the time her father spends with Felipe, the Mexican boy from the orphanage who does odd jobs around the house.

When her father has to take her mother to Houston to see the doctor, Maggie is left behind to struggle with the jealousy that is sweeping away her common sense. But soon she is facing the battle of her life when the very sea she loves, stirred up by one of the most powerful hurricanes of the century, ravages Galveston—destroying homes and lives in a powerful and violent flood. Her only chance of surviving through the night is to join forces with Felipe as they try to ride out the storm together.

Ages 8 to 12

ISBN 0-8027-8787-8

9 780802 787873

104 Illustrating poetry

Because the words themselves are very often "painting pictures," poetry does not always lend itself naturally to illustration. But when a partnership works, the outcome can exceed the sum of its parts.

There have not been many successful partnerships between poets and artists over the years. In adult terms, Leonard Baskin's superb drawings for Ted Hughes' verses spring to mind, while Walter de la Mare and Edward Ardizzone are a hard act to follow in children's poetry.

The approach to the illustration of poems is a very different undertaking from the response in illustration to narrative prose. A poem is a complete statement, which the reader may enjoy in a variety of ways on a personal level, and it is important the illustrator is not too literal in the approach. Usually, successful illustration of poetry involves a greater than normal level of subjectivity from the artist; it forms a parallel visual statement, a counterpoint to the words, especially where the poetry is lyrical in tone. Playful children's poems, nonsense rhyme, and doggerel can all benefit greatly from illustration, particularly when the words themselves can be incorporated into the imagery or integrated into the page design in a musical way.

Walking the Bridge of your Nose, by Michael Rosen, is illustrated by Chloë Cheese, a highly respected

SHAPES ON THE PAGE *Elements referred to in various "mind benders" are loosely represented within plenty of white space.*

TEXT AND IMAGE *An opportunity to create a complete page design and backdrop to the words is seized by the artist, Chloë Cheese. Wordplay poems are handled in a variety of ways. On the left-hand page she imagines a family puzzling over the riddle, while the hilarious "Belagcholly Days" is illustrated with a representation of the cold-ridden poet.*

artist and printmaker. The pages are alive with a colorful fusion of word and image, which are to be read and experienced as one. The book is a collection of wordplay poems and tongue-twisters. It is hard to imagine a more perfect harmony of word and image in a children's picture book.

Chloë Cheese's work lends itself particularly well to poetry. Her unique and idiosyncratic drawing and painting seem to dance with the words and create a seamless visual backdrop. "You have to be very careful with poetry," she told me, "You can't be too literal. You are trying to capture the magic and the fantasy in the words. *Walking the Bridge of Your Nose* was marvelous to work on. There's so much fantasy in there—and, of course, you're often not tied to time or place. This means that the pictures can flow much more easily. It was very liberating."

In *Einstein, the Girl who Hated Maths*, Satoshi Kitamura not only illustrated John Agard's poems, he took control of the overall design of the pages. This was important, as it allowed the illustrator to create an integrated word and image statement around complex ideas, made fun through poetry.

PARALLEL THOUGHTS *Satoshi Kitamura's ingenious visual accompaniment to John Agard's poem shows a clear empathy with the poet's words and a real understanding of their layers of meaning.*

DESIGN MOTIFS *Alan Drummond's designs for this tiny volume are in the form of playful, elegant motifs that decorate the pages and form breaks between sections.*

CONCEPTUAL INTERPRETATIONS *In this spread, the poet and artist have created a seamless fusion where words and pictures speak to each other. The double-page spread of the poem becomes another work with Satoshi's doodles in the margins.*

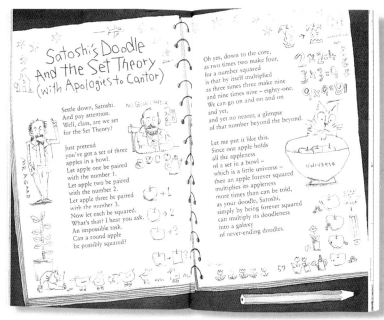

106 Following your passions

These tall "column" illustration panels were introduced as a way of saving space for the text in Koshka's Tales. The format provided an interesting compositional challenge for the artist. The artwork is executed with a mixture of inks, watercolor, and gouache, with spots of gold paint here and there.

If an illustrator's work is fired by and infused with his or her own passions and preoccupations, it is likely that the results will be all the more convincing. James Mayhew's love of theater, opera, and all things Russian has informed much of his illustrative work and choice of subject matter.

As a young art student, James was torn between theater design and illustration. Although he chose the latter, theater and music continue to play an important role in his work. As well as writing and illustrating a number of highly successful picture books, James is particularly well known for the illustrated collections and anthologies on which he has worked, which have reflected his cultural interests.

It started with descriptive music. "As a child I was introduced to *Peter and the Wolf*. The Russians tended to specialize in this approach, "pictorial music," you might call it. As a youth I listened to rock and pop like everyone else, but it wasn't enough. I found myself going back to this kind of music, music that conjures up pictures. And my

sketchbooks were full of Russian cities, though I'd never been there. I traveled through Russian stories and was totally enchanted. They seemed so much more alive than our sanitized versions. When I was at art school I finally went to the USSR (as it was then). We went to Leningrad and Moscow. It was a big culture shock. I was impressed by the sense of commitment that Russians had to their own indigenous culture."

James found his illustration course difficult at first. "It was a practical choice: I thought there was a more realistic chance of employment in illustration. But my influences were all theatrical, people such as Chagall, Bakst, Natalia Goncharova, and Ivan Bilibin. The course was heavily biased toward editorial/conceptual projects. After the Russia trip I narrowed down my range of media. I had been a bit all over the place up to then and had had a few run-ins with the tutors. In my final year, I created a whole new portfolio of work. I used inks on a china clay paper."

At his first interview with a publisher, he was told his work was too small, too dark, and too suicidal. "I didn't have anything in my work that was suitable for children's books. Strangely, I went to see Orchard Books by accident, not knowing that they were a children's book publisher. I had done a dummy at college for a children's book competition. My tutors hated it. I showed Orchard the dummy and the next day they phoned to say that they were interested in publishing it."

It soon became clear to James that the children's book world was the place he wanted to be. He had an artist's agent, but needed a literary agent (see pages 130–131) and was taken on by the legendary Gina Pollinger, who became an important influence on his career. "She saw

Royal Opera House

This little sketchbook study was produced by James while waiting for an opera production to begin.

my Russian drawings and saw that there was a whole other part of me. Gina managed to persuade Kingfisher to do a book of tales from Russia (*Koshka's Tales*, 1993). Koshka is Russian for cat. There are legends of story-telling cats in Russian culture and I decided to use this as a framework, rather like the *Arabian Nights*. I reread many folktales, and discovered how brilliantly constructed they are. If you try to alter them too much, they fall apart."

James Mayhew's passion for Russian folk traditions is apparent in this richly decorative cover design.

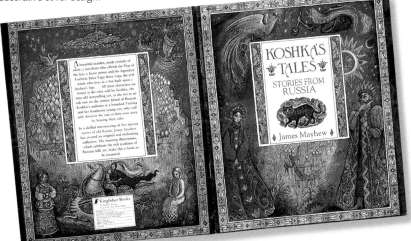

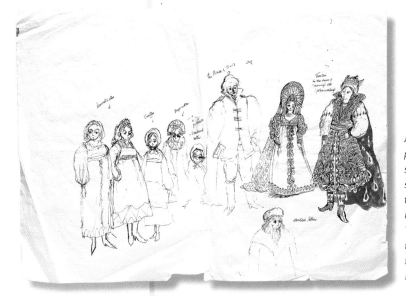

James Mayhew produces numerous sheets of costume studies and designs in the early stages of illustrating a book. The close relationship that his work has to theater design is clearly evident.

Decorative panels and borders are inspired by traditional folk art motifs, found in wood carvings and peasant costumes from the region.

The various strands of research come together in James Mayhew's finished illustrations, combining reality and fantasy in this vignette that runs around the edge of a block of text.

checklist • history books • games and puzzles • "how-to" books • alphabet books • counting books • illustrated dictionaries

Introduction

Illustrating facts that cannot be represented by photographs is an extensive and important area of work for illustrators. Bringing learning to life requires skills in research methodology allied with creative vision.

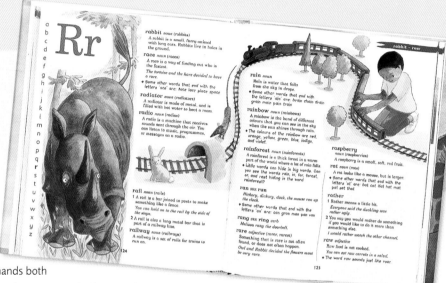

Although some people may think of nonfiction illustration as being a lesser or more prosaic art form, it can be a highly creative area that demands both technical, problem-solving skills and aesthetic vision. The best nonfiction illustration can be both informative and visually stimulating. The area covers a broad range of subject matter—for example, history books, practical "how to" books, puzzles and games, alphabet books, and counting books.

LEARNING NUMBERS
Counting books provide the opportunity for illustrators to have fun in introducing children to the concept of numbers.

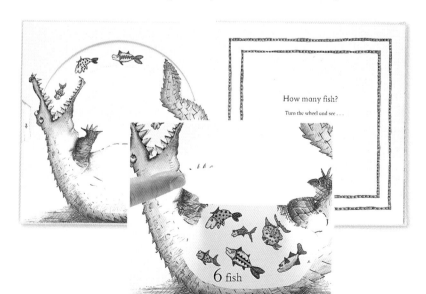

WORDS AS STORIES *Dictionaries for chidren are often profusely illustrated as with Emma Chichester Clark and Andrew Delahunty's Oxford First Illustrated Dictionary.*

LETTERFORMS AS IDEAS
The letters of the alphabet can be made meaningful and fascinating to children through ideas such as Kirstin Roskifte's unpublished project The A to Z House.

If pictures that are designed primarily to educate young readers can also enchant and delight, then learning becomes a pleasure. My own childhood was enriched by artists' interpretations of history, geography, and natural history. In the case of the former, it was often through the books written and illustrated by C. Walter Hodges, such as *Columbus Sails*, originally published in 1939 by G. Bell and Sons Ltd, but reissued frequently ever since.

Illustrators' interpretations of far-off places and undersea worlds drew me into areas of knowledge that no words could ever do. C.F. Tunnicliffe's paintings of African wildlife for the cards that came free with Brooke Bond Tea started a life-long addiction to tea drinking. I would try to get through as much of the stuff as possible in order that another packet could be bought to boost my card collection. Today, when I read about a black rhinoceros or a warthog, I still see Tunnicliffe's paintings in my mind's eye.

In an age when we can "walk with dinosaurs" on television and in film, or experience an interactive, virtual journey into the tombs of the pharaohs, these books must now compete with numerous other communication media. Somehow, however, the static image still has the power to capture a child's imagination in a unique way, allowing the eye and mind to travel and linger at their own pace.

PUZZLES AND PROBLEMS

Puzzle books and games provide a major outlet for illustrators with good conceptual and technical skills. Books continue to provide a popular and reflective alternative to computer games.

NARRATIVE APPROACHES

Illustrating children's history books allows for an intimate, narrative approach to the subject as in my own illustrations to Lloyd George and the First World War.

Nonfiction illustration

110 History books

The ability to bring the past to life through exciting illustration is a skill that will always be in demand—or at least until time machines allow us to take a camera to a Stone Age settlement, to Custer's Last Stand, or to the signing of the Yalta Agreement.

Good draftsmanship is essential in re-creating scenes of everyday life from the past successfully, and the ability to light figures and spaces convincingly is also important. Reference material will be needed for this kind of work, and so it is back to the recurrent theme of making sure that the source material does not control the work. For example, when putting together figures in a group composition that have been photographed separately, it is likely that the light will be coming from different directions in different images. If these figures are to be relocated into a setting, which may be anything from a mountaintop to a grand ballroom, they will need to be consistently lit. Nothing is more obvious to the trained eye than static figures appearing to be posing in a wooden manner as if for a series of individual photographs. Plan a composition in advance, making a tonal sketch of the composition before taking reference photographs.

MODELING FOR REFERENCE
Reference photographs shown alongside finished artwork give an indication of the improvization that is often needed.

ACTING THE STORY
For this Viking scene, I photographed friends posed in position, and added costume detail later from a variety of reference sources. (People in History, by Fiona Macdonald.)

Searching thrift stores and antique bookstores is second nature to an illustrator. Books full of photographs can be key reference points.

A photograph provides the starting point for illustrating the lives of Native Americans.

PIECING IT TOGETHER *An unearthed antiquated reference book provides photographs of horse and rider, and the basic posture for an American Indian portrayed outside his teepee. Several elements are drawn together and composed, with the teepee, to create an unboxed shape that will work well within the design of a page.*

The groomed horse in the photograph is roughed up a little to look more like a Great Plains' horse. The male figure is metamorphosed into a Native American, and the figures of the woman and child, sketched from life, are reworked with appropriate clothing.

The illustrated page showing the scene in final layout.

Research is obviously of paramount importance. Publishers may supply reference material for specific elements, but a good stock of reference books of costumes, furniture, and other subjects is essential for anyone who specializes in this field of illustration. For photographic realism, costumes and models can be hired—or long-suffering friends engaged to approximate a given movement or action, or the way clothing might fall. Photographic references can be used indirectly, or directly for clothing, hair, decoration.

Nonfiction illustration

112 Practical, "how-it-works" books

Explaining to a child the inner workings of machinery or the details of topography is usually best done pictorially. This kind of illustration work requires both technical skill and practical expertise, as well as a keen interest in getting under the skin of things.

The term "information illustration" tends to suggest a purely technical approach to drawing, but explanatory pictures can also be entertaining and aesthetically pleasing. Pictorial maps, exploded views of aircraft and ships, and bird's-eye views of cities and villages, can all be brought to life through the curiosity and skill of the artist. It is only by taking things apart and organizing them in a comprehensible way that we can truly see inside things.

This is perhaps not an area of illustration where it is particularly appropriate to talk in terms of technique, except to say that the need for clarity can sometimes dictate the use of clean line and flat color. The overriding importance of communicating the information rules out any indulgent or gratuitous mark making. The things that single out the specialist in this field are an appetite for research, design, and organization and a desire to make information exciting and visually digestible.

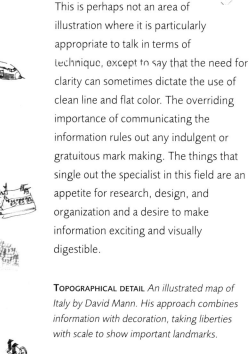

TOPOGRAPHICAL DETAIL *An illustrated map of Italy by David Mann. His approach combines information with decoration, taking liberties with scale to show important landmarks.*

MAPPING OUT THE STREETS *David Mann made an early sketch for a proposed aerial view of a covered market area. A pencil sketch was scanned into the computer and flat color added.*

IN AND AROUND THE SHUTTLE *These drawings come from a project designed to give the child a greater understanding of the make up of the space shuttle. It begins with very rough drawings as the artist "feels his way" around the subject, and is gradually crystallized into simple line and flat color shapes.*

An early sketch, produced on several large pieces of paper joined together, for a diagram of the Shuttle.

 A more complete color version of the Shuttle with further added cut-away information. Color is added through Adobe Photoshop.

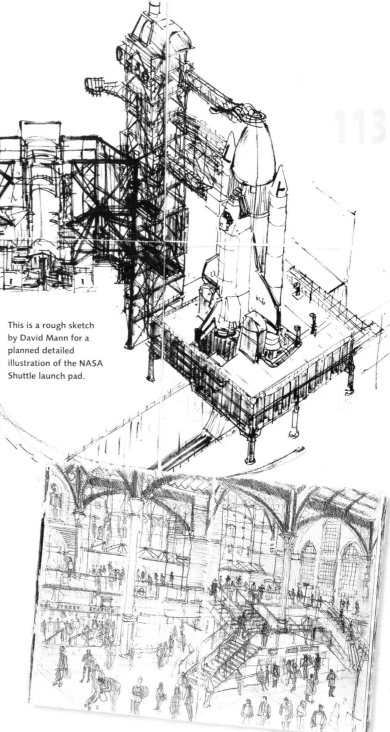

This is a rough sketch by David Mann for a planned detailed illustration of the NASA Shuttle launch pad.

Extensive and thorough research is of great importance with this kind of explanatory illustration. A range of reference sources is required if the artist is to make visible that which is usually unseen.

In a current student project that involves the "exploded" view of a railroad terminus, the intention is to show all the workings, not only the platforms, ticket offices, and restaurants, but the offices and loading bays that service the terminus. The work involves long hours of observational drawing inside and outside the building itself, to gain familiarity with the structure and workings of the space. Next comes a letter to the operators requesting information about the layout of the building and its history. The various strands of information are then pieced together to create a large-scale image of the terminus that will be informative, entertaining, and aesthetically pleasing.

GATHERING THE KNOWLEDGE *Working on location, David Mann builds up a thorough understanding of his subject through drawing in the sketchbook. He plans to create a pictorial explanation of the internal and external workings of the railroad terminus.*

checklist • learning through pictures • playing with words and letters • connecting shapes to letterforms • visualizing numbers

Nonfiction illustration

114

Alphabets, dictionaries, and counting books

Pictures can help children to become familiar with letterforms and words. Illustrated alphabets and dictionaries have played a leading role in children's book illustration throughout its history.

Some of the earliest chap books (see page 8) contained illustrated letterforms and, of course, further back in time medieval manuscripts were exquisitely decorated with illuminated letters. This is an area in which illustration is always in demand, and there is always the possibility of new approaches.

Alphabet books can be as simple in concept as "A is for Apple," and each artist will bring something new to the design and illustration. Or they can contain hidden clues and messages. Dictionaries for children have similarly used pictures in a variety of ways to help children make connections between the shapes of letters and the objects or concepts that they represent. In the book *Children Reading Pictures: Interpreting Visual Texts* by Evelyn Arizpe and Morag Styles, the authors' research contains a comment by Amy, aged five years. "I always remember pictures," she says. "I sometimes forget words." An illustrated dictionary can help to bridge this gap, and the responsibility on the artist is in some ways greater in this context, where the function

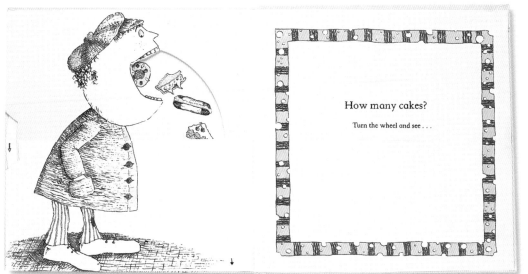

How many cakes?

Turn the wheel and see . . .

PLAYING WITH NUMBERS *Counting books can be made highly entertaining, as in Amanda Loverseed's* The Count-Around Counting Book.

ALPHABET BOOKS *An alphabet of rooms formed into the shape of the initial letter of the room name has been created by Kristin Roskifte. Illustrations such as these can be used to help children learn English by word/picture associations.*

of the image is explicit. Of course, if the pictures can delight, enchant, and amuse as well as inform, the likelihood of the child learning is that much greater.

In the *Oxford First Illustrated Dictionary*, compiled by Andrew Delahunty, Emma Chichester Clark rises to the challenge particularly well, providing an integrated design framework for the words on the page. This gives a visual counterpoint to the lists, the pictures varying from depictions of individual objects to busy scenes containing elements and objects whose definitions appear alongside. Six characters appear throughout the book, helping the reader to engage more intimately with the words.

Counting books play as big a part in the development of numeracy as alphabet books do in the development of literacy. By giving the child something visually stimulating to connect with numbers, you are engaging her instantly with the concept of counting. "Six smiling soldiers" or "ten talking tadpoles" are likely to be more interesting to the child than a mere set of counting sticks, and, of course, much more fun to draw!

MAKING CONNECTIONS *In these designs by Christine Hasledine, the connections between the shapes of the letters and the animal names or sounds, give children a playful introduction to the alphabet.*

Mazes and hidden treasure

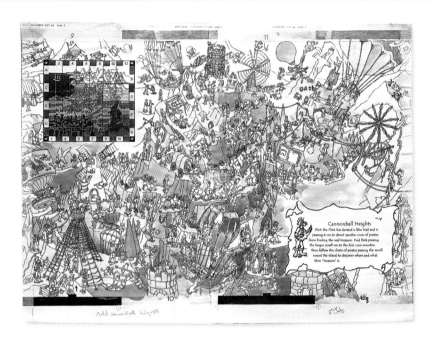

Anna Nilson uses photocopies of her line drawings to experiment with color. This allows for things to be adjusted before, rather than during, the final stages.

It takes a particular kind of mind to conceive and design the sort of complex visual puzzles that will keep children amused for hours. Anna Nilson's books bring together art and mathematics, and her book *Pirates* is the product of meticulous planning.

At art school, Anna Nilson was obsessed with life drawing. "I was insistent on what I wanted to learn, and spent most of my time drawing the figure, anatomy, and costume." After college she dabbled in freelance illustration, and went into teaching art in schools. She continued to draw, paint, and sculpt, with a strong bias toward analytical representation. A keen interest in the natural world eventually led to a position teaching natural history illustration. During this period, she led drawing trips to tropical regions of the world. A methodical and organized thinker,

Anna took a close look at the children's book scene and identified a niche in the problem-solving sector. She has come up with the concept for a number of books, some of which she illustrated herself. "I still find it strange to be referred to as an author. I am not sure what I am. Everything comes to me in visual form. My ideas start with images, which I draw, and the rest follows."

In the early 1990s Anna was commissioned to create *Terrormazia*, illustrated by Dom Mansell, a fascinating and complex maze game.

Pirates, aimed at children aged eight years and older, was both conceived and illustrated by Anna Nilson. "I have wanted to do something with maps for some time. I always loved hidden-treasure maps as a child so I thought, 'why don't I make this a map-reading book?'"

In this test sheet, a dip pen was used over the initial pencil line. The variation in line quality affected the all-important readability, so this approach was rejected.

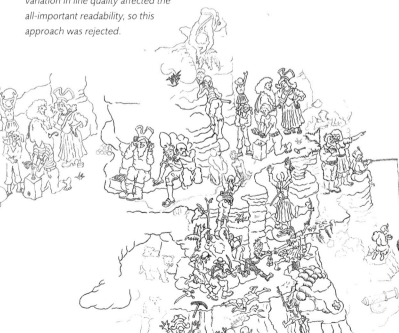

Anna's working method involves designing everything in miniature initially. "I needed to work out how I could divide a giant map up into 12 spreads." Each spread of the book is in the form of a complex and densely populated scene, each of which forms a section of a larger map. "There was a perspective problem, of course, as things flatten out as they recede into the distance. Another issue was whether or not I could give each page its own color identity without it seeming as if it wasn't part of the whole."

METICULOUS PLANNING

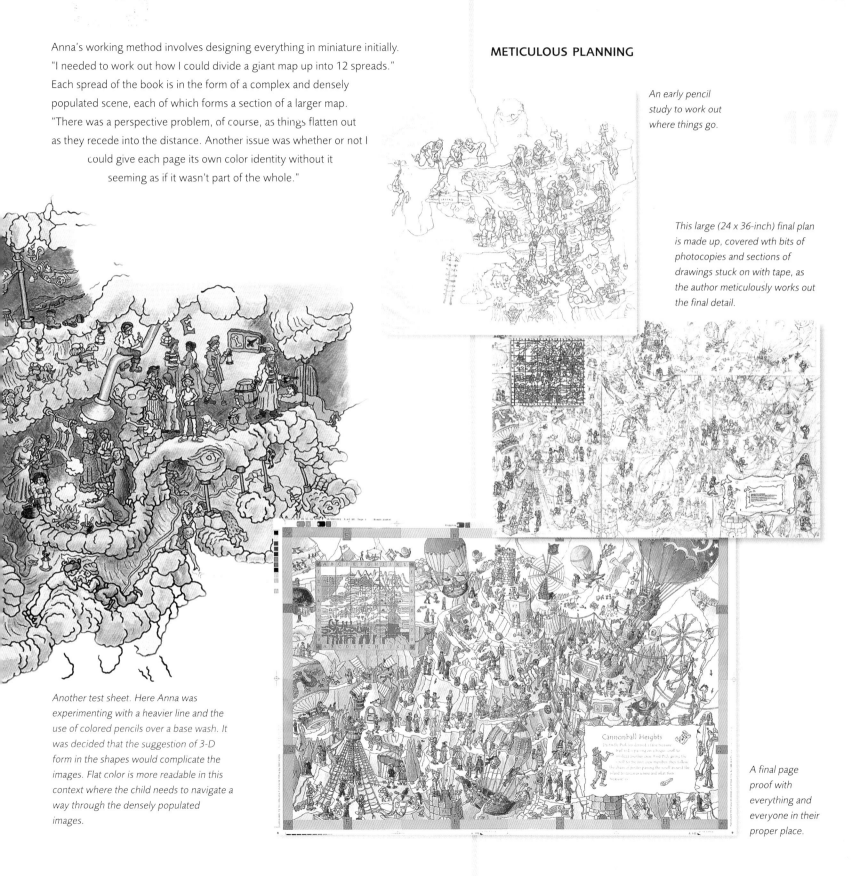

An early pencil study to work out where things go.

This large (24 x 36-inch) final plan is made up, covered wth bits of photocopies and sections of drawings stuck on with tape, as the author meticulously works out the final detail.

Another test sheet. Here Anna was experimenting with a heavier line and the use of colored pencils over a base wash. It was decided that the suggestion of 3-D form in the shapes would complicate the images. Flat color is more readable in this context where the child needs to navigate a way through the densely populated images.

A final page proof with everything and everyone in their proper place.

checklist • dynamics of shapes • layout • type/image balance • type as image • aesthetics • format

Introduction

A well-designed book offers an all-round aesthetic experience, something that it is good to behold even before you have properly explored its contents. Careful consideration must be given to all aspects of the layout of a page.

A few decades ago, people were less familiar with the term "graphic designer" (first coined, I believe, by the great American designer and illustrator, William Addison Dwiggins) than they are today. It is the graphic designer's job to bring all the visual and textual elements of the book into a coherent, aesthetically pleasing whole. When an illustrator is working on a book for a publisher there will be, or should be, a close working relationship with the designer. In picture books an illustrator/author is likely to have a clear idea about how the book should look as a whole. Increasingly the design, typography, and illustration of a picture book are inseparable, and often conceived by one person.

When the text is hand rendered, or printed in colors over the image, text and image can become one, with exciting results.

JACK'S BEAN PROBLEM

INTEGRATION On this page, designer and illustrator decide to use the block of text as a shape that supports the giant's weight, wittily crushing the first few words underfoot.

SUBVERSION *In The Stinky Cheese Man and Other Fairly Stupid Tales, designer Molly Leach, writer Jon Scieszka, and artist Lane Smith subvert all the usual rules as image, text, and design converge to create meaning.*

—J.S. & L.S.
(your name here)

This book is dedicated to our close, personal, special friend:

I know. I know. The page is upside down. I meant to do that. Who ever looks at that dedication stuff anyhow? If you really want to read it—you can always stand on your head.

GRAPHIC EFFECT *In this digitally created double-page spread by Debbie Stephens, colors and shapes are used primarily for their graphic effect on the page.*

This presents problems for the publisher however, because it usually rules out the possibility of translating the text into other languages. So, as a rule, text is printed separately in black so that it can be reprinted over an image when it is translated.

Good design extends to much more than choice of typeface. At every stage of the book's development, one needs to think about how best the design can seamlessly integrate the various elements. In picture books, design and content can sometimes become inseparable, as in the anarchic dialog between the characters and the page itself in Lane Smith and Jon Scieszka's *The Stinky Cheeseman and other Fairly Stupid Tales*, designed by Molly Leach.

At the other end of the spectrum, demonstrating a more traditional but no less satisfying approach is *The Cockerel and the Fox*, retold and illustrated by Helen Ward. This is a typically handsome production from a publishing house that clearly cares about all-round production values and book design. Helen Ward's illustrations are strongly design led, with careful attention given to the shapes that various elements make against the white of the paper (see overleaf).

MOBILE TEXT *Lisa Evans makes a sweeping dynamic composition of image and text with a spread from her student project,* The Fantastic Fire Fluff Monster.

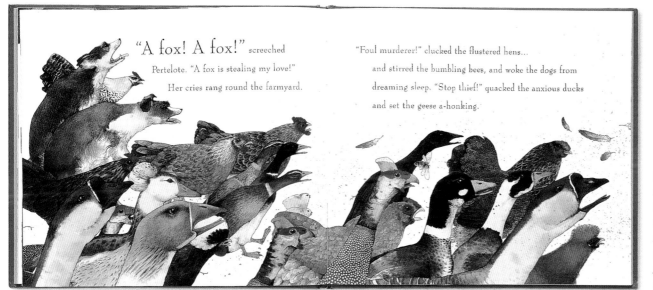

"A fox! A fox!" screeched Pertelote. "A fox is stealing my love!" Her cries rang round the farmyard.

"Foul murderer!" clucked the flustered hens... and stirred the bumbling bees, and woke the dogs from dreaming sleep. "Stop thief!" quacked the anxious ducks and set the geese a-honking.

SHAPES ON THE PAGE *The strong left to right dynamic of this page from Helen Ward's* The Cockerel and the Fox *creates a vibrant momentum and sense of expectation. The pure white of the paper as a background gives greater strength and impact to the shapes on the page.*

Design and typography

120 Dynamics of composition and layout

The arrangement of shapes across a double page spread plays a key role in the way we read a pictorial sequence, both in terms of directing the eye and aesthetic balance.

Exploiting the format By facing right to left the fox contradicts the visual flow of the book and becomes more threatening. The landscape format of the spread is thoroughly exploited, with every inch considered in terms of its graphic potential. The russet color of the fox and the terra verte of the cabbages are beautifully complementary.

In *The Cockerel and the Fox*, a predominant left to right dynamic carries us through the book until the final spread as the fox gets his comeuppance. Helen Ward explains that a mutual respect has grown between designer and illustrator as they have worked together. "I trust him to choose the typeface," she told me. She develops her page designs with a strong sense of where the text will need to be positioned.

This is something that student illustrators often overlook. Helen Ward's double-page spread designs are a particularly good example of a meticulous attention to arrangement. It is quite unusual to see such a fundamentally traditional or realist approach to illustration

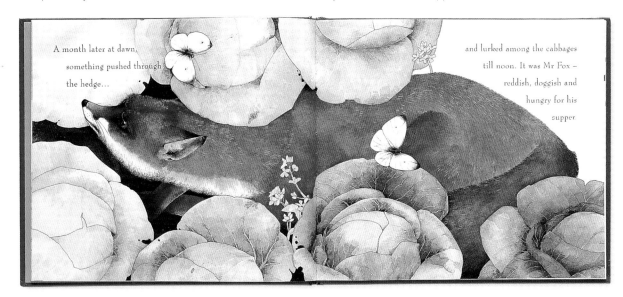

A month later at dawn, something pushed through the hedge...

and lurked among the cabbages till noon. It was Mr Fox – reddish, doggish and hungry for his supper.

Shapes on a page Helen Ward's meticulous preliminary pencil studies show an equal attention to the positive and negative shapes on the page. These drawings are designs as much as they are representations of scenes. The artist's exquisite draftsmanship reflects a thorough understanding of the animals' anatomies to draw them convincingly from a range of angles and viewpoints.

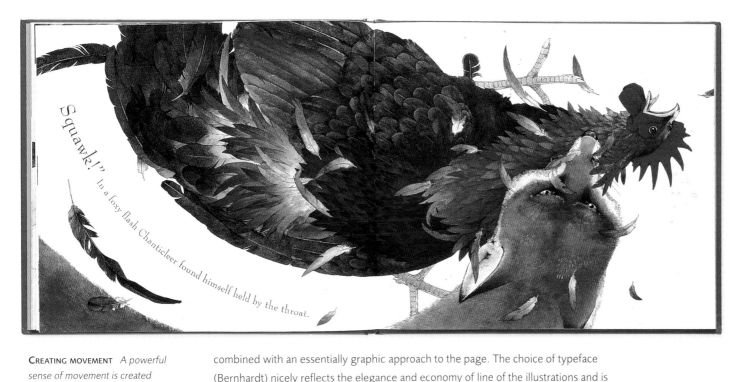

"Squawk!" In a foxy flash Chanticleer found himself held by the throat.

CREATING MOVEMENT *A powerful sense of movement is created across the pages as the text follows the arch of the cockerel's back.*

combined with an essentially graphic approach to the page. The choice of typeface (Bernhardt) nicely reflects the elegance and economy of line of the illustrations and is of a weight that doesn't overpower the delicate watercolors. A bolder and weightier version of the same face is used to emphasize the occasional word or phrase. The book itself is bound in a matte *terra verte* green paper with a small chicken-wire motif printed in black in the center. The illustrated dust jacket is predominantly colored in a complementary burgundy, with a matte surface around the edges, and spot-laminated with gloss in the vignetted illustration.

REAL SPACE AND PICTURE SPACE
In A Trail of Feathers *by Hannah Webb and Paula Metcalf (a collaborative student project) landscape format compositions are considered in terms of their representations of real space, and their design as shapes in harmony with the type on the page. In each design the artist has created a convincing space that also acts as frame for the line of text.*

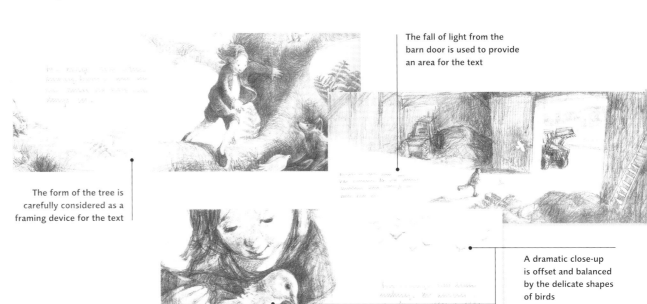

The fall of light from the barn door is used to provide an area for the text

The form of the tree is carefully considered as a framing device for the text

A dramatic close-up is offset and balanced by the delicate shapes of birds

Design and typography

122 A concern for design

As with all things visual, the look and feel of children's books evolves and grows over time. Many illustrators now demand a close involvement with the overall design and production of their books.

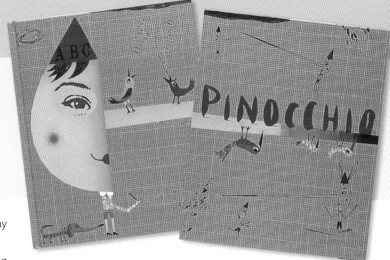

Most publishers will say that they care deeply about the way that their books are designed and produced, but of course approaches and standards vary greatly. Individual publishing houses gain particular reputations for the visual quality of their output, and sometimes it can be the smaller, independent companies who set the pace in this area. Where the publisher is working to comparatively small sales projections, there is perhaps greater latitude for innovation in design and illustration. Looking around the Bologna Children's Book Fair (see page 127) it is possible to find all sorts of exciting and unexpected approaches to design from countries around the world. If you are interested in taking a more idiosyncratic and authorial approach to the overall production of a book, you might try approaching one of these smaller companies.

SLIPCASE *Sara Fanelli's sumptuous production of Pinocchio features a slipcase that cleverly lengthens our hero's nose as the book is taken out.*

TEXT AS TEXTURE *In this spread from Les Petits Héritages, Frédérique Bertrand cleverly uses text to create the textures of the sweater.*

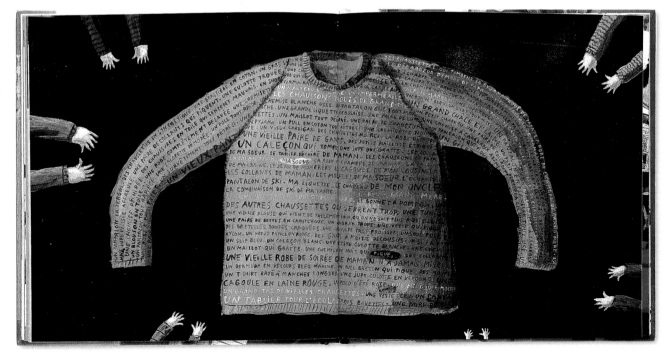

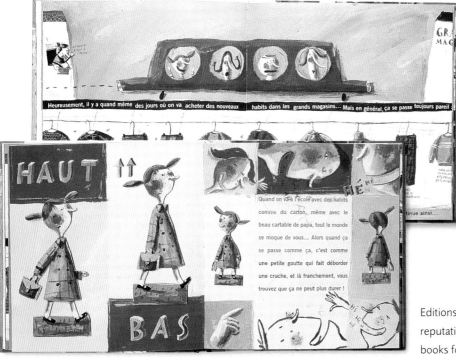

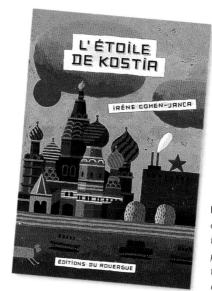

BLOCKS *Jochen Gerner's cover for L'Etoile de Kostia features panels of hand-painted titles that reflect the flat, geometric shapes of the image.*

DESIGN AND COLOR *An exuberant design and harmonious use of color make this spread a joy to look at aesthetically, while being easy to follow for the child. Hand-rendered text and haphazardly laid out sans-serif type seem to co-exist comfortably on this spread.*

Editions du Rouergue, a publisher based in Southern France, has gained a reputation among illustrators and designers for high quality illustrated books for children. Editor Cécile Emeraud explained that when the company first began to publish for children in the mid 1980s, its distinctive approach to pictures was regarded with much suspicion. Now, of course, the company's books are much imitated. The first book that Rouergue produced was illustrated by an artist who submitted samples of work speculatively, and this has encouraged them to ensure that all such submissions are carefully looked at. Many of the books demonstrate the use of hand-rendered text integrated into the pictorial design. For many publishers, this approach would have to be ruled out because of translation difficulties, but it can bring a real vitality to the page if the illustrator is sensitive to design and composition. Where an artist stamps a highly personal and individual approach to design on a book, it can become a more satisfying object. The choice of paper for the production of a book will have a noticeable bearing on its "feel." The artist should have a view on what weight of paper should be used for the pages, whether the cover boards would be best served by a matte or laminated coating, and any other decisions that impact on the visual and tactile quality of the book.

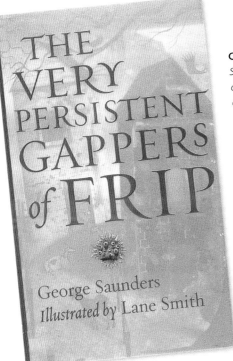

COLLABORATION *Lane Smith works closely with designer Molly Leach to create attractive, stylish books. Here a transparent vellum dust jacket carries the titles and gives a glimpse of the illustrated boards.*

PUSHING THE BOUNDARIES *Øyvind Torseter's freewheeling, abstract* Mister Random *is published in Editions du Rouergue's innovative Touzazimute series, "...a space reserved for illustrators' self-expression, aimed at the widest possible audience but rarely granted an outlet in the press or media."*

124 Type as image

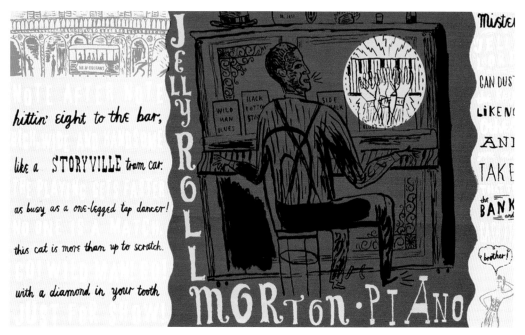

Word and image are inseparable elements of an integrated design in this typical design for a spread from Jonny Hannah's Jazz.

Artists who illustrate children's books are likely to be working on a range of other creative projects at the same time—for example, editorial work for magazines, exhibitions, and so on. When an artist with as broad a range of activity as Jonny Hannah decided to create a children's book, it was always going to be groundbreaking.

Jonny Hannah has enjoyed considerable success as a graphic artist since his graduation in 1999. His distinctive illustrative work has appeared in national and international publications, in editorial, design, and advertising fields. He has a sharp interest in hand-rendered typography and traditional print processes.

The story of the book *Jazz* is one of a long journey with many twists and turns. The original idea was for a story loosely based around a group of characters in a block of apartments, one of whom is a piano player. Although Jonny's visual work was much admired, this idea became overworked and somehow never quite came together. He says that he was naive about children's books, thinking more or less

that "anything would do," and speaks highly of the publishers' help and the level of trust they have placed in him. Walker Books' Managing Director, David Lloyd, suggested a book on the theme of jazz. The two, along with designer Deirdre MacDermot, began a creative dialog aimed at making a beautiful book that would ignite in children an interest in music. The result is a piece of design, in which word and image fuse seamlessly into one. Once again, it wasn't all plain sailing. "Initially," says Jonny, "I put words into the mouths of the musicians; they were doing the speaking. I became uneasy about this. It felt presumptuous, somehow. Then we thought, 'let's give it some rhythm,' and I went away and wrote it as a sort of jazz poem. It wasn't easy to do. I brought it in and sat down with David and the editor, Maria Budd, and thrashed it out."

As the text and image became increasingly one and the same thing, Jonny's hand-rendered type being such an integral part of each page, it became clear that non-English language editions were not going to be possible. To the publisher's credit, it seems that sheer faith in the project and in the abilities of the artist, author, and designer have produced a beautifully designed book.

The question arises about whether such a sophisticated piece of design will appeal to children. Genuine research is needed to determine how children respond to different pictorial and design idioms, as there are too many preconceptions about what children like. Jonny Hannah very much hopes that the book does work for children. "I think there is also

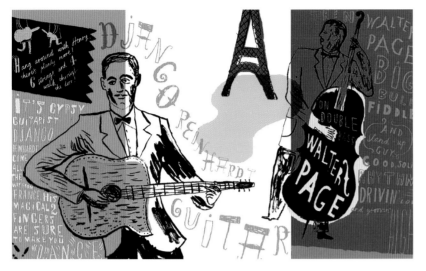

Colloquial speech and image are experienced simultaneously by the reader in a "read-aloud" format that races along enthusiastically in a blaze of color and musicality.

a perception that jazz music is a bit inaccessible even for adults," he says, "but it's just pop music, really—it's all about having fun, having a good time. I hope that children can find a way in through the characters and through the rhythms and sounds of the words, which are often onomatopoeic. I'd love it if the book encouraged some children to listen to jazz music."

ECLECTIC INFLUENCES

All artists are influenced by the work of others and various movements in art and design. Good influences are absorbed and processed, helping to form the unique you. Many of Jonny Hannah's interests in American music, writing, and graphic art of the 1940s, 1950s, and 1960s have influenced his work: Blue Note jazz music covers, the writings of Charles Bukowski, the designs of David Stone Martin and Ben Shahn, the limitations of letterpress printing.

The cover design for Jazz. Jonny Hannah has cleverly incorporated the titles into the label of an old 78 rpm vinyl record album.

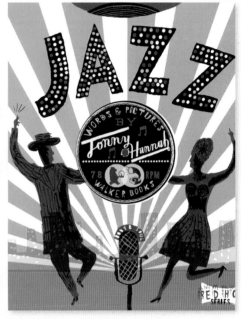

These two sketches were made for Jonny Hannah's original children's book concept, which was based on a group of characters living in a block of apartments.

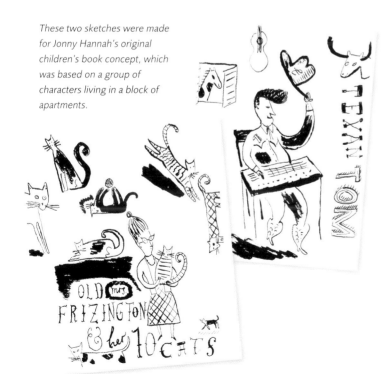

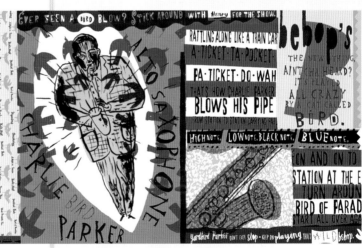

A frenzy of word and image that demonstrates the author's periods of influence, while at the same time feeling thoroughly modern.

checklist • researching the market • presenting yourself • artists' agents • personal contacts • contracts and money

Introduction

Having worked hard on all the various skills and approaches covered in this book, the moment comes when you are ready to approach a children's book publisher and test their response to your work. Have you done your research? Are you ready?

You will no doubt have come across those frightening texts, usually written by art directors and editors, with statements along the lines of, "It doesn't matter how brilliant you are—you won't get any work unless you present yourself in a professional manner." Illustrators are not generally born self-promoters, being happier to get on with the work they love to do. Nobody ever seems to point out the other side of the coin, which is that no matter how well you market yourself it won't be much use if the work isn't very good.

Nevertheless, it is important to give yourself the best chance of success by looking at matters from a busy editor's or art director's point of view. Children's book illustration is a highly competitive field. Each year an army of eager art graduates is unleashed on the market place, not to mention the

number of untrained people of all ages with talent in this area who wish to bring the good news to the publishing world. So it is unreasonable to expect editors to have lots of time to spare to pour over unsolicited samples, dummies, and portfolios. It is less likely that a face-to-face portfolio presentation can be scheduled at the top children's book publishers. It has to be said, that levels of visual literacy among publishing employees who could be the first point of contact, do vary enormously. It often comes as a surprise to graduates to find that, after three years of critical dialog within an art school environment, feedback from potential commissioners is not so illuminating or perceptive. The fact that those sitting "in judgment" are, by and

SCAN THE SHELVES *Time spent in book shops researching who's publishing what is time well spent.*

large, not art trained may also come as a shock, and it is as well to be prepared for the inevitable "brighten your colors and make your characters more appealing and cute."

KNOW YOUR MARKET You must research the market. If you are serious about what you do, you will have a deep interest in the history of the subject—the

children's books of the past—and in the climate and trends of the present. Although it is important to have a sense of what is contemporary, it is even more important not to be captive to it. At any time in the past, there have been books on the shelves by artists with long and glorious careers behind them alongside books by young artists who may or may not have gone the distance.

Check out who is publishing what. Every publishing house has its own approach or leaning, and it is a waste of everyone's time to submit entirely inappropriate work to a particular publisher. Conversely, if you are able to demonstrate a thorough knowledge of the books published by a company that you have approached, it will impress and reassure everyone that you are serious.

There is, of course, the "Catch 22" syndrome when publishers want to know if you have been published by another company before they decide to take a risk themselves. This is extremely common. A student returned from a meeting at a leading publishing house to discuss her new picture book roughs, and related how the entire atmosphere of the meeting changed when she casually mentioned that she had written and illustrated a published picture book. The responses to her ideas were instantly more positive and respectful. This is to be expected, so it is necessary to project professionalism in order to secure that all-important first commission.

In a busy and very competitive field, a personal introduction goes a long way. You may have an instructor who has contacts, and his or her recommendation may make a big difference. If you are creating your own picture books, a well-presented dummy sent to an identified editor with an accompanying

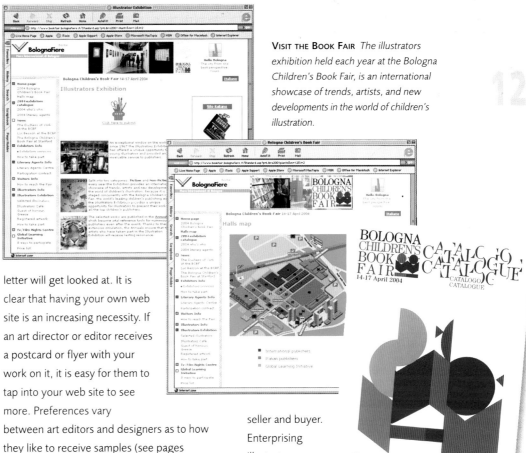

VISIT THE BOOK FAIR The illustrators exhibition held each year at the Bologna Children's Book Fair, is an international showcase of trends, artists, and new developments in the world of children's illustration.

127

letter will get looked at. It is clear that having your own web site is an increasing necessity. If an art director or editor receives a postcard or flyer with your work on it, it is easy for them to tap into your web site to see more. Preferences vary between art editors and designers as to how they like to receive samples (see pages 132–133).

BOLOGNA CHILDREN'S BOOK FAIR

Each year in early April, the world of children's book publishing descends on the northern Italian city of Bologna for a feverish few days of trading. Deals are struck, or at least nurtured, between sales directors and publishers from North America and Europe and from the southern hemisphere. For many publishers it is essential their books sell worldwide for translation into other languages to make the economics of production work. Foreign editions are known as co-editions, and account for the majority of the sales of a book.

A stroll around the cavernous conference halls of Bologna reveals meetings between

seller and buyer. Enterprising illustrators may choose to make a visit to show their portfolio around, taking the golden opportunity when all the publishers are in one place at the same time.

As well as trading, there is a program of lectures and presentations from top illustrators, writers, and publishers, and an exhibition of selected illustration work in fiction and nonfiction. The work in this exhibition is chosen from entries to the Fair's annual competition, the deadline for which is normally mid-November. Work submitted may be either unpublished or published, but must have been created in the year of entry.

Professional approaches

If you present yourself in a professional manner, it is more likely that others will have confidence in you. In children's books publishing, getting along well with the people you are working with is particularly important.

After all, unlike the world of the one-off editorial illustration, a 32-page book means a close working relationship between editor and artist for a considerable period of time. So if you are to get work, the designer or editor is going to want to be reassured that you are organized, reliable, and pleasant to work with.

These qualities will need to be projected from the outset in a competitive market.

PREPARING YOUR PORTFOLIO

A neat, well-presented portfolio of work is essential. It should be a manageable size. No one is going to want a huge folder thrown on the office desk, and besides, children's books are usually small,

and samples of work are best displayed at an appropriate scale. If your original artwork is large, you should get good quality small-scale prints made. Don't put too much work in. You may have a dummy book to show if you are presenting an idea, and alongside that a couple of finished spreads. Samples of illustration work as a general guide to what you do need not exceed eight sleeves (16 sides). Never put anything in the portfolio that you are not happy with or are unsure about. The golden rule is to leave it out if you have any doubts. There is nothing worse from the publisher's point of view than being told, "Oh I really hate that one" or, "I don't work like that anymore."

PORTFOLIOS *A simple, neat, and not overloaded portfolio makes life easier for the acquisitions editor.*

When preparing a portfolio try to vary the pace of the pages, showing work in different formats and different styles.

PROMOTIONAL MATERIAL Printed postcards showing samples of your work can be produced quite inexpensively and will be most effective in keeping your work under the art director's eye.

If you care about your presentation, you will want to have your own letterhead. This may be a simple, sober, purely typographic design, or illustrated, and that will depend on your temperament and taste. This can be augmented by a "With compliments" slip and personalized invoice. Web sites are important as a promotional tool, and you may want to set one up so you can direct people to view it at their leisure. Some publishers only want to view illustrators' work through web sites; others prefer sample material provided as hard copy, mailed to them with accompanying contact information (see page 133).

SELF-PROMOTION Business cards and brochures that are big enough to show a selection of work, yet small enough to be pinned up, or filed for easy reference, make the best "calling" cards. A well-presented and attractive letterhead will give a good impression. Be sure your name and contact details are prominent.

WEB SITES Art editors vary in their preferences, but it is clear that a web site is becoming an increasing advantage for the illustrator. This one, belonging to Katherina Manolessou (www.lemoneyed.com) is easy to navigate and richly colorful.

Getting published · Professional approaches

ARTISTS' AGENTS *Stereotypical images of the pros and cons of engaging with an agent suggest the differing opinions based on varying personal experiences.*

ARTISTS' AGENTS Many children's book illustrators and illustrator/authors choose to be represented and promoted by agents. Many choose not to. What are agents? Should you have one?

In reality, the choice may not be yours, as it should not be assumed an agent will take you on. He or she needs to be sure that they can get you commissions, and thereby earn them money and keep both parties happy. Essentially, an agent represents a number of artists (and, in the case of literary agents, authors), and endeavors to secure commissions for them. The agent takes a percentage of the overall fee from the commissioner for providing this service.

Artists' agents, as the name suggests, deal with commissioned art. They represent a number of illustrators (the number varies greatly from one agency to another), and will compete in the market place on behalf of their artists. They will be looking for work in the worlds of advertising, design, magazines, and children's book publishing.

Agents will typically charge between 25 and 33 percent of the commission fee for their work. Generally speaking, the agency will do

its best to promote the work of an illustrator and to negotiate as high a fee as possible—it is as much in their interest as it is in the illustrators'.

Artists may not be natural business people, and it takes a great deal of courage and confidence to put a realistic value on your own work and to hold out for a higher figure. It is all too easy to accept what might be a derisory fee, especially when you are just starting out on your career. So a third party, with good business sense and without the handicap of being the creator of the work, is likely to be able to negotiate a fee that is high enough to compensate for the percentage that is lost to them.

Contractual agreements between artists and agents vary. Some artists' agents operate without contracts, working on the basis of trust. It is important that the artist and agent agree on whether the agent should take a cut on all the artist's commissions or on only certain areas of work. Good communication is essential if trust is to be maintained.

Some commissioners of illustrations prefer not to deal with agents, feeling that they come between the designer or editor and

the artist. There will always be a full range of opinions on the pros and cons of agents, depending on personal perspectives and experience. At one extreme they are the stereotypical sharks, and at the other they may prove to be guardian angels. Many author/illustrators have very close and supportive relationships with their agents and some will cite their contributions as having a major positive influence on the development of their careers, professionally and artistically.

You will need to establish yourself before an agent will agree to take you on (although some are good talent spotters and regular visitors to graduation shows). This will give you a chance to get to know the business firsthand.

To be proactive in securing yourself an agent, there are a host of web sites to be sourced via search engines, although a recommendation is the route of choice.

LAWS OF COPYRIGHT Ideas themselves cannot be copyrighted, but how you express your ideas can. As soon as you draw, write, or compose something in some tangible form, the idea in its tangible form is copyrighted and you are the holder. Although you do not need to register your

copyright to have it protected, no action for infringement of copyright can be undertaken unless the copyright of a work is registered. So you can send your work to an editor for consideration without registering the copyright, and then have the publisher acknowledge the copyright in your name when the book is published.

When a work is published, a copyright notice should appear in all copies publicly distributed. It must include either the symbol or the word "copyright," the year of publication, and the name of the copyright owner. Within three months of publication of such work, the copyright owner or the owner of the exclusive right of publication must deposit within the Copyright Office two complete copies of the work for the use of the Library of Congress. Publication without a notice or with an incorrect notice will not automatically invalidate the copyright or affect the ownership. However, any error or omission should be corrected as soon as possible to prevent the eventual loss of protection.

ARTWORK FOR REPRODUCTION

When creating illustrations for reproduction, there are key things to remember about the presentation of artwork. Most original artwork is laser scanned on a cylindrical drum. This means your image has to be taped down onto a drum with the image facing outward, so you need to leave white space (about 2 inches / 5 cm) around the edge of the image.

Full bleed is the term used when an image in a book goes right to the edge of the paper. When preparing your original, be sure you continue the image beyond the actual size of the page and provide trim marks to show the edge of the page. If you

choose to work larger than the actual reproduction size, make sure that all your originals are produced proportionally to the same degree of enlargement, i.e., half-up or quarter-up in size.

If you have produced your illustration digitally you will need to prepare it for submission as a TIFF or JPEG which can be e-mailed or provided on disk. By either method, the document will need to be at least 300 dpi (dots per inch). Always check with the art editor first. You may choose to

REPRODUCTION TERMINOLOGY The style or accuracy of the illustration will determine how much bigger the artwork should be. The diagonal line is an easy way to scale artwork up or down as the ratio of the vertical to the horizontal remains the same. Illustrations are usually drawn larger than the actual size required.

provide a printout for the reproduction house to be able to match color accurately.

When delivering artwork, label the work clearly on the back or on a protective overlay:
1. Title of book and publisher
2. Chapter or page reference
3. The size or proportion for reproduction, e.g., s/s (same size) or half-up
4. Your name and contact information

Be sure the artwork is securely packaged with cardboard, and if it is not to be delivered by hand, use a courier or mail service that will insure and record delivery.

Trim marks to show where the edge of the page will be cut

Getting published

The publisher's view

A question prospective students frequently ask when applying for a place in an illustration course is, "What do you want to see in my portfolio at the interview?" The answer is "surprises." But what do publishers want to see from aspiring children's book illustrators?

Louise Power and Jemima Lumley are both highly experienced acquistioners of illustration for children's books. Louise has 25 years' experience of working with

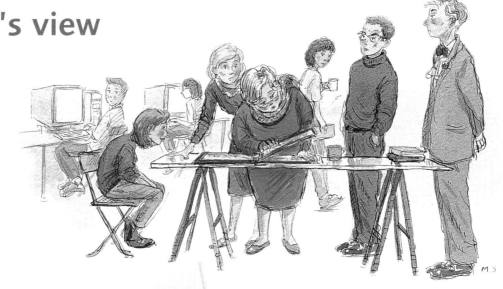

illustration and illustrators as Art Consultant with Walker Books. Jemima Lumley is Associate Art Director with Orchard Books, part of the Franklin Watts group. Their preferred method of approach from aspiring illustrators is to receive a few color photocopies or printouts of sample work, accompanied by a letter that demonstrates the sender knows something about the company he or she is approaching and what it publishes. In other words, the same standard letter sent to dozens of completely different publishing houses is not acceptable. "If you can mention some of our company's books you have seen and admire, all the better," says Jemima. "A little flattery does no harm!"

Patricia Whyte

From: Dean Bassinger
Sent: Friday, June 20, 2004 3:34 PM
To: Patricia Whyte
Subject:

HI PAT

ATTACHED ARE SOME SAMPLES OF MY WORK WHICH I'D LIKE YOU TO CONSIDER AND LET ME KNOW IF YOU HAVE ANY COMMISSIONS YOU WISH ME TO UNDERTAKE.

THERE ARE 10 JPEGS. IF YOU HAVE ANY PROBLEMS VIEWING THESE, DO LET ME KNOW BECAUSE I CAN SEND YOU TIFFS, OR EVEN PROVIDE MY SAMPLES ON CD. I JUST NEED TO HEAR WHETHER YOU CAN ACCESS THESE OR NOT.

I THINK YOU WILL LIKE MY IDEAS, AND I HAVE LOTS MORE. I AM JUST IN THE MIDDLE OF GETTING A WEBSITE TOGETHER AND THEN I CAN LET YOU KNOW SO YOU CAN VIEW EVEN MORE OF MY WORK.

I WILL ALSO SOON BE SORTING OUT MY AGREEMENT WITH AN ARTISTS' AGENT, AND THEN I CAN LET YOU HAVE MY DETAILS. YOU WILL SEE THAT I AM KEEN TO WORK WITH YOUR BOOK COMPANY ESPECIALLY BECAUSE YOU HAVE IMAGES THAT ARE VERY SIMILAR TO MY STYLE AND I THINK YOU WOULD BENEFIT FROM WORKING WITH ME.

ONE OF MY FIRST QUESTIONS WOULD BE ABOUT YOUR TERMS AND COPYRIGHT.

I HOPE TO HEAR FROM YOU SOON

BEST WISHES

DEAN BASSINGER

artwork samples 1 artwork samples 2

MAKING THE WRONG IMPRESSION *A rambling e-mail attaching sample work will force itself on the hapless recipient. This one is likely to antagonize and irritate, rather than attract an invitation or commission, and is destined for the trash can.*

In order to find the name of the person who acquires art in a particular company, check the web site or phone to ask. He or she may be "Art Director" or "Acquisitions Editor." Louise says that if she likes the samples that are sent, she will invite the artist in to see more work and to get to know him or her. She prefers not to have work sent electronically. "Someone telephoned the other day and said, 'Can you have a look at my web site?' In some ways, children's publishing is quite old fashioned: Personal contact is still important." Jemima will look at work sent by e-mail, but also feels that this can be time-consuming (views on this vary greatly between publishers, so it is important to check first).

Everyone seems to agree about the importance of personal contact. If a project goes ahead, the artist will be working closely with the publisher for anything from a few months to a couple of years. "The chemistry has to be right," says Jemima. "And the artist has to be able to take advice or criticism. Sometimes you offer advice and you see the barriers go up immediately; so you think, how will this person be if we work together?"

Louise echoes these views, "You can't be too precious," she says. "If you send in a dummy book you shouldn't do too much finished work at that stage but just

enough to get over the idea and perhaps one finished piece. The publisher is going to have a big say in the format and design if it goes ahead, so you would have to re-do much of it. Some artists are naturally good designers and others are not."

Jemima Lumley and Louise Power both feel it should be possible for illustrators to be flexible and open to suggestion without necessarily compromising their integrity as artists. Clearly, in a competitive field, what is required is a combination of good work, sound research into the market, and the ability to get along with people.

HOW TO APPROACH A PUBLISHER *A simple, straightforward covering letter encloses samples. It is well set out and care has been taken to get the details right, even down to supplying return mailing material.*

The artist has done the research and ascertained the name, position, and correct spelling of the addressee

A simple reminder of a recent meeting that is quickly followed up

The existence of a web site is advised, enabling the Art Director to see more as desired

Contact details are immediately accessible

4488 Mandy Way
Hill Valley
CA 94941
Tel: 415-384-5368
email: deabs@yahoo.com

June 20, 2004

Patricia Whyte
Art Director, Children's Books,
Finest Book Publishing
909 Liondale
Philadelphia, PA 404321

Dear Ms Whyte

It was a pleasure to meet at our recent graduation exhibition, and I thank you for your interest in my illustrations.

I am pleased to enclose some samples of my recent work, and would be most grateful if you would consider me for future illustration commissions. My web site *www.mandyway.com* provides an opportunity to view further material.

It would be appreciated if you could return my samples in due course, and I have enclosed return mailings for this purpose.

I look forward to hearing from you.

Yours sincerely,

D. Bassinger

Dean Bassinger

Contracts and money

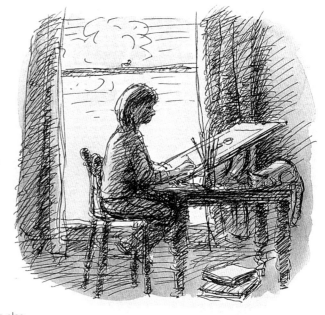

Publishers will have a set budget for the acquisition of artwork. This occasionally is negotiable. When you are just starting your career as an illustrator, the fee offered may seem more than reasonable, but it is important to consider the amount per illustration, how much time you will need to spend on research, the cost of materials, and so on. If you are asked to quote for the job yourself, remember that you may have an opportunity to come down from the fee you quoted, but you will never be able to go up.

If you are commissioned to do "work for hire"–that is a one-time illustration, you would not normally sign a full contract, but instead be given a purchase order. You must make sure you receive a written document. A purchase order may vary from publisher to publisher in the manner it lays out terms and conditions of the assignment.

You should always try to retain ownership/copyright of the original illustrations, and only sell a license to the publisher to reproduce them. Retaining ownership of the originals means that you have the option to sell them at a later date should you wish to do so. There is a growing market for original illustrations, and their value is increasingly recognized. Publishers, though, will normally insist that you make the originals available to them for about three years.

Owning copyright means that future income from use of the work will be yours, and your family's, until 75 years after your death.

Be sure you understand what rights you are assigning to the publisher, i.e., whether you are assigning them the right to reproduce the images in one publication only or whether you are also assigning the right to re-use the images in other books with no further payment.

THE CONTRACT If you are the author/illustrator of a picture book, the contract will be more complex. You will be offered an advance against royalties. What this means is that the advance is set against a certain projected number of sales, at which point the advance will be paid off and you begin to receive royalty payments on further sales. These amounts vary but if you are author and illustrator they are about 10 percent of the retail price of each book in the case of a hardback, and 5 percent on paperbacks (illustrator alone, expect about 5 percent for hardback sales). This usually applies only to home trade sales at a discount of 50 percent or less; high-discount home sales, foreign editions/bookclub sales, etc., are usually a percentage of the money the publisher receives, rather than a percentage of the retail price.

It is possible the book will not sell enough copies for you to begin to receive a royalty, but you will not have to pay the advance back whatever the outcome.

If you accept the offer made to you, then, and only then, will you be presented with a contract. Check any option clauses that might commit you to showing your next work to the same publisher, which is usually included to protect their investment in you. Also, look out for details of what happens if the company closes up or if the book goes out of print. If in doubt, ask, or refer to organizations that give legal advice.

If the book does well, your next advance is likely to be higher or you may be offered a two-book deal. Before you know it, you will be earning a living at one of the most enjoyable, rewarding, and meaningful forms of artistic endeavor imaginable.

GETTING PAID *A purchase order is a legal document laying out the rights and duties of both publisher and commissioned supplier. You will be expected to sign the purchase order and return it with an invoice when the work is complete.*

PURCHASE ORDER FOR CREATIVE WORK

THIS PURCHASE ORDER DOES NOT ACT AS AN INVOICE. PLEASE INVOICE WHEN THE WORK IS COMPLETED

TO:

PROJECT TITLE:

RETURN TO:

DATE:

DESCRIPTION OF WORK:

BOOK CODE:

DELIVER BY:
(Failure to deliver the work on time or in accordance with the above brief may result in a reduction in or cancellation of the agreed fee).

AGREED FEE:

In consideration of the abovementioned fee paid by Finest Book Publishing to me on del... acceptance of the work described above, I hereby grant to Finest Book Publ:... non-exclusive license in the said work for the full period of conv... Finest Book Publishing agrees to credit me as the orig... original, has not previously been published... way a violation or an infringem... Publishing against ... Finest B...

SIGNA

SIGNEL
FINEST

Please sign :

FIN

Return to: the name of the publisher's employee for all submissions on the assignment

Description of work: the written brief for the supplier which may precis briefing meetings

Deliver by: the required deadline for finished illustrations

Conditions: check the small print for the terms of copyright and/or ownership in the finished artwork

Signatures: the supplier signs first, and the publisher countersigns

Book code: designated by the publisher for accounting purposes. It must be quoted in all correspondence or invoicing in connection with the assignment

INVOICE

Dean Bassinger
4488 Mandy Way
Hill Valley CA 94941
Tel: 415-384-5368
email: deabs@yahoo.com

Be sure to supply your name and address

Address your invoice to the person who commissioned you. Use their full name and title

To: Patricia Whyte
Art Director
Finest Book Publishing
909 Liondale
Philadelphia
PA 400321

Date: June 20, 2004

Order number: 028-04
Reference code: ICB

Itemize the work you have supplied

To supply: 3 full color illustrations
6 black and white line drawings

(@ 300dpi on disc)

For accounting purposes, include your own reference and the publisher's reference

Include the agreed fee

Total: $500

Glossary

BLAD A booklet used in book publishing and usually made up of the intended cover and three to eight printed sample pages. Used to promote new titles at book fairs, sales conferences, etc.

BLEED **(1)** Printed matter designed to run off the edge of the paper. Also used by bookbinders to describe over-cut margins. **(2)** An ink that changes color or mixes with other colors, sometimes caused by **lamination**.

BLURB Promotional text on the flap of a book jacket or the outside back cover of a paperback.

BODY TYPE Text normally used for the main text of a book, not captions or headings. The size range is usually 6 to 16 pt. Picture books may have a body type size up to 30 pt.

COLOR CORRECTION Alteration to the color values of an illustration either by the original photographer using color balancing filters or by adjusting the color scanner to produce the correct result. Subsequent corrections can be done on the **color separations** or on an electronic page composition system.

COLOR SEPARATION In color reproduction the process of separating the various original colors of an image by color filters in a camera or electronic scanner, so that the color separation film and then printing plates can be produced.

COMBINATION LINE AND HALFTONE WORK Halftone and line work combined on one set of films, plates, or artwork.

CONTINUOUS TONE Illustration (photograph, drawing, or painting) consisting of a broad range of tone.

COPY Manuscript, typescript, transparency, or artwork from which a printed image is to be prepared. May also be supplied in electronic form.

COPYRIGHT The right of an author or artist to control the use of their original work. Although broadly controlled by international agreement there are substantial differences between countries.

CORNER MARKS These may be on the original artwork, film, or printed sheet and can also serve as register marks during printing or as **cut marks** for use in the finishing operations.

CROPPING Trimming or masking a photograph or artwork so that a detail, its proportions, or size are in line with those required.

CUT MARKS Marks printed on a sheet to indicate the edge of a page to be trimmed.

CUT-OUT **(1)** An illustration from which the background has been removed to provide a silhouette. **(2)** A display card or book cover with a pattern **die-cut** in it.

DIE-CUT Steel cutting rules bent into an image shape and used to cut into board or paper—used in novelty books.

DOUBLE-PAGE SPREAD See **spread**.

DUMMY A sample for a job made up with the actual materials and to the correct size to show bulk, style of binding, and so on. Also a complete mock-up of a job showing position of type matter and illustrations, margins, and other details.

ENDPAPERS Lining sheets used at each end of a book to fasten the case to the first and last sections of a case binding.

ETCHING The **mordant** effect of a chemical on plate or film. In lithography, the solutions are applied to the plate after imaging to make the nonimage sections both water attractive and ink repellent.

FLAT COLOR An area of printed color with no tonal variations.

FLUSH LEFT OR RIGHT Type set to line up at left or right of column.

FOLIO **(1)** A page number and so a page. **(2)** a large book in which the full-size sheet only needs to be folded once before binding.

FONT A set of type of one face or size.

FOUR-COLOR PROCESS Color printing by means of the three primary colors (yellow, magenta, cyan) and black superimposed. Each plate is produced from separations which have been made from the originals on a scanner or process camera.

GRAIN The direction in which the fibers lie in a piece of paper—some strongly-textured papers can add interesting effects in washes and shadows to watercolor paintings.

GRAPHICS TABLET Used in computing by compositors and in electronic-page composition systems for layout or system control.

GUTTER The margin down the center of a **double-page spread**, sometimes equal to to two back margins.

HALF UP Instruction to prepare artwork 50 percent larger than final size so that it can be reproduced at 66 percent to eliminate any blemishes in the original.

HALFTONE Printing tone illustrations by breaking them down photographically into dots, used in lithography.

IMPOSITION Plan for placing pages on a printing sheet so that when folded, each page will be in the correct sequence.

IN PRO/PORTION (**1**) Individual items of artwork that are to be enlarged or reduced by the same amount during reproduction. (**2**) Instruction that one dimension of an artwork is to be enlarged/reduced in the same proportion as the other.

ISBN International Standard Book Number. A unique ten-figure number that identifies the language of publication of a book, its publisher and its title, plus a check digit. Often also included in a barcode.

JUSTIFY Positioning of type lines so they are evenly spaced on left and right.

LAMINATING Applying transparent or colored plastic films, usually with a high gloss finish, to printed matter to protect or enhance it. Various films are available with different gloss, folding, and strength characteristics.

LINE ART Artwork entirely in black on white with no intermediary tones.

LAYOUT Any indication for the organization of text and pictures with instructions about sizing and so on for reproduction or printing.

LIGHT BOX A box with a translucent glass top lit from below giving a balanced light suitable for color matching on which color transparencies, prints, and proofs can be examined or compared.

MONOCHROME A single color.

MORDANT (**1**) Adhesive for fixing gold leaf. (**2**) Fluid used to etch lines on a printing plate.

OFFSET (**1**) Lithographic (and sometimes letterpress) method of printing in which the ink is transferred from the printing plate to an offset blanket cylinder, and then to the paper, board, metal, or whatever on which it is required. (**2**) To reproduce a book in one edition by photographing a previously printed edition.

PRELIMS Pages at the beginning of a book consisting of half-title, title page, copyright page, contents, and other pre-text materials such as acknowledgments and introduction.

PROOF A representation on paper of any type or other image made either from the plates or directly from the film used in their production.

RECTO Right-hand page.

REPRODUCTION The entire printing process from the completion of typesetting until litho plates reach the press. This includes the use of process cameras, scanners, retouching, and the **imposition** and platemaking operation.

ROUGH An unfinished **layout** or design.

ROUGH PROOF A proof that is not necessarily in position or on the correct paper.

SECTION Paper folded to form part of a book or booklet. Sections can be made up of sheets folded to 4, 8, 16 but rarely more than 128 pages, perhaps from two 64-page sections.

SPREAD Printed matter spread across two facing pages.

VIGNETTE Effect applied to halftones that, instead of being squared up or cut out, have the tone etched gently away at the edges.

VERSO Left-hand page.

Resources

READING LIST

Alderson, Brian. *Sing a Song for Sixpence*. Cambridge, England: Cambridge University Press, 1986.

Arizpe, Evelyn & Styles, Morag. *Children Reading Pictures Interpreting Visual Text*. London: Routledge/Farmer, 2002.

Barr, John. *Illustrated Children's Books*. London: British Library, 1986.

Blake, Quentin. *The Magic Pencil*. London: British Council, 2002.
 Words and Pictures. London: Jonathan Cape, 2000.

Bland, David. *A History of Book Illustration*. London: Faber & Faber, 1958.

Carle, Eric. *The Art of Eric Carle*. New York: Philomel Books, 1996.

Coates-Smith, Wendy & Salisbury, Martin, editors. *Line 2*. Cambridge: Anglia Polytechnic University, Department of Art & Design, 2001.

Cotton, Penni. *Picture Books sans Frontières*. London: Trentham Books, 2000.

Cummins, Julie, editor. *Children's Book Illustration and Design*. Glen Cove, NY: PBC International, 1998.
 Wings of An Artist: Children's Book Illustrators Talk About Their Art. (Activity Guide by Barbara Kiefer) New York: Harry N. Abrams, 1999.

Darling, Harold. *From Mother Goose to Dr. Seuss: Children's Book Covers 1860-1960*. San Francisco: Chronicle Books, 1999.

Doonan, Jane. *Looking at Pictures in Picture Books*. Stroud, Gloucestershire: Thimble Press, 1993.

Feave, William. *When We Were Young*. London: Thames & Hudson, 1977.

Felmingham, Michael. *The Illustrated Gift Book 1880-1930*. Menston, England: Scolar Press, 1988.

Graham, Judith. *Pictures on the Page*. Sheffield, England: National Association for the Teaching of English, 1990.

Hearn, Michael P., Clark, Trinkett & Clark, Nichols B. *Myth, Magic, and Mystery: One Hundred Years of American Children's Book Illustration*. Lanham, MD: Roberts Rinehart/The Chrysler Museum of Art, 1996.

Herzog, Walter. *Graphis No. 156 and 177*. Zurich: The Graphis Press, 1975-1976.

Hodnett, Edward. *Five Centuries of English Book Illustration*. Menston, England: Scolar Press, 1988.

Hürlimann, Betina. *Picture Book World*. Oxford, England: Oxford University Press, 1968.
 Three Centuries of Children's Books in Europe. Oxford, England: Oxford University Press, 1967.

Kingman, Lee, Foster, Joanna & Lontoft, Ruth G., compilers. *Illustration of Children's Books: 1957-1966*. Boston: The Horn Book, Inc., 1968.

Klemin, Diana. *The Illustrated Book, its Art and Craft*. London: Bramall House, 1970.
 The Art of Art for Children's Books. New York: Clarkson N. Potter, 1966.

Lanes, Selma G. *The Art of Maurice Sendak*. New York: Harry N. Abrams, 1980.

Lewis, John. *The 20th Century Book*. London: The Herbert Press, 1967.

Martin, Douglas. *The Telling Line*. London: Julia MacRae Books, 1989.

Powers, Alan. *Children's Book Covers*. London: Mitchell Beazley, 2003.

Preiss, Byron, editor. *The Best Children's Books in the World*. New York: Harry N Abrams, 1996.

Schuleviz, Uri. *Writing with Pictures*. New York: Watson Guptill, 1985.

Sendak, Maurice. *Caldecott and Co.: Notes on Books and Pictures*. New York: Farrar, Straus & Giroux, 1988.

Silvey, Anita, editor. *Children's Books and their Creators*. Boston: Houghton Mifflin, 1995.

The Society of Illustrators, compiler. *The Very Best of Children's Book Illustrators*. Cincinnati: North Light Books, 1993.

Steiner, Evgeny. *Stories for Little Comrades: Revolutionary Art and the Making of Early Soviet Children's Books*. Seattle: University of Washington Press, 1999.

Whalley, Joyce I. & Chester, Tessa R. *A History of Children's Book Illustration*. London: John Murray, 1988.

Wintle, Justin & Fisher, Emma. *The Pied Pipers*. New York: Paddington Press, 1979.

USEFUL BOOKS AND PERIODICALS

Artist's & Graphic Designer's Market, Writer's Digest. Published annually. The guide to get your work sold, commissioned, published, and shown. Lists thousands of industry contacts, buyers of all types of graphic art and illustrations, greeting card companies, art galleries, and record labels.

Children's Books in Print, R.R. Bowker. Published annually. A guide to all American children's books in print, complete with contact information for all publishers, distributors, and wholesalers listed.

Hart, Russell and Starr, Nan (illustrator) *Photographing your Artwork*, 1987, *2nd edition*, Amherst Media, 2000. Learn how to obtain grants and commissions, and how to submit works to galleries.

Writer's Market, Writer's Digest. Published annually. Detailed listings on more than 8,000 editors, book publishers, consumer magazines, script buyers, trade and professional journals, plus more than 300

agents. Also includes information on what each editor wants, how much they pay, and how often they buy.

ORGANIZATIONS

Children's Book Council, 12 37th St, 2nd Floor, New York, NY 10018-7480. *www.cbcbooks.org* Deals with both authors and illustrators of children's books.

Graphic Artists Guild, 90 John St, Suite 403, New York, NY 10038-3203 *www.gag.org* Assistance for graphic designers and illustrators.

Society of Illustrators, 128 E 63rd St, New York, NY 10021 *www.societyillustrators.org* Information for illustrators.

The Author's League of America Inc., 234 W.44th St, New York, NY 10036. Advice for all authors. Also has sample contracts.

The Authors Guild, 31 E 28th St, 10th Floor New York, NY 10016-7923. Publishes a quarterly bulletin. It offers author and freelance-journalist members free contract reviews and assistance in disputes with publishers.

Joint Ethics Committee, PO Box 179, Grand Central Station, New York, NY 10003. Sponsored jointly by the Art Directors Club of New York, the American Society of

Magazine Photographers, the Graphic Artists Guild, the Society of Illustrators, and the Society of Photographers and Artists Representatives. Mediates or arbitrates disputes between graphic artists and clients.

Poets & Writers, Inc., 72 Spring Street, Suite 301, New York, NY 10012. Publishes *Poets & Writers Magazine*, a leading journal for creative writers.

The Purple Crayon *www.underdown.org* An online children's book editor's site that features basic information for writers and illustrators, as well as a publishing glossary, book recommendations, interviews, and articles about the owner's experiences in children's publishing.

Society of Children's Book Writers and Illustrators, 8271 Beverly Blvd., Los Angeles, CA 90048. Largest children's writing organization in the world. It is a network for the exchange of knowledge between writers, illustrators, editors, publishers, agents, librarians, educators, and booksellers.

Volunteer Lawyers for the Arts, 1 East 53rd St, 6th floor, New York, NY 10022-4201. Provides free legal services for those meeting income requirements. Referrals to similar organizations in other cities.

For information regarding the annual Children's Book Fair held in Bologna, Italy: *www.bookfair.bolognafiere.it*

Index

Index

Credits

The author wishes to thank all those artists who have so generously provided examples of their work for reproduction in this book, in particular the many students, graduates, and staff of APU Cambridge School of Art whose work appears throughout these pages.

Quarto would also like to thank and acknowledge the following:

Key: l left, r right, c center, t top, b bottom

Pages 1, 144 Thomas Taylor, from *The Loudest Roar* (Oxford University Press 2002) © Thomas Taylor 2002. Reproduced by permission of the artist and publisher • 2, 36b, 59l, 75b, 77b Kristin Roskifte, from *Alt Vi Ikke Vet (All That We Don't Know)* (J.W. Cappelens Forlag AS) © Kristin Roskifte. Reproduced by permission of the artist and publisher • 3, 62b Sarah McConnell, from *Little Fella Superhero* (Orchard Books) © Sarah McConnell. Reproduced by permission of the artist and publisher • 4, 37bl David Shelton, from the magazine series *The Horrible Collection* (Eaglemoss Publications Ltd) © Eaglemoss/David Shelton. Reproduced by permission of the artist and publisher • 5tl, 45t Adrian Reynolds, from *Harry and the Dinosaurs Say Raah!* by Ian Whybrow (Gullane 2001) © Adrian Reynolds. Reproduced by permission of the artist • 5tc Paula Metcalf (student work). Reproduced by permission of the artist • 5tr, 72 Lane Smith, from *Squids Will Be Squids* by Jon Scieszka (Viking 1998) © Lane Smith. Reproduced by permission of the artist • 5 vignettes Pam Smy (studies). Reproduced by permission of the artist • 6t, 74t Sara Fanelli, from *Mythological Monsters* (Walker Books Ltd) © Sara Fanelli. Reproduced by permission of the artist and publisher • 6b Edward Ardizzone, from *Tim and Lucy Go to Sea*. © Edward Ardizzone 1938. Reproduced by permission of the Artist's Estate • 7 Eberhard Binder, from *Mr Clockman* by Helga Renneisen (Oliver & Boyd 1967) © Eberhard Binder. Reproduced by permission of the artist's widow Elfriede Binder • 13t Edward Ardizzone, from Ark Magazine (The Royal College of Art) © Edward Ardizzone. Reproduced by permission of the Artist's Estate • 13b Antonio Frasconi, from *See and Say* (Harcourt Brace and Company NY 1955) © Antonio Frasconi. Reproduced by permission of the artist. All rights reserved • 15t Allan Drummond, from *The Willow Pattern Story* (North-South Books NY 1992) © Allan Drummond. Reproduced by permission of the artist • 15b, 54br John Lawrence, from *This Little Chick* (Walker Books Ltd) © John Lawrence. Reproduced by permission of the artist and publisher • 16t, 76t Lane Smith, from *The Happy Hocky Family* (Viking) © Lane Smith. Reproduced by permission of the artist • 17t Steve Johnson, from *The Frog Prince Continued* by Jon Scieszka (Viking 1991) © Steve Johnson 1991. Reproduced by permission of the artist, Penguin Books Ltd, and Penguin Group (USA) Inc • 17b Extracts from *Flying* by Kvĕta Pacovská, Marianne Martens (Translator). Published by North-South Books (Nord-Sud Verlag AG) © Kvĕta Pacovská.

Reproduced by permission of the artist and publisher • 18t Tony DiTerlizzi, from *The Seeing Stone* (Spiderwick Chronicles) by Holly Black. (Simon & Schuster Children's Books) © Tony DiTerlizzi. Reproduced by permission of the artist and publisher • 18b Quentin Blake, from *The Green Ship* (Jonathan Cape) © Quentin Blake. Reproduced by permission of the artist and The Random House Group Ltd • 19t, 38t, 85 Alexis Deacon, from *Beegu* (Hutchinson) © Alexis Deacon. Reproduced by permission of the artist and The Random House Group Ltd • 19c, 19b Sara Fanelli, from *First Flight* (Jonathan Cape) © Sara Fanelli. Reproduced by permission of the artist and The Random House Group Ltd • 33b Dan Williams, from *Fine Feathered Friend* (Egmont Books Limited, London) © Dan Williams 2001. Reproduced by permission of the artist and publisher • 39b, 82t Alexis Deacon, from *Slow Loris* (Hutchinson) © Alexis Deacon. Reproduced by permission of the artist and The Random House Group Ltd • 41b Martin Salisbury, from *Baboushka* (SC4) © Martin Salisbury. Reproduced by permission of the artist • 43t Adrian Reynolds, from *Silly Goose and Daft Duck Try to Catch a Rainbow* by Sally Grindley (Dorling Kindersley 2001) © Adrian Reynolds. Reproduced by permission of the artist • 44l, 50t John Holder, from *The Folio Book of the English Christmas* (Folio Society 2002) © John Holder. Reproduced by permission of the artist and publisher • 45c, 97l, 103tl Martin Salisbury, from *The Midnight Fox* by Betsy Byars (Faber and Faber 2002) © Martin Salisbury. Reproduced by permission of the artist • 51t, 66r Martin Salisbury, from *Bungee Hero* by Julie Bertagna (Barrington Stoke 2000) © Martin Salisbury. Reproduced by permission of the artist and publisher • 52 Jane Simmons, from *The Dreamtime Fairies* (UK + Australia: *Where the Fairies Fly*) (Orchard Books) © Jane Simmons. Reproduced by permission of the artist and publisher • 53bl Jane Simmons, from *Ebb & Flo and the Greedy Gulls* (Orchard Books) © Jane Simmons. Reproduced by permission of the artist and publisher • 53br Jane Simmons, from *Come on Daisy* (Orchard Books) © Jane Simmons. Reproduced by permission of the artist and publisher • 60, 61 Bee Willey, from *Bob Robber and Dancing Jane* by Andrew Matthews (Jonathan Cape). Reproduced by permission of the artist and The Random House Group Ltd • 68t Georgie Ripper, from *My Best Friend, Bob* (MacMillan 2001) © Georgie Ripper. Reproduced by permission of the artist and publisher • 70tl Satoshi Kitamura, from *Sheep in Wolves' Clothing* (Andersen Press) © Satoshi Kitamura. Reproduced by permission of the artist and publisher • 70b, 71 Satoshi Kitamura, from *Comic Adventures of Boots* (Andersen Press) © Satoshi Kitamura. Reproduced by permission of the artist and publisher • 73l, 123bl Lane Smith, from *The Very Persistent Gappers of Frip* by George Saunders, Molly Leach (designer) (Villard) © Lane Smith. Reproduced by permission of the artist • 74b Lane Smith, from *Maths Curse* by Jon Scieszka (Viking 1995) © Lane Smith. Reproduced by permission of the artist • 75t

Credits

John Lawrence, from *Tiny's Big Adventure* by Martin Waddell (Walker Books Ltd) © John Lawrence. Reproduced by permission of the artist and publisher • 75c, 122b, 123tl Frédérique Bertrand, from *Les Petits Héritages* (Éditions du Rouergue) © Frédérique Bertrand. Reproduced by permission of the artist and publisher • 76b Paula Metcalf, from *Norma No Friends* (Barefoot Books www.barefootbooks.com) © Paula Metcalf 1999. Reproduced by permission of the artist and publisher • 84 Quentin Blake, from *Cockatoos* (Jonathan Cape) © Quentin Blake. Reproduced by permission of the artist and The Random House Group Ltd • 86bl Helen Stephens, from *Busy Digger* by Anna Nilson (Campbell Books) © Helen Stephens. Reproduced by permission of the artist and publisher • 86br, 108bl, 115tl Amanda Loverseed, from *The Count-Around Counting Book* (Collins) © Amanda Loverseed. Reproduced by permission of the artist and publisher • 87t Eva Tatcheva, from *Witch Zelda's Birthday Cake* (Tango Books) © Eva Tatcheva. Reproduced by permission of the artist and publisher • 87br Eva Tatcheva, from *Witch Zelda's Beauty Potion* (Tango Books) © Eva Tatcheva. Reproduced by permission of the artist and publisher • 88 Sam McCullen (student project) © Sam McCullen. Reproduced by permission of the artist • 94t, 95b Martin Salisbury, from *Supernatural Stories* (Kingfisher) © Martin Salisbury. Reproduced by permission of the artist and publisher • 94b James Mayhew, from *To Sleep, Perchance to Dream—A Child's Book of Rhymes* (The Chicken House) © James Mayhew. Reproduced by permission of the artist and publisher • 95t Pam Smy, from *50 Great Stories for 7–9 year-olds* (Miles Kelly Publishing Ltd) © Pam Smy. Reproduced by permission of the artist and publisher • 98 Martin Salisbury, from *Arthur Warrior Chief* by Mick Gower (OUP) © Oxford University Press. Reproduced by permission of the artist • 99 Chris Priestley, from *Death and the Arrow* (Doubleday) © Chris Priestley. Reproduced by permission of the artist and publisher • 100t Martin Salisbury, from *Act of God* Edited by Undine Giuseppi (Macmillan Education) © Macmillan Education. Reproduced by permission of the publisher • 100c Jane Human, from *In the Heat of the Day* by Michael Anthony (Heinemann) © Jane Human. Reproduced by permission of the artist • 100b Jane Human, from *A Small Gathering of Bones* by Patricia Powell (Heinemann) © Jane Human. Reproduced by permission of the artist • 101 Illustrations © Niroot Puttapipat 2003/4 The Artworks 020 7610 1801 www.theartworksinc.com • 102t Beppe Giacobbe, from *Fifteen Love* by Robert Corbet (Walker & Company NY). Reproduced by permission of the artist and publisher • 102b Beppe Giacobbe, from *Walk Away Home* by Paul Many (Walker & Company NY). Reproduced by permission of the artist and publisher • 103tr Jochen Gerner, from *De Nulle Part* (Éditions du Rouergue) © Jochen Gerner. Reproduced by permission of the artist and publisher • 103b Michelle Barnes, from *Stolen by the Sea* by Anna Myers (Walker & Company NY). Reproduced by permission of the artist and publisher • 104

Chloë Cheese, from *Walking the Bridge of Your Nose* by Michael Rosen (Kingfisher Publications plc) © Chloë Cheese 1995. Reproduced by permission of the artist and publisher • 105tl, 105tr Satoshi Kitamura, from *Einstein, the Girl who Hated Maths* by John Agard (Hodder & Stoughton Ltd) © Satoshi Kitamura. Reproduced by permission of the artist and publisher • 105b Alan Drummond, from *A Treasury of Poetry* (Running Press) © Alan Drummond. Reproduced by permission of the artist and publisher • 107bl James Mayhew, from *Koshka's Tales* (Kingfisher Publications Plc) © James Mayhew 1993. Reproduced by permission of the artist and publisher • 108t, 114 Emma Chichester Clark, from *The Oxford First Illustrated Dictionary* compiled by Andrew Delahunty (Oxford University Press 2003) © Emma Chichester Clark. Reproduced by permission of the artist and publisher • 109t, 109br Martin Salisbury, from *Lloyd George and the First World War* (Wayland) © Wayland. Reproduced by permission of Hodder & Stoughton Ltd • 109bl Anna Nilson, from *Pirates* (Little Hare) © Anna Nilson. Reproduced by permission of the artist and publisher • 110t, 110br, 111br Martin Salisbury, from *People in History* by Fiona Macdonald (Demsey Parr) © Demsey Parr 1998. Reproduced by permission of the artist and Parragon Publishing • 118 Lane Smith, from *The Stinky Cheese Man and Other Fairly Stupid Tales* by Jon Scieszka, Molly Leach (designer) (Viking 1992) (c) Lane Smith. Reproduced by permission of the artist • 119b Helen Ward, from *The Cockerel and the Fox* (Templer 2002) © Helen Ward. Reproduced by permission of the artist and publisher • 122t Sara Fanelli, from *Pinocchio* by Carlo Collodi. (Walker Books Ltd) © Sara Fanelli. Reproduced by permission of the artist and publisher • 123tr Jochen Gerner, from *L'Étoile de Kostia* © Jochen Gerner. Reproduced by permission of the artist • 123br Øyvind Torseter, from *Mister Random* (Éditions du Rouergue) © Øyvind Torseter. Reproduced by permission of the artist and publisher • 124–125 Jonny Hannah, from *Jazz!* (Due to be published in February 2005 by Walker Books Ltd) © Jonny Hannah. Reproduced by permission of the artist and publisher • 127 Reproduced by permission of the Bologna Children's Book Fair.

All other illustrations and photographs are the copyright of Quarto Publishing plc. While every effort has been made to credit contributors, Quarto would like to apologize should there have been any omissions or errors—and would be pleased to make the appropriate correction for future editions of the book.